LIGHTHOUSES
of the World

Visit our website at www.skyhorsepublishing.com.

10 9 8 7 6 5 4 3 2 1

Library of Congress Cataloging-in-Publication Data is available on file.

Cover design by Owen Corrigan
Cover photo credit: Thinkstock

Print ISBN: 978-1-62914-191-6
Ebook ISBN: 978-1-62914-319-4

Printed in China

LIGHTHOUSES
of the World

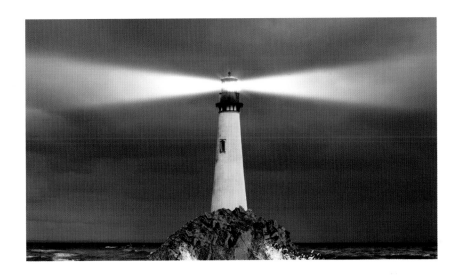

Lisa Purcell

Skyhorse Publishing

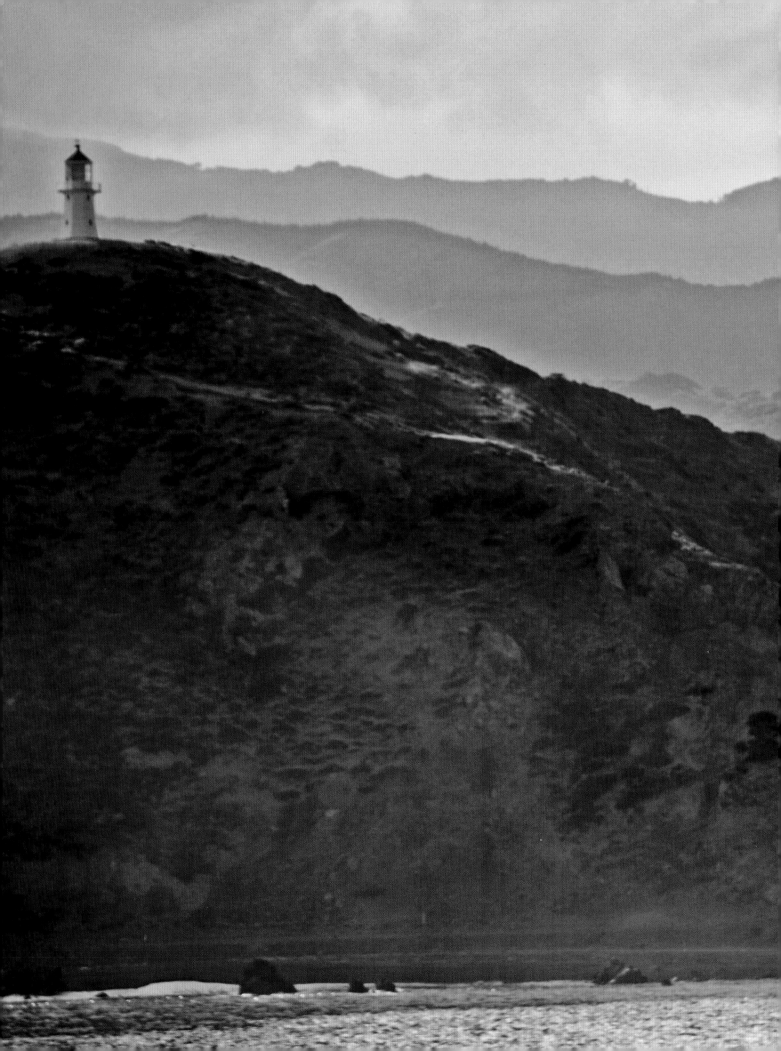

Contents

◀ **Pencarrow Head**, Wellington

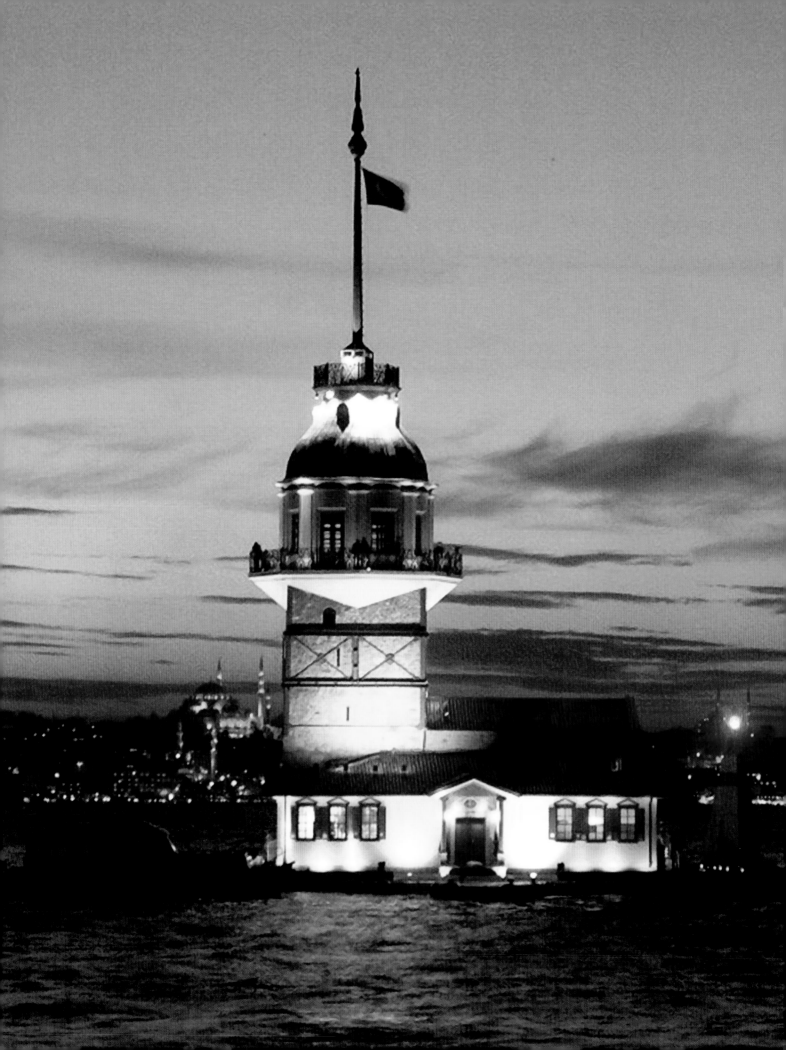

◄ **Maidens Tower**, Turkey

A BRIEF HISTORY OF LIGHTHOUSES

The building of lighthouses implies the development of nautical powers, and as the oceans and seas became more important in trade, travel and exploration, Seafarers—who had long sailed at the whim of the elements—moved to secure their environment to assure the fleet's safe passage. The very first lighthouses were built with the intention of welcoming ships and stimulating trade, but these early sailors eventually realized that these beacons could be used to warn of dangerous conditions, such as rocky ledges, shallow areas, or submerged shoals.

Perhaps the most famous lighthouse of all time was built in the third century BC to light the way to Alexandria, Egypt—it was situated on the eastern point of Pharos Island. The building is thought to have been almost 500 feet tall, with a light visible from 35 miles away. Commissioned by Alexander the Great's general, Ptolemy I Soter, it was made up of three distinct levels. It

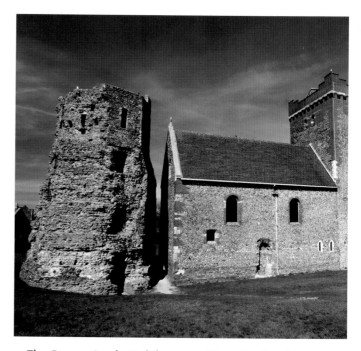

▲ The Dover Castle Lighthouse in Kent, England, was built by the Romans in 46–50 AD. The octagonal structure was originally 80 feet tall, but only the bottom four floors remain today.

▼ The world's oldest surviving wave-washed lighthouse is located off the coast of Angus, Scotland. Since 1811, the Bell Rock Lighthouse has withstood the onslaught of heavy wind and waves. It even survived a helicopter crash in 1955.

was designed by Sostratos, and built by thousands of Egyptian slaves. The Pharos Lighthouse was the model for lighthouse technology for more than a millennium. One of the Seven Wonders of the World in the Hellenistic period, the lighthouse stood until destroyed by an earthquake in 1323.

While nothing came close to matching the Pharos Lighthouse for more than a thousand years after its erection, some Roman beacons did cast a glow over the waters during this period. The remnants of one of the twin lighthouses at Dover, built during the first century, still stand, at La Coruña in Spain, their contemporary, the Tower of Hercules, still functions as the oldest active Roman lighthouse.

The fall of the Roman Empire resulted in a diminished need for navigational beacons, primarily due to decreased trade, and as a result recorded information about lighthouses in the next seven centuries is next to nonexistent. In China in the ninth century, they hung lanterns at the top of tiered edifices, such as Mahota Pagoda, which still stands in Shanghai. The Mahota pagoda was a beacon for ships in the Huangpu River, which served as an outlet to the Yangtze. Pagodas served primarily as religious temples with only

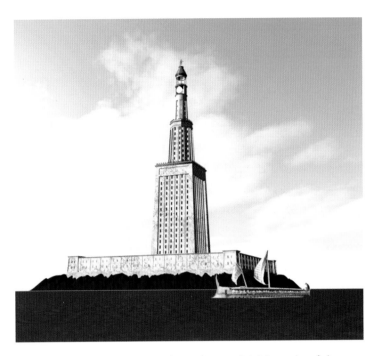

▲ Graphic reconstruction based on a 2006 study of the Pharos Lighthouse of Alexandria, which was hailed as one of the Seven Wonders of the Ancient World.

▼ The Pharos Lighthouse of Alexandria took 12 years to build and was constructed of marble blocks with lead mortar.

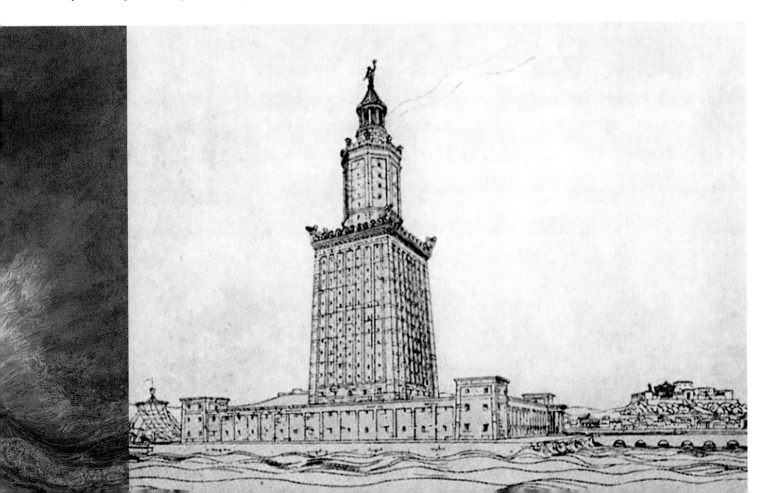

secondary navigational functions. Although some lighthouses were built during the Middle Ages, no technological advancements were made. The oldest surviving example is a twelfth-century beacon, tended by monks in Ireland at Hook Head, which continues to function to this day.

In 1492, armed with the development of the triangular "lateen sail"—a massive improvement on the traditional square-shaped sails—and spurred on by pressure from competing nations, Christopher Columbus embarked on an expedition to establish a new trade route to Asia, with the blessing (and funding) of King Ferdinand II of Aragon and his bride Queen Isabella I of Castile. Columbus's voyages to North America opened the ports of the New World to massively expanded naval traffic, and the New World colonies that sprang up soon saw the need to build beacons at important ports; the Spanish established a watchtower in the 1500s in St. Augustine in what is now Florida, which is one of North America's earliest lighthouses.

The English, in the colony of Massachusetts, erected a makeshift beacon to light Boston Harbor as early as 1673. Boston Light, the first official lighthouse in what would become the United States, was built in 1716. In England, John Smeaton invented lighthouse innovations that would be taken up by the rest of the world. He began work on the third lighthouse at Eddystone in 1756—the Eddystone Light was intended to warn sailors of the dangerous rocks that lurked beneath the water that had wrecked so many ships. Smeaton's endeavor was a great leap forward in lighthouse development. The building crew used hydraulic lime in conjunction with a system of dovetail joints to anchor

▸▸Hook Head Light in Ireland was built in the 12th century. It remained an active aid to navigation throughout its history except for a period of 16 years in the 17th century when civil war broke out. The modern facade encases the centuries-old structure.

▾ The Mediterranean could be treacherous to travel, and though the construction of lights helped ease the journey, it did not speed it up. It is believed the Romans built at least 30 lighthouses on the Mediterranean.

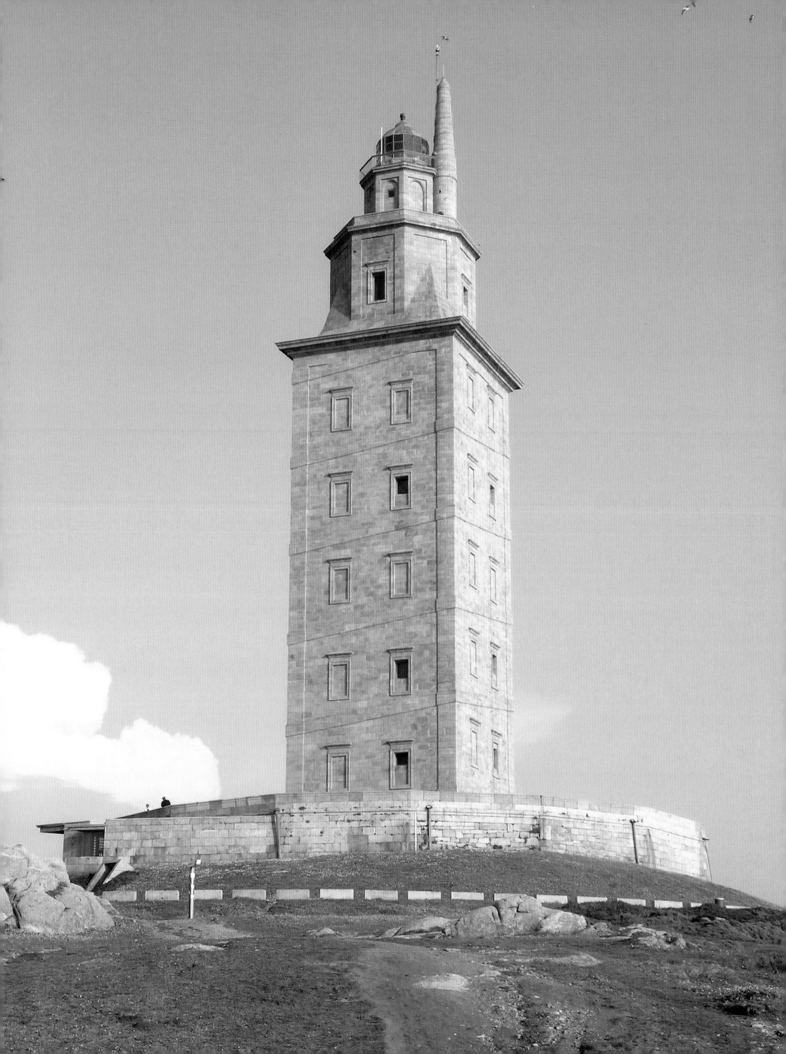

the stones to the rock and each other—the great advantage of hydraulic lime is that it cures underwater. Smeaton's tower at Eddystone was modeled on the trunk of an oak tree, thickening gradually to a wide base. It shone for over 100 years.

Another British engineering advancement took place at Inchcape—or the Bell Rock—in the North Sea, 12 miles east of Scotland. The credit for the design of the tower goes to Robert Stevenson, the onsite engineer, and John Rennie. The tower was composed of precisely cut interlocking granite and sandstone pieces, and was Scotland's first revolving light: twenty-four candles, each with a silvered parabolic reflector, rotated on a clockwork base. The 1811 tower stands today in testament to the precise execution of the difficult undertaking at Bell Rock which had previously posed seemingly insurmountable challenges, including total submersion of the rocks at high tide.

In the modern era, many lighthouses became automated, and without the care of keepers began to deteriorate; still more lighthouses were rendered obsolete by navigational developments, such as the Global Positioning System (GPS). In America, the U.S. Coast Guard called for the demolition of several lighthouses that were no longer active aids to navigation, and while some lights were torn down, many local communities rose up in outraged support of their lighthouses, with the result that in 2000, the U.S. federal government passed the Historic Lighthouse Preservation Act. This legislation, and similar laws passed around the globe, ensures that many of the lights that guided the vessels of our ancestors are now open to the public, and will continue to shine in the future.

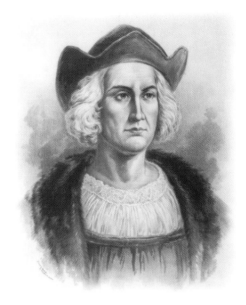

▲ Christopher Columbus made four trips to the New World. Between his third and fourth trips, Columbus and his brothers were arrested for supposed acts of torture used to govern Hispaniola. They were released after six weeks.

◄◄ The Romans built the Tower of Hercules in Spain in the second century AD. It is the oldest active lighthouse in the world. Legend has it that the light was built on the spot where Hercules slew the giant Geryon and then buried his head and weapons. The light appears above a skull and crossbones on the coat-of-arms of La Coruña.

◄ Sir James Douglass was a prolific lighthouse builder and designer in the late 19th century.

Lighthouses of
AFRICA

Kribi Lighthouse

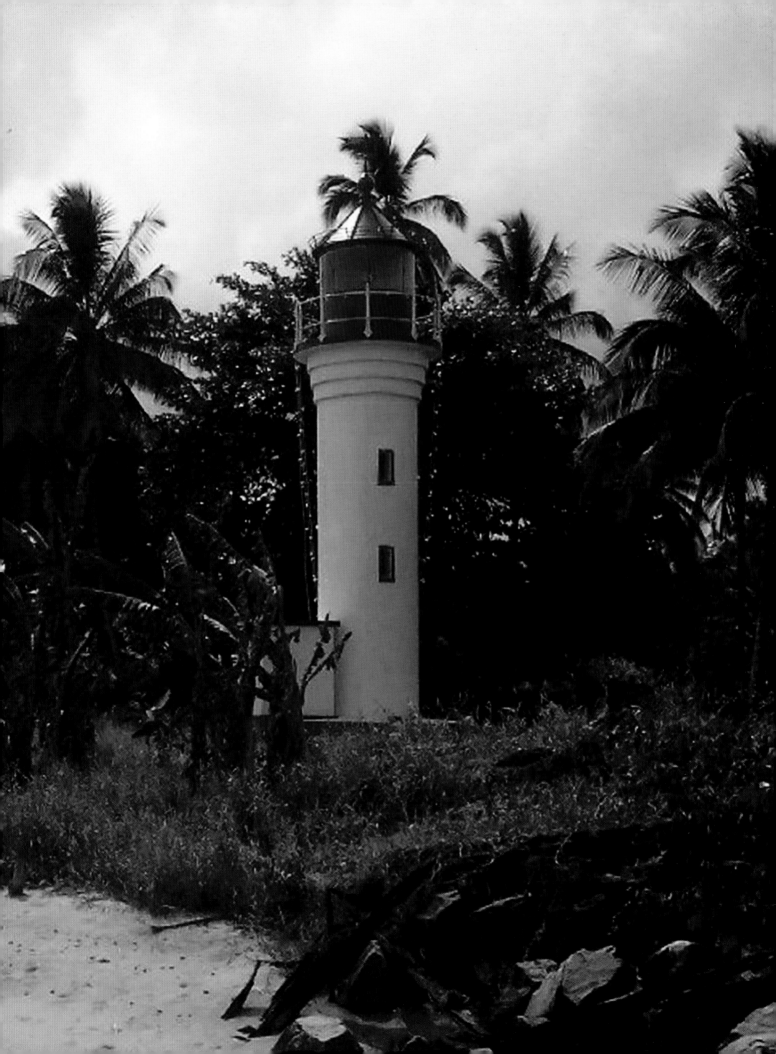

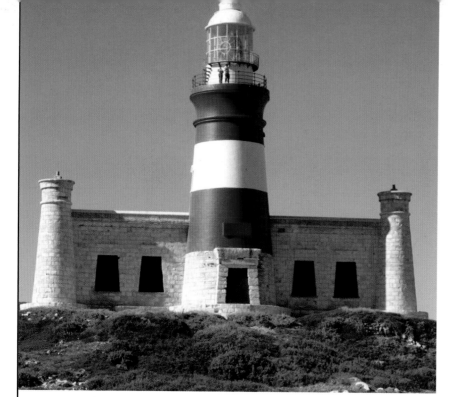

<div style="writing-mode: vertical">Lighthouses of Africa</div>

◄ Cape Agulhas Lighthouse:

Situated at Cape Agulhas on the southernmost tip of Africa, the Cape Agulhas Lighthouse was the third lighthouse to be built in South Africa, and is the second oldest still operating there after Green Point.

Year first constructed	1848
Height	27 m

►► Danger Point Lighthouse:

Located on the southern point of Walker Bay, near Gansbaai, Danger Point Lighthouse is an imposing white octagonal tower with a red lantern dome. HMS Birkenhead, one of the first iron-hulled ships commissioned by the Royal Navy, famously foundered on the perilous reef less than a mile from Danger Point in 1852 with the loss of 450 lives. No fewer than seven wrecks still litter the rocks beneath the lighthouse.

Year first constructed	1895
Height	45m

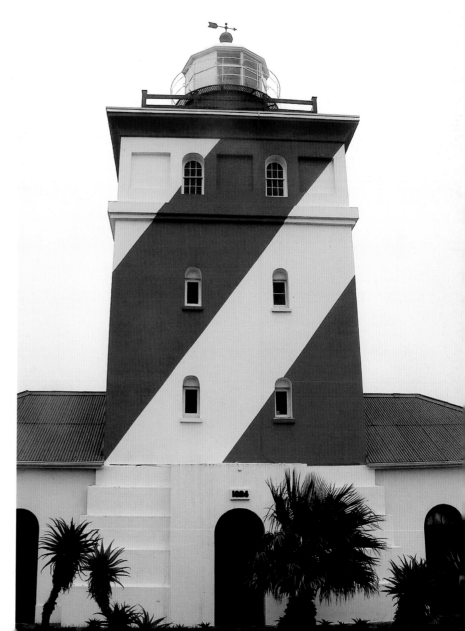

► The Green Point Lighthouse:

The oldest operational lighthouse in South Africa, Green Point in Cape Town was the first solid lighthouse on the South African coast, designed by the German architect Heman Schutte. The foghorn emits such a mournful "bovine" drone that it is referred to locally as "Moaning Minnie."

Year first constructed	1824
Height	16m

Plaque commemorating the sinking of the Birkenhead, affixed to the Danger Point lighthouse

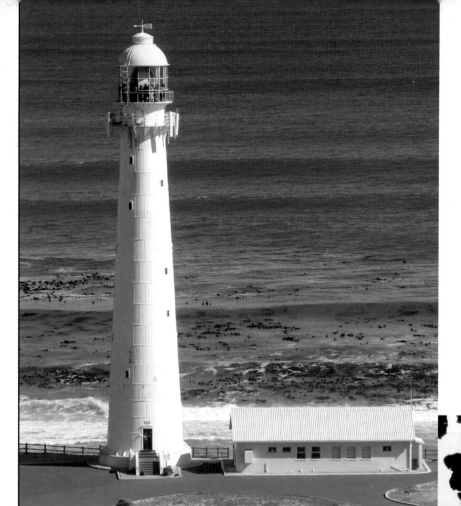

◄ Slangkop Lighthouse:

The Slangkop Lighthouse, located in Kommetjie, is the tallest cast-iron tower on the South African Coast. This white lighthouse has been operational since March 4, 1919, and has a range of 33 nautical miles (60km).

Year first constructed	1919
Height	33m

▸▸ Seal Point Lighthouse:

Seal Point Lighthouse is located on Cape St. Francis in South Africa where a deadly reef has claimed numerous passing ships. The lighthouse is still operational today, and also houses a museum. As well as saving human seafarers, the lighthouse is nowadays famed for its penguin rescue and rehabilitation facility which is also located in the lighthouse grounds.

Year first constructed	1878
Height	27.75m

▸ Nosy Alañaña Lighthouse:

At a height of 197 feet (60 m) the Nosy Alañaña Lighthouse is the tallest lighthouse in Africa, and the nineteenth tallest traditional lighthouse in the world. The octagonal concrete tower is situated on a tiny island called the Île aux Prunes, in Madagascar, and is also known as the Île aux Prunes Lighthouse.

Year first constructed	1932
Height	60m

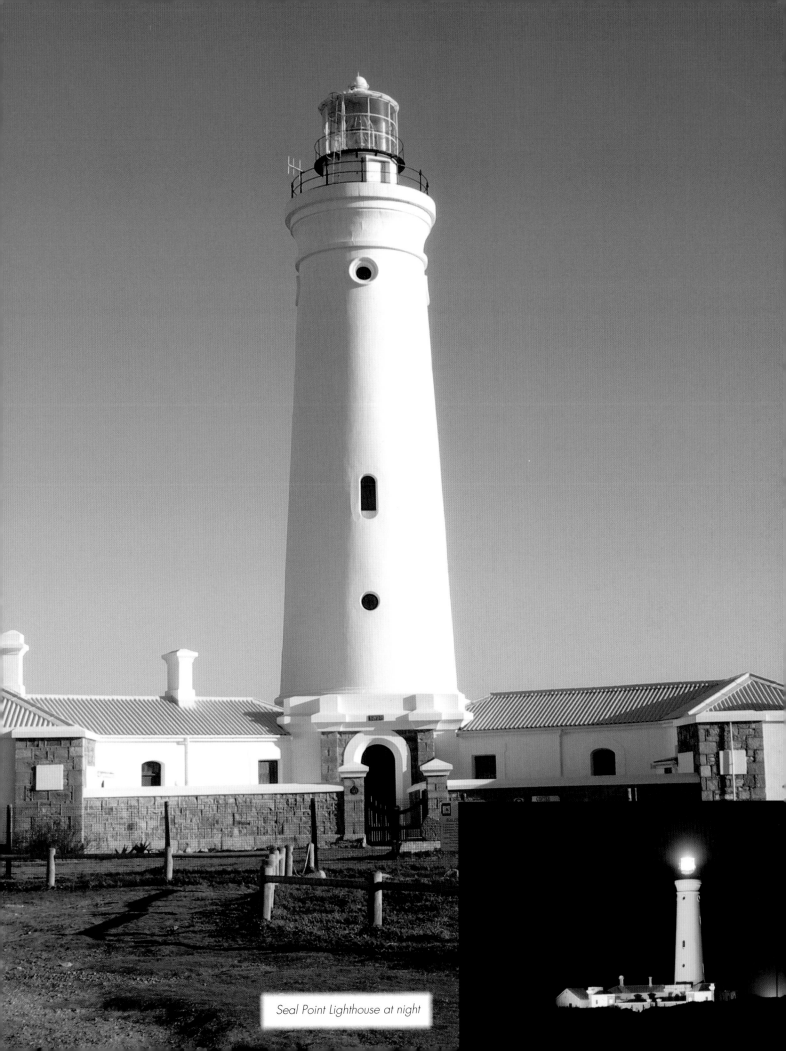

Seal Point Lighthouse at night

▲ Port Said Lighthouse:

Considered a unique example of 19th-century architecture, the Lighthouse of Port Said in northeast Egypt is one of the most important landmarks in that famous sea port. The lighthouse was designed by the French architect François Coignet and commissioned by the Khedive of Egypt and Sudan, Ismail the Magnificent. Located at the mouth of the Suez Canal, the lighthouse construction was completed just a week before the canal's inauguration.

Year first constructed	1869
Height	56 m

▶ *The lighthouse of Port Said in the 1930s*

▶▶ Kribi Lighthouse:

Kribi lighthouse is a white, cylindrical, stone-built tower with a red latern and gallery. It is located in Kribi, in the southern area of Cameroon near the Gulf of Guinea. The lighthouse was constructed by the Germans who originally colonized Cameroon. Initially, there was a keeper's cottage next to the lighthouse, but that has since disappeared.

Year first constructed	1906
Height	15m

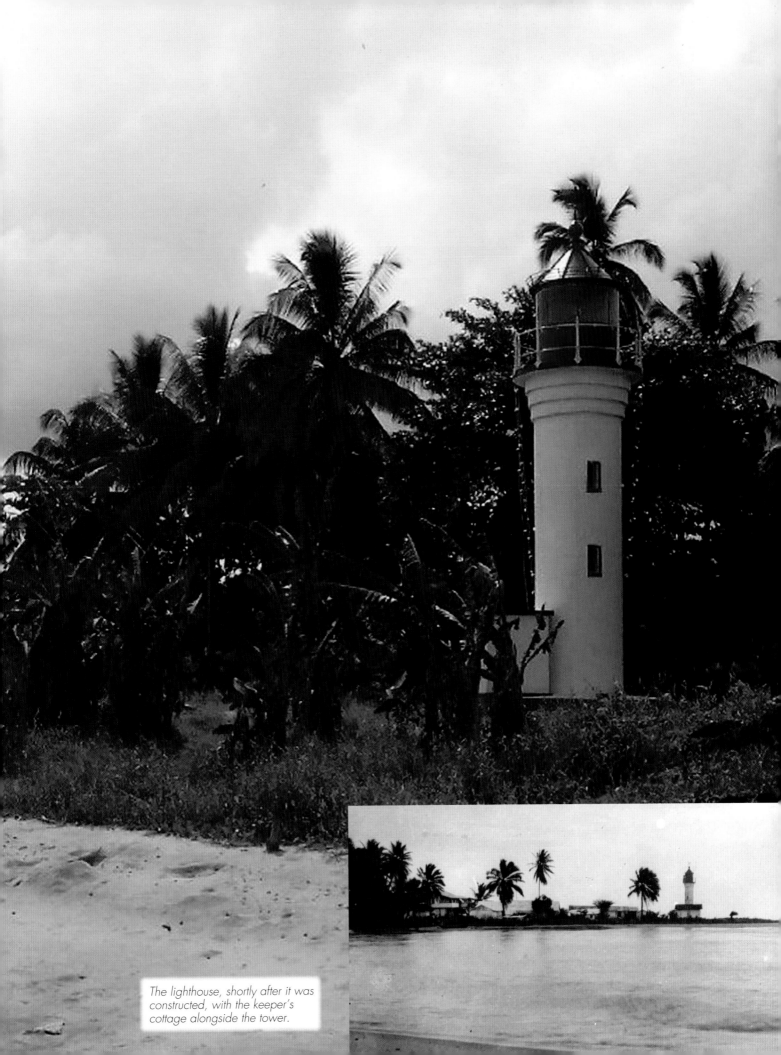

The lighthouse, shortly after it was constructed, with the keeper's cottage alongside the tower.

Lighthouses of
AUSTRALASIA

Castle Point lighthouse

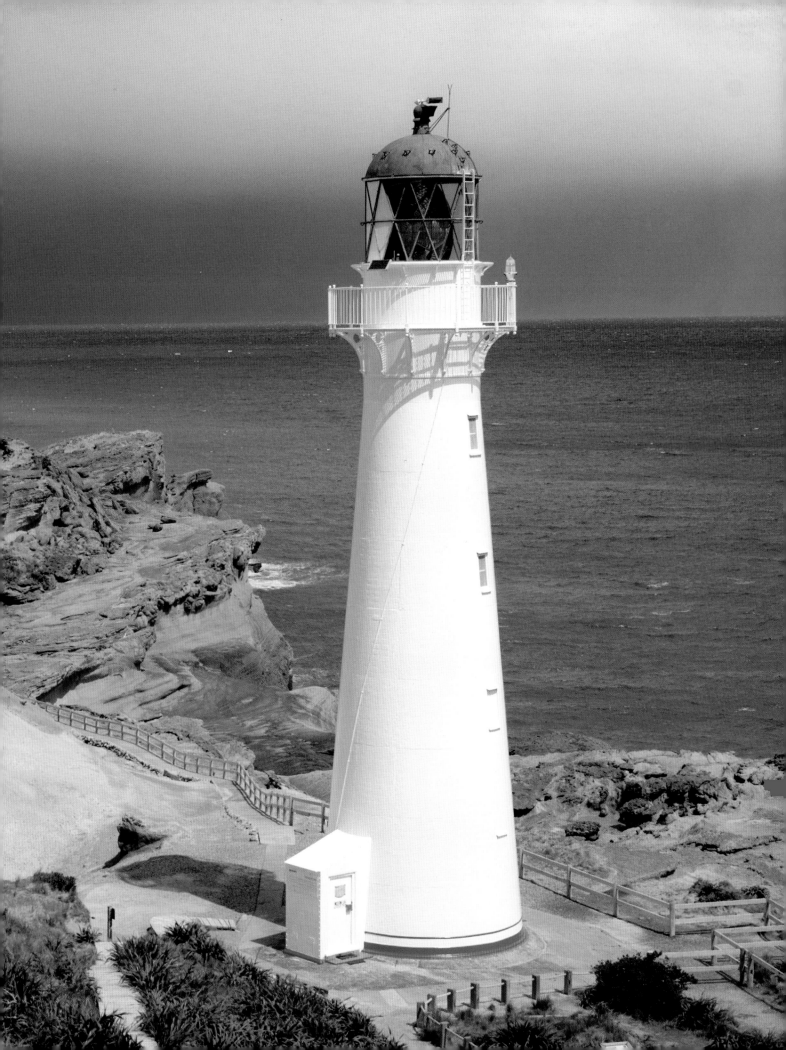

Australia's oldest continuously used pilot station, Low Head Lighthouse is situated at the mouth of the Hebe River in Low Head, Tasmania. The lighthouse was built by convict labor to alert shipping to the Hebe Reef (named after the infamous loss of the Hebe in that location in June 1808). The original stone tower fell into ruin by the 1880's and the existing structure was built in 1888. Originally painted entirely white, the red band was added in 1926 to improve visibility in daylight. Today, the light is fully automated.

Year first constructed	1833
Height	19 m

▸▸**Cape Byron Lighthouse:**

Australia's most powerful light with an intensity of 2,200,000 cd, Cape Byron Lighthouse has a cylindrical tower constructed with concrete blocks and a large lobby and service rooms at the base with distinctive castellated walls. Cape Byron is an active lighthouse located at the easternmost point of the Australian mainland, in New South Wales, about 2 miles northeast of Byron Bay.

Year first constructed	1901
Height	23m

▸ **Grotto Point Lighthouse:**

Also known as Port Jackson Entrance Range Front Light, Grotto Point is an active lighthouse located on a rocky headland at the southernmost tip of Balgowlah Heights, on the north side of Sydney Harbour, in New South Wales. The light shines through an unusual horizontal slit that is located at approximately two thirds of the height of the tower.

Year first constructed	1910
Height	8m

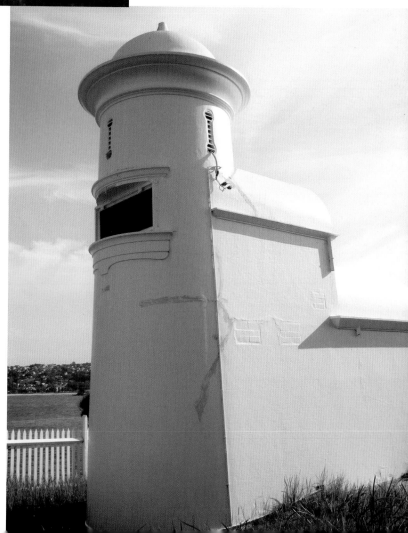

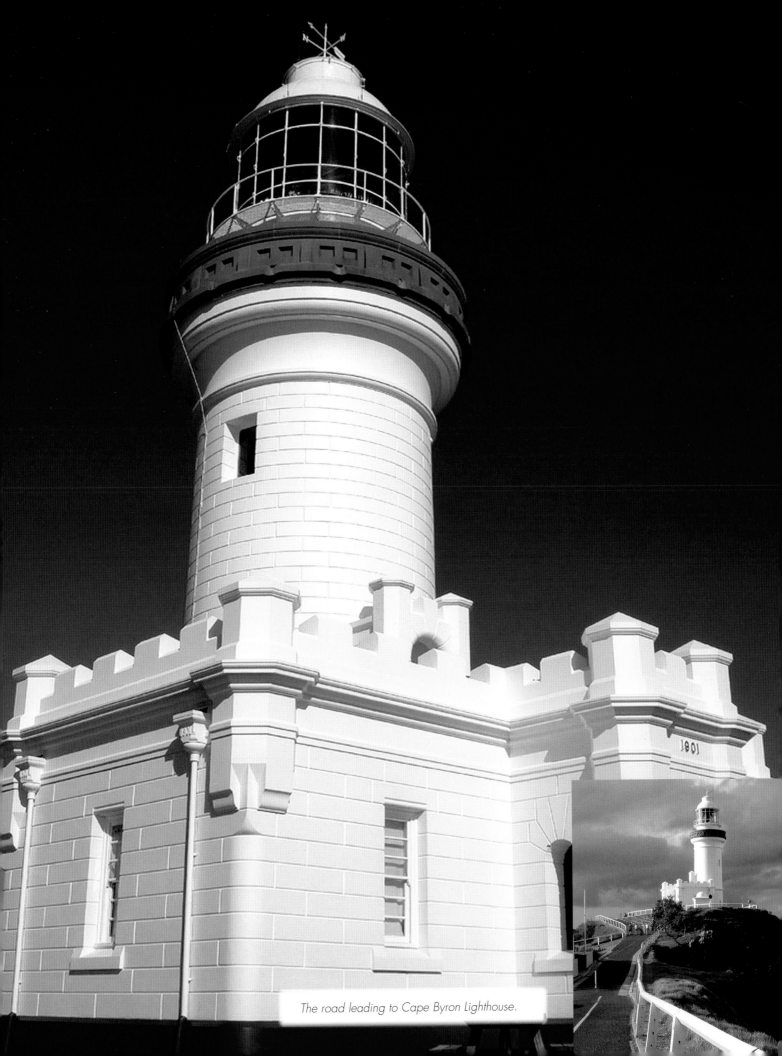

The road leading to Cape Byron Lighthouse.

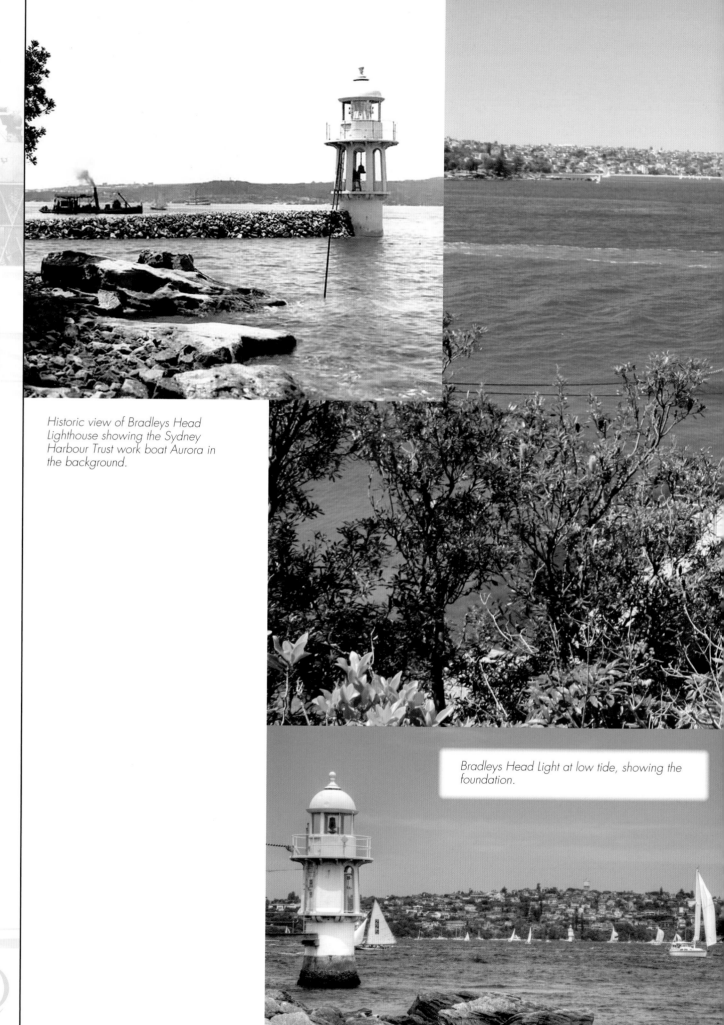

Historic view of Bradleys Head
Lighthouse showing the Sydney
Harbour Trust work boat Aurora in
the background.

Bradleys Head Light at low tide, showing the
foundation.

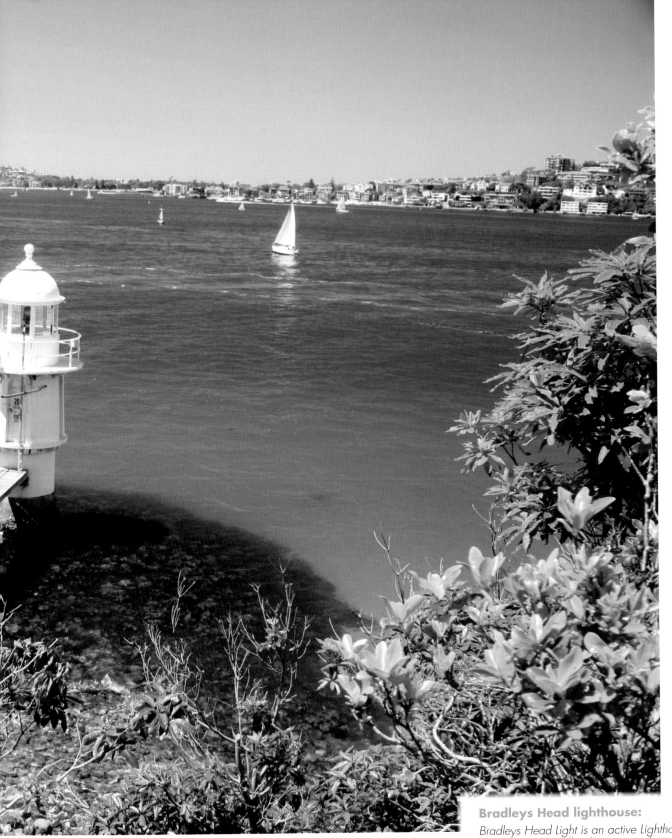

Bradleys Head lighthouse:

Bradleys Head Light is an active Lighthouse located on a headland projecting from the north shore of Sydney Harbour, New South Wales, Australia, within the Sydney Harbour National Park. The sibling of Robertson Point Light, Bradleys Head Lighhouse is mounted on a rock and connected to the shore via a footbridge. Situated nearby is the mast of HMAS Sydney, a monument to Australian sailors killed in combat.

Year first constructed	1905
Height	6.1 m

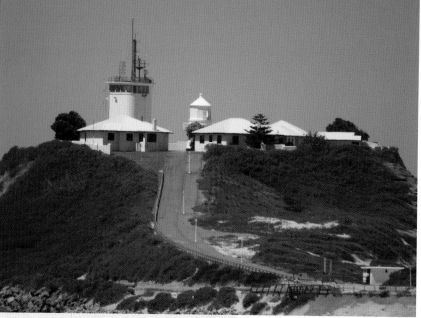

◄ Nobbys Head Lighthouse:

A sandstone tower situated on what was originally a small islet at the entrance to Newcastle Harbour, New South Wales, Australia, Nobbys Head Lighthouse was originally tended by three lighthouse keepers but became fully automated in 1934. By 1846, the islet was joined to the mainland by a causeway. Three keeper's cottages still exist at the site, alongside a tall, cylindrical signal station tower and other structures that house the port watch.

Year first constructed 1858
Height 9.8 m

►► Shark Island Lighthouse:

Shark Island Light is an active pile lighthouse situated about 65 feet (20m) north of Shark Island, Port Jackson, in Sydney Harbour, New South Wales, Australia. The name of the island refers to its shape, which somewhat resembles a shark. The light is only visible in the harbor fairway, between Shark Point and Point Piper.

Year first constructed 1913
Height 12m

▼ Montague Island Lighthouse:

Montague Island Light is an active lighthouse constructed in dressed granite blocks that were quarried on the island, which is located five and a half miles (10km) from New South Wales, Australia. The lighthouse is situated at the highest point of Montague island.

Year first constructed 1881
Height 21m

Nobbys Head Light, 1902.

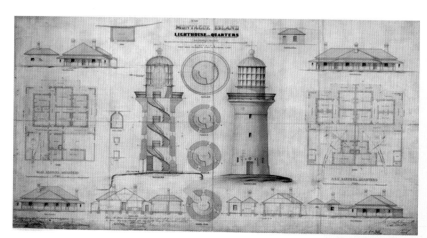

Original plans for the Montague Island lighthouse, 1878.

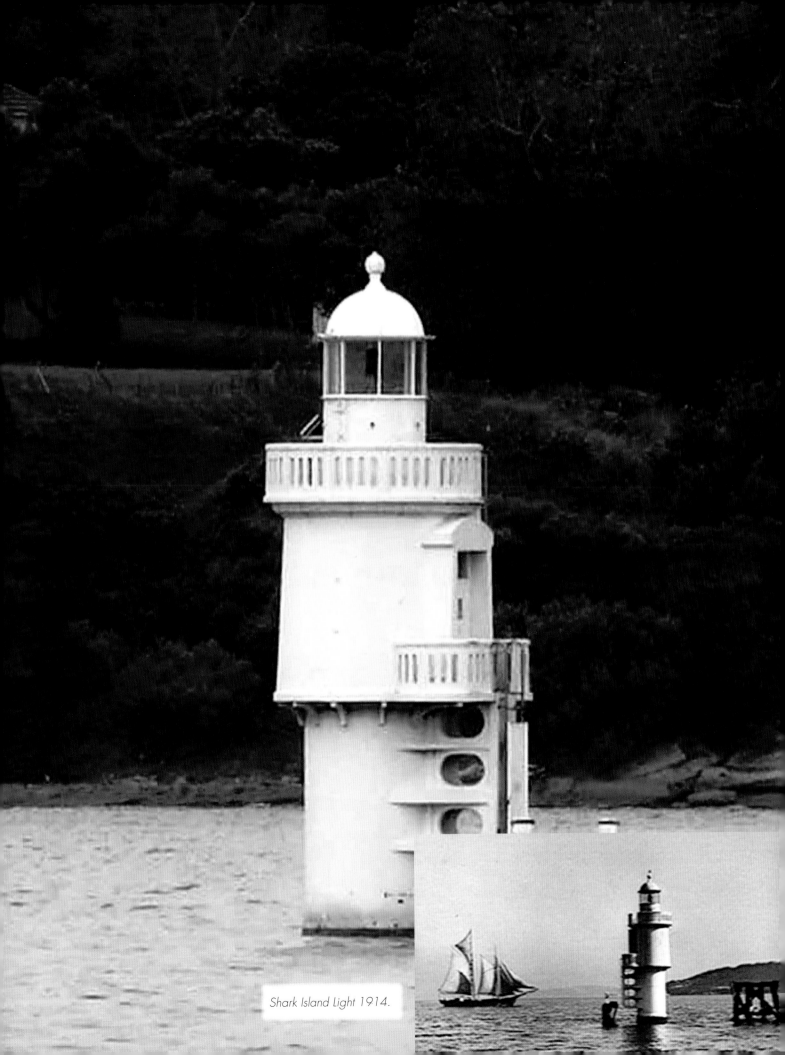

Shark Island Light 1914.

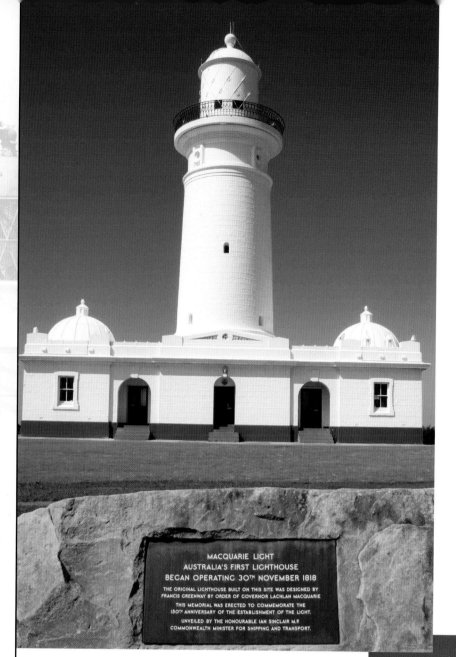

MACQUARIE LIGHT
AUSTRALIA'S FIRST LIGHTHOUSE
BEGAN OPERATING 30TH NOVEMBER 1818

THE ORIGINAL LIGHTHOUSE BUILT ON THIS SITE WAS DESIGNED BY
FRANCIS GREENWAY BY ORDER OF GOVERNOR LACHLAN MACQUARIE

THIS MEMORIAL WAS ERECTED TO COMMEMORATE THE
150TH ANNIVERSARY OF THE ESTABLISHMENT OF THE LIGHT.

UNVEILED BY THE HONOURABLE IAN SINCLAIR M.P.
COMMONWEALTH MINISTER FOR SHIPPING AND TRANSPORT.

◄ The Macquarie Lighthouse:

The first lighthouse site in Australia, the Macquarie Light is also the longest serving lighthouse site in Australia. Also known as South Head Upper Light, it is situated on Dunbar Head, close to the entrance to Sydney Harbour. The gray, dressed granite tower is equipped with a white lantern dome and a gallery. The original lens, now housed in the Narooma Lighthouse Museum, was replaced in 1986 by solar-powered quartz halogen lamps radiating two beams of 120,000 cd.

Year first constructed	1818
Height	26m

►► Robertson Point Lighthouse:

Also known as Cremorne Point Light, the Robertson Point Lighthouse is an active lighthouse located at Cremorne Point, on the lower North Shore of Sydney, Australia. The sibling of Bradleys Head Light, the lighthouse is situated on a rock that is joined to shore by a footbridge. The lighthouse is painted white with a gallery and lantern dome topped with a spherical finial.

Year first constructed	1910
Height	7.9m

▼ Kiama Lighthouse:

Also known as Kiama Harbour Light, Kiama Light is located close to the Kiama Blowhole on Blowhole Point, south of Kiama Harbour, New South Wales, Australia. The lighthouse is constructed of concrete-clad brick topped by a domed lantern with a large balcony and elaborate railings. The cylindrical, white tower is enclosed by a hexagonal fence. The light was automated in 1920.

Year first constructed	1887
Height	16m

Kiama Light c.1926 showing the principal and assistant keepers' houses.

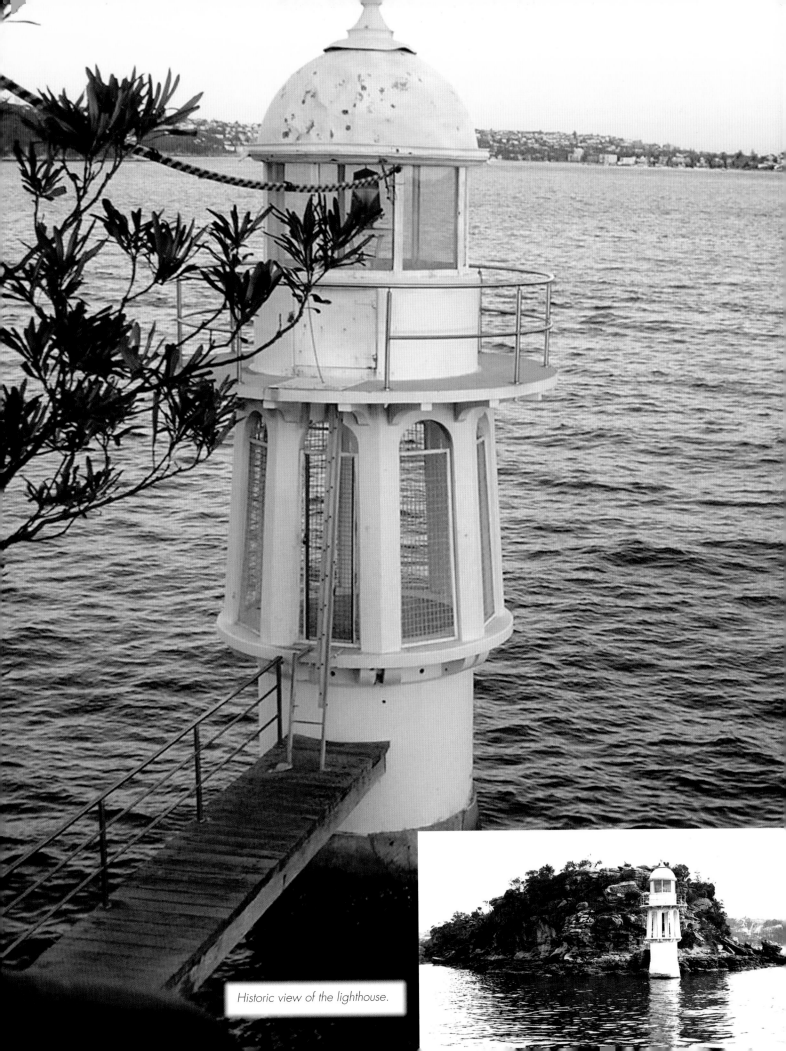

Historic view of the lighthouse.

◄ Wollongong Head Lighthouse:

Also known as Flagstaff Lighthouse or Flagstaff Point Light, Wollongong Head Lighthouse is an active lighthouse situated in Wollongong, south of Sydney, Australia, overlooking the Tasman Sea. It was the first new lighthouse to be built in New South Wales since the turn of the 20th century and was the first lighthouse in Australia to install fully automatic flashing lights. It was listed as a heritage site in January 2000.

Year first constructed	1936
Height	25.3m

►► Hornby Lighthouse:

Also known as South HeadLower Light, the Hornby Lighthouse is an active light situated on the tip of South Head, New South Wales, Australia. It signals the southern entrance to Port Jackson and Sydney Harbour, as well as alerting vessels to the perilous submerged rocks of South Reef. The need for the light was made apparent by the loss of two ships in 1857, the Dunbar and the Catherine Adamson. Built in dressed sandstone and adorned with distinctive vertical red stripes, it is the third oldest lighthouse in New South Wales.

Year first constructed	1858
Height	9.1m

▼ Baring Head Lighthouse:

Baring Head Lighthouse is a distinctive hexagonal concrete tower situated at Baring Head on New Zealand's North Island. It is the nearest lighthouse to Wellington city, and was one of the last major lighthouses to be built in New Zealand. Although inaccessible to the public, it can be viewed from the beaches along Wellington's western harbor entrance.

Year first constructed	1935
Height	12m

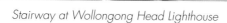

Stairway at Wollongong Head Lighthouse

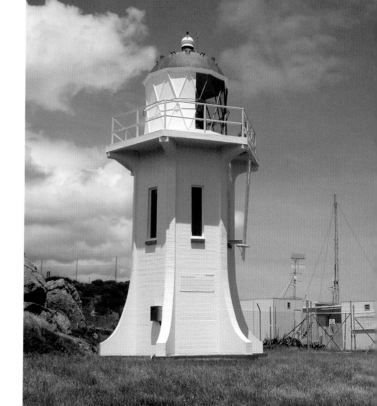

Hornby Lighthouse, 1917.

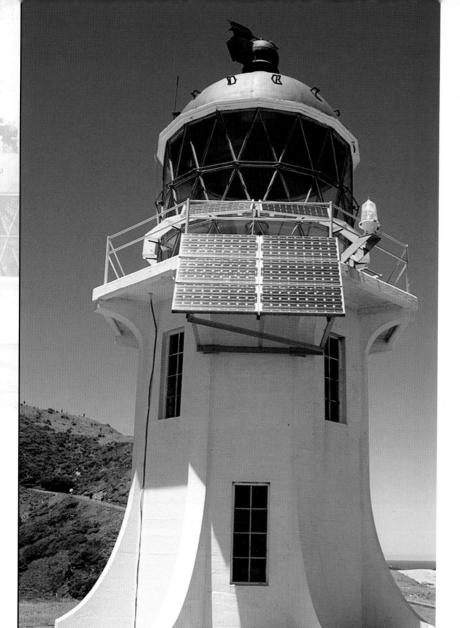

Located in the Northland Region of the North Island of New Zealand, the Cape Reinga Lighthouse enjoys iconic status in New Zealand and is a popular tourist destination, even though the lighthouse itself is not open to the public. The lighthouse was fully automated in 1987 and is now monitored remotely from Wellington. Today, the light is powered by solar-charged batteries.

Year first constructed	1941
Height	10m

▶▶ The Amédée Lighthouse:

At 184 feet (56m), the Amédée Lighthouse, "Le Phare Amédée", is one of the tallest lighthouses in the world. It is located on Amédée Island, New Caledonia. Due to the lack to skilled stonemasons at the colony, the enormous iron tower was prefabricated in Paris in 1862—the first metallic lighthouse constructed in France. Before being shipped to the French colony, the tower was first displayed in Paris and became a popular tourist attraction. It was then disassembled and transported via the Seine River to the port of Le Havre before finally beginning its voyage to New Caledonia. It was first lit on November 15, 1865.

Year first constructed	1862
Height	56m

▶ The Castle Point Lighthouse:

The Castle Point Lighthouse is a lighthouse near the village of Castlepoint in the Wellington region of the North Island of New Zealand. It is owned and operated by Maritime New Zealand.

Year first constructed	1913
Height	23m

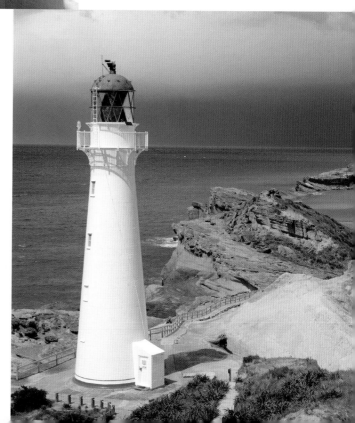

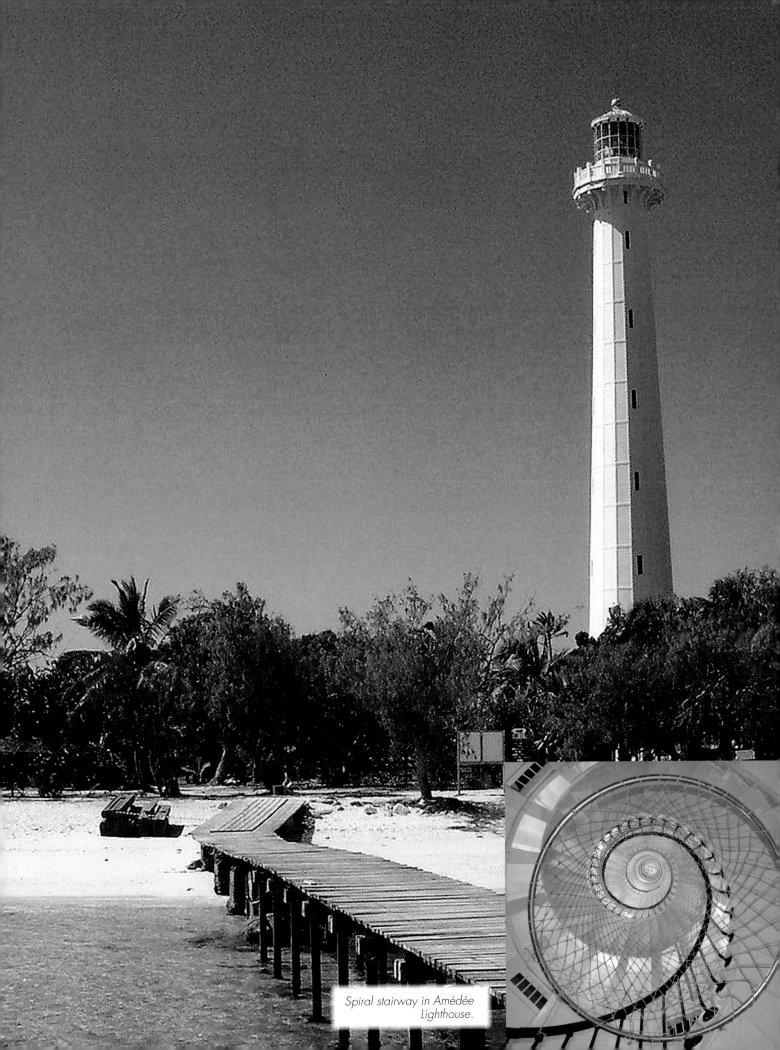

Spiral stairway in Amédée Lighthouse.

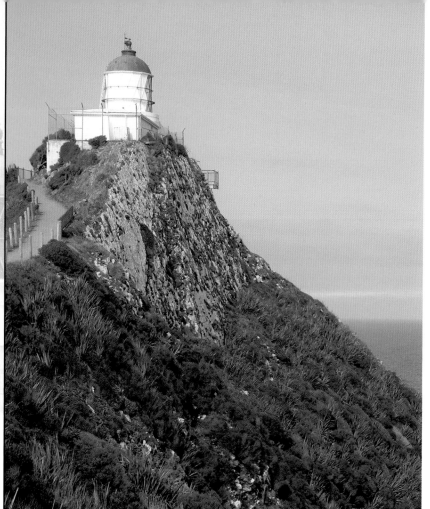

◄ **Nugget Point Lighthouse:**

Nugget Point Lighthouse is located in the Otago region of New Zealand's South Island. It was built from 1869 to 1870 and first lit on July 4, 1870. Constructed from locally quarried stone, the relatively squat, cylindrical, white tower is enclosed by a fence, but the site itself is accessible via a walking track and has a viewing platform affording spectacular views of "the Nuggets," rocky islets surrounding Nugget Point.

Year first constructed	1870
Height	9m

▶**Western Channel Pile Lighthouse:**

Also known as the West Wedding Cake due to its distinctive tiered shape, Western Channel Pile is an active pile lighthouse located off Georges Head at Mosman, Sydney Harbour, Australia. It marks the western end of the Sow and Pigs Reef. The lighthouse collapsed in December 2006 and was reconstructed and restored to operation in December 2008.

Year first constructed	1924
Height	11m

▸ **Waipapa Point Lighthouse:**

One of the last wooden lighthouses built in New Zealand, Waipapa Point Lighthouse is located at Southland, on South Island. First lit on January 1, 1884, the lighthouse was built in response to the wreck of the passenger steamer Tararua on reefs situated off Waipapa Point on April 29, 1881, with the loss of 131 lives. The hexagonal white tower has a balcony and a latticed lantern topped by a gray dome. Since 1988, the light has been powered by solar energy.

Year first constructed	1883
Height	13m

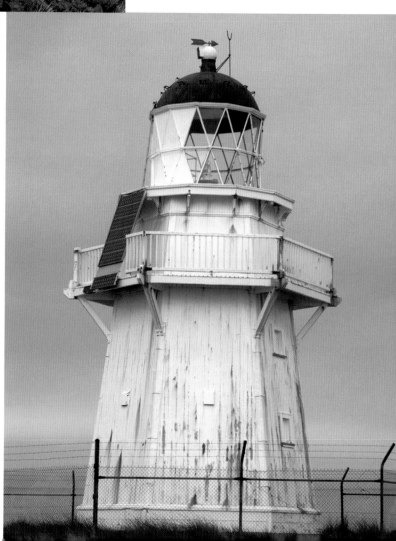

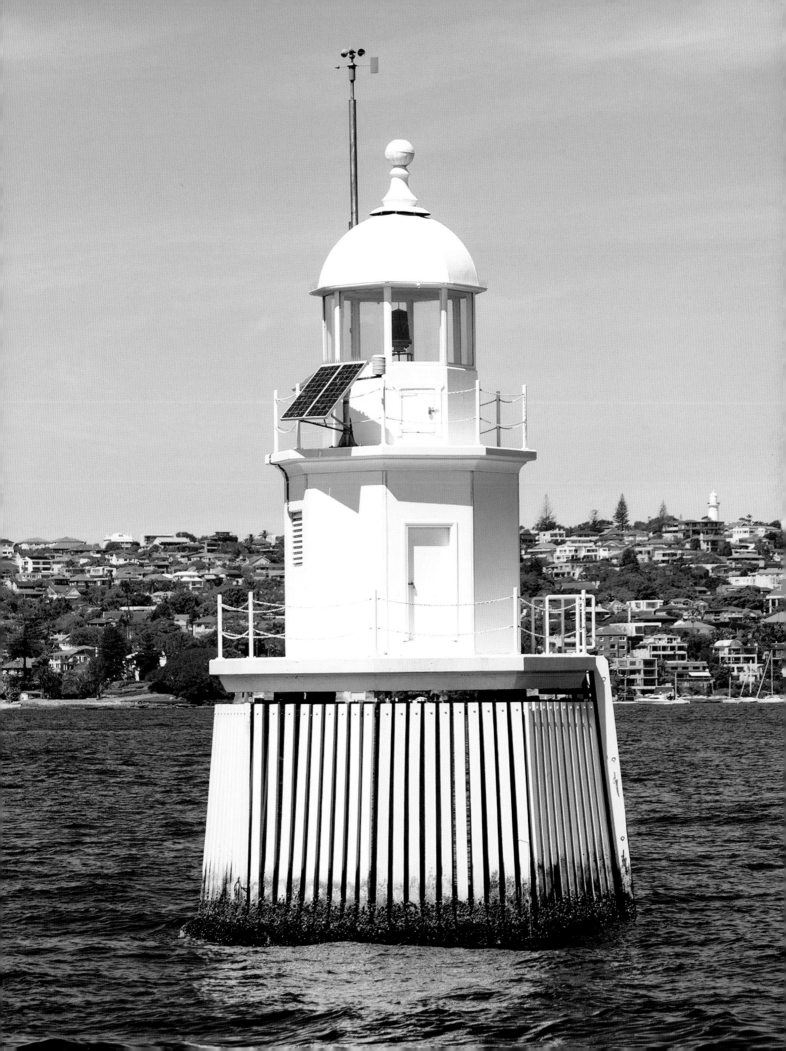

Lighthouses of
ASIA

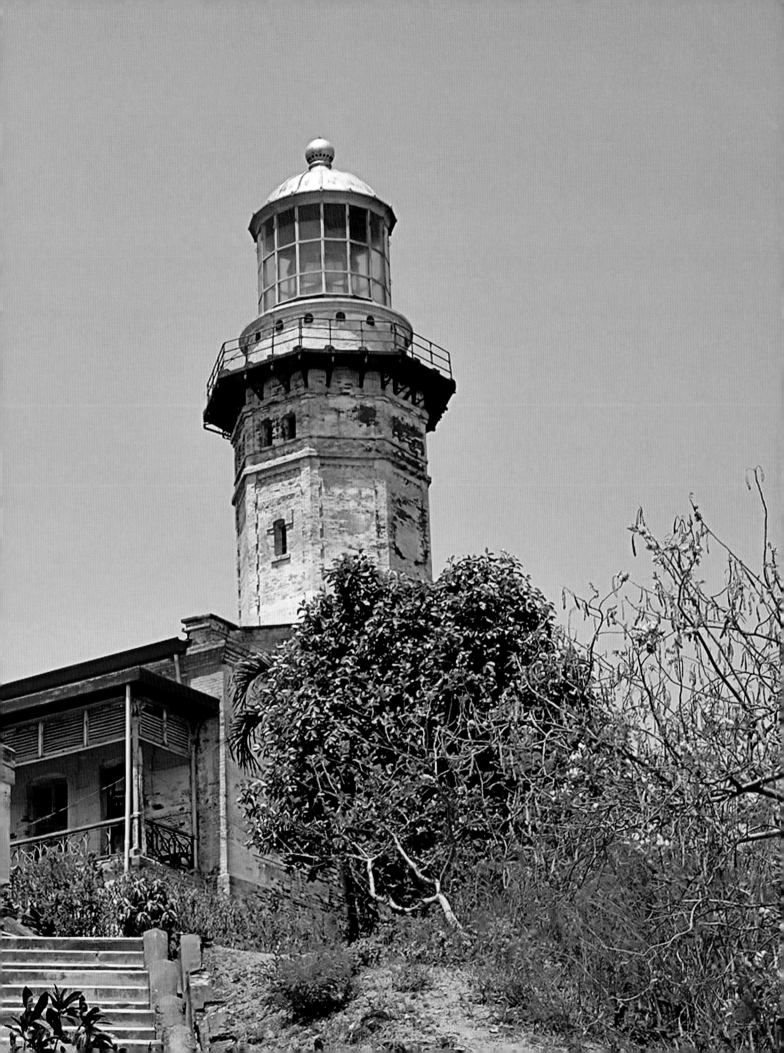

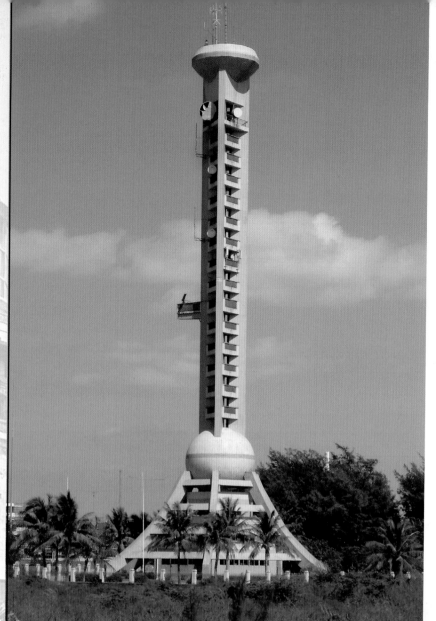

◀ Baishamen Lighthouse:

Baishamen Lighthouse is situated on Haidian Island, Haikou, in the province of Hainan, China. At 236 feet (72m) tall, the lighthouse is the sixth tallest lighthouse in the world, and the second tallest in China. Reminiscent of Paris's Eiffel Tower in shape, the slender triangular tower rises from a three-storey hexagonal base. Constructed from pale concrete, this active lighthouse has a focal plane of 256 feet (78m) and emits a white flash every six seconds.

Year first constructed	2000
Height	72m

▶▶ Basco Lighthouse:

Basco Lighthouse is located in Batanes, the northernmost province of the Philippines. The lighthouse is a six-storey, tapering, cylindrical tower constructed of reinforced concrete. The white lighthouse has a viewing gallery on the fifth floor and is topped by a red-domed lantern.

Year first constructed	2003
Height	20.1m

▶ Apo Reef Lighthouse:

The Apo Reef Light was a historic lighthouse constructed on Bajo Apo Island in Apo Reef Natural Park, in the Mindoro Strait, west of the province of Occidental Mindoro, in the Philippines. It was constructed as a cast-iron, skeletal tower to warn ships of the treacherous shallow reefs the region. It tower was the tallest lighthouse tower ever erected in the Philippines. The modern tower is 110 feet (33m) tall.

Year first constructed	1905
Height	36m

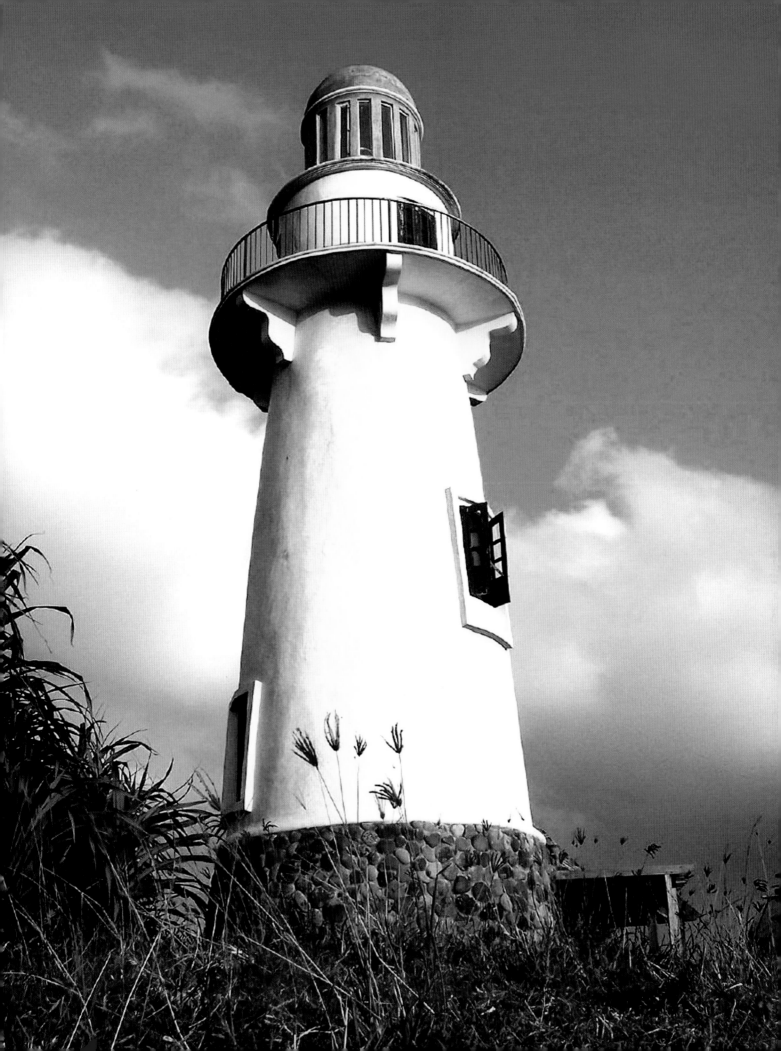

◀ **Cape Engaño Lighthouse:**

Cape Engaño Lighthouse is a historic ruin located on the Palaui Island in the town of Santa Ana, in the province of Cagayan, in the Philippines. Located on the summit of a hill in the northeasternmost point that forms Cape Engaño, it was designed to light the approach from the Pacific to the extreme northeast point of Luzon, and the channel between the Babuyanes Islands and the mainland.

Year first constructed 1892
Height 14.3m

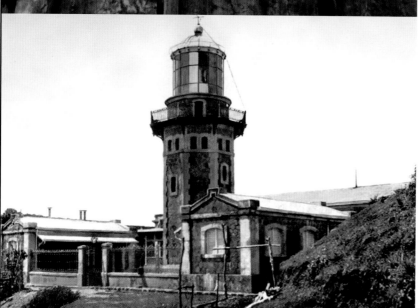

▸▸**Eluanbi Lighthouse:**

Located on Cape Eluanbi, the southernmost point of Taiwan, Eluanbi Lighthouse was built during the Qing Dynasty in 1888 to protect local shipping from hidden reefs. The original lighthouse was unusual in that it was heavily armed, with numerous gun holes built into the tower and a surrounding trench. The fortification was included due to frequent raids by local tribes. Damaged by Allied bombing during World War II, the lighthouse was rebuilt as a more traditional conical, concrete and iron tower in 1962. Today, it is known as "The Light of East Asia," because its intensity of 1,800,000 is the most powerful among Taiwan lighthouses.

Year first constructed 1888
Height 21.4m

Cape Engaño lighthouse in 1903

▸ **Raffles Lighthouse:**

Raffles Lighthouse is named after Sir Stamford Raffles, the founder of modern Singapore in 1819. The lighthouse is situated in the Straits of Singapore, about 9 miles (17km) south of the main island. The Raffles Lighthouse was first proposed in 1833, but construction was not completed until 1855. The stones used in its construction come from the granite quarries on Pulau Ubin. The tower is entirely white and is a classic conical design tapering elegantly toward a latticed lantern with a domed top.

Year first constructed 1855
Height 29m

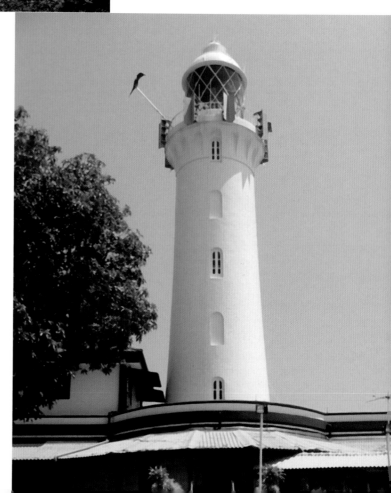

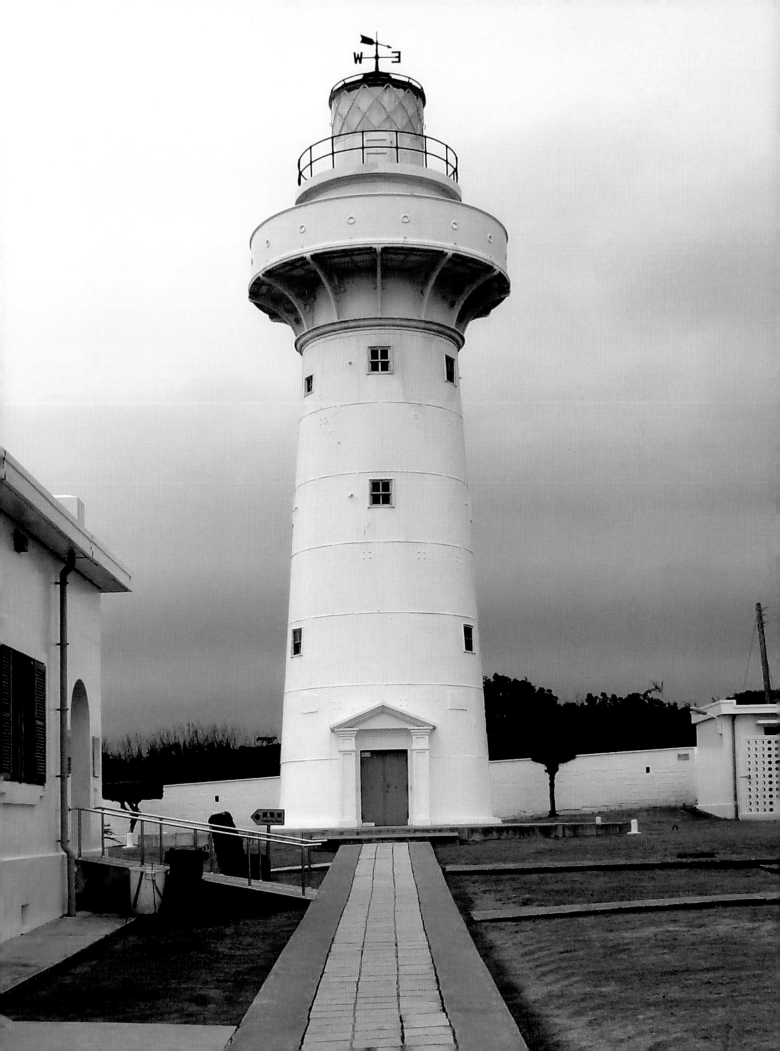

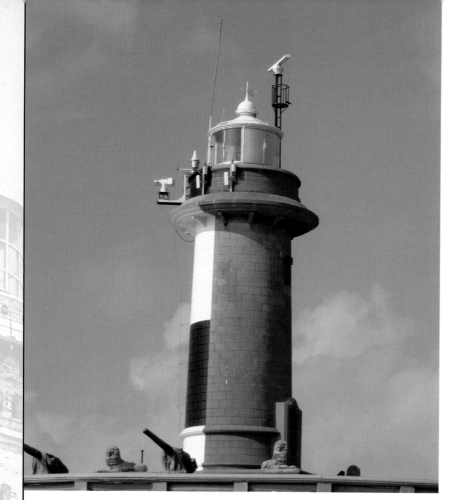

◄ Colombo Lighthouse:

Colombo Lighthouse is located at Galbokka Point, south of the Port of Colombo in Sri Lanka. The lighthouse was built in 1952 after the Old Colombo Lighthouse was deactivated when its light became obscured by nearby buildings as part of the Colombo Harbor Expansion project. The lighthouse is built on a 40-foot (12m) high concrete base adorned with four statues of lions and two 4-inch cannons, which were a gift from the United Kingdom. The tower itself is constructed in stone and the seaward facing side is painted in a distinctive black-and-white checkered pattern.

Year first constructed	1952
Height	29m

►► Cape Bojeador Lighthouse:

Also known as Burgos Lighthouse, Cape Bojeador Lighthouse is a cultural heritage structure in Burgos, Ilocos Norte, set high on Vigia de Nagpartian Hill overlooking the scenic Cape Bojeador in the Phiippines. Built during the Philippines's Spanish Colonial Period, the lighthouse still functions as a guiding beacon to vessels entering the Philippine Archipelago from the north. The octagonal tower is constructed in brick and is coated with fading white paint.

Year first constructed	1892
Height	19.8m

► Dondra Head:

Dondra Head Lighthouse is an offshore lighthouse in Dondra, Sri Lanka, operated and maintained by the Sri Lanka Ports Authority. It is situated on Dondra Head near the southernmost point in Sri Lanka and is the tallest lighthouse in the country. It was designed by Sir James Nicholas Douglass and constructed by William Douglass using stone and steel imported from Great Britain.

Year first constructed	1890
Height	49m

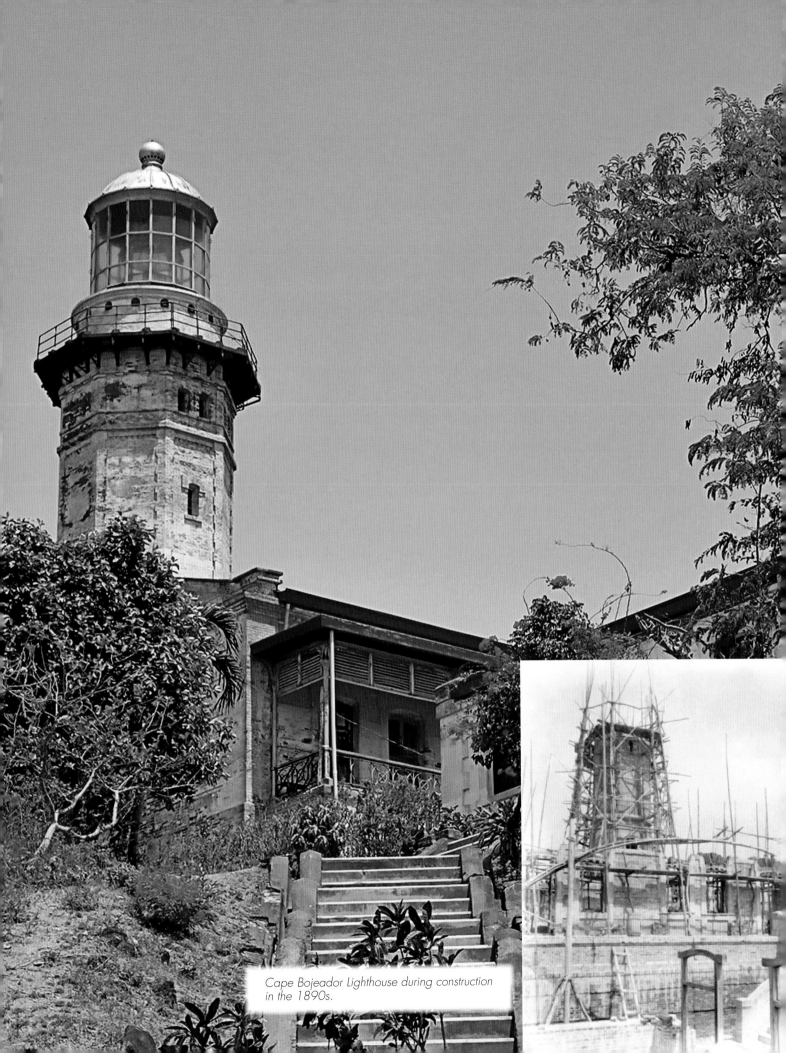

Cape Bojeador Lighthouse during construction in the 1890s.

◄ Galle Lighthouse:

Galle Lighthouse is located in the Bay of Galle on the southwest coast of Sri Lanka within the walls of Galle Fort, which is a UNESCO world heritage site and popular tourist attraction. The lighthouse is operated and maintained by the Sri Lanka Ports Authority. It is Sri Lanka's oldest light station dating back to 1848, although the original lighthouse was destroyed by fire in 1934. The tower itself is constructed in cast iron and withstood the tsunami of December 2004, which caused such devastation in the region.

Year first constructed	1939
Height	26.5m

►►The Sultan Shoal Lighthouse:

The Sultan Shoal Lighthouse was built in 1895 to guide shipping through the Straits of Malacca into Singapore. It was constructed during the time when the late Commander Charles Quentin Gregan Craufurd was the Master Attendant of Singapore, and is highly unusual in that the tower itself, with its ornate balcony, is situated on the top of a two-storey house.

Year first constructed	1896
Height	18m

Lighthouses of
EUROPE

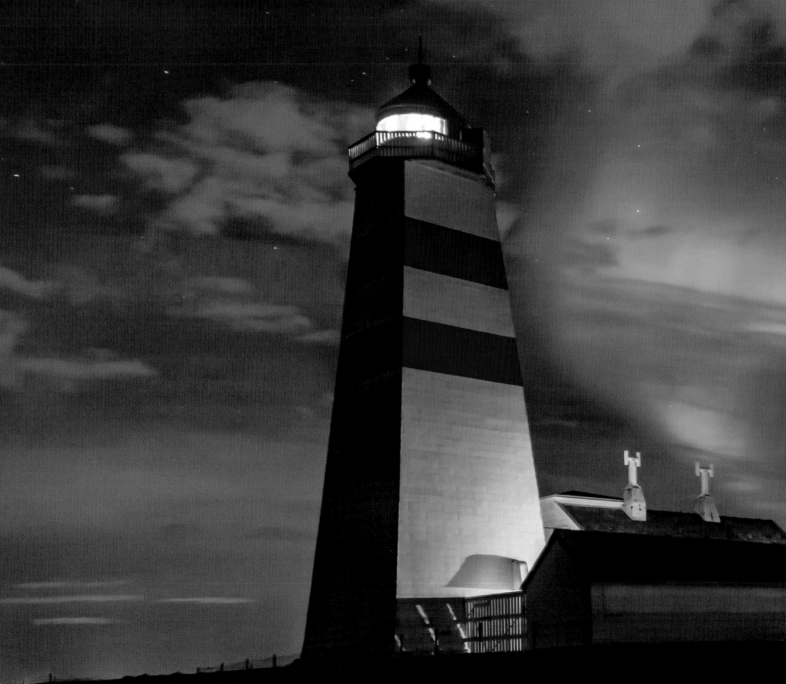

◄ Lange Nelle lighthouse:

Lange Nelle Lighthouse is located in Ostend, Belgium, and was designed to guide North Sea trawlers safely into Ostend Harbour. The present lighthouse tower was opened in 1948 and is over 200 feet (60m) tall with 27 nautical miles (50km) visibility, using the Fresnel lens lighting system. In 1998, the lighthouse tower was painted white with highly distinctive blue "waves."

Year first constructed	1948
Height	65m

►►The Dueodde Lighthouse:

Located on the beautiful Bornholm Island, known as "the Pearl of the Baltic," Dueodde Lighthouse is Denmark's tallest lighthouse and one of the most important of the Baltic Sea. It has a distinctive octagonal white tower constructed in concrete with a blue gallery, and was designed to guide shipping away from the extreme southern tip of the island.

Year first constructed	1960
Height	48m

▼ Skagen Lighthouse:

Also known as Skagen's Grey Lighthouse, Skagen Lighthouse is located 2.5 miles (4 km) northeast of Skagen in the far north of Jutland, Denmark. It was designed by architect Niels Sigfred Nebelong, and was first lit on November 1, 1858. Skagen Lighthouse is the northernmost lighthouse in Denmark and until 1952 was the country's tallest. Dueodde Lighthouse in Bornholm is now just one meter taller.

Year first constructed	1747
Height	21m

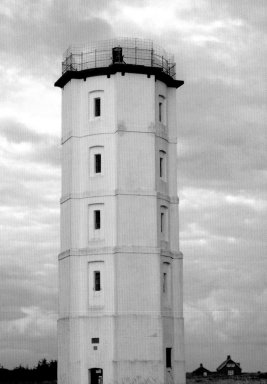

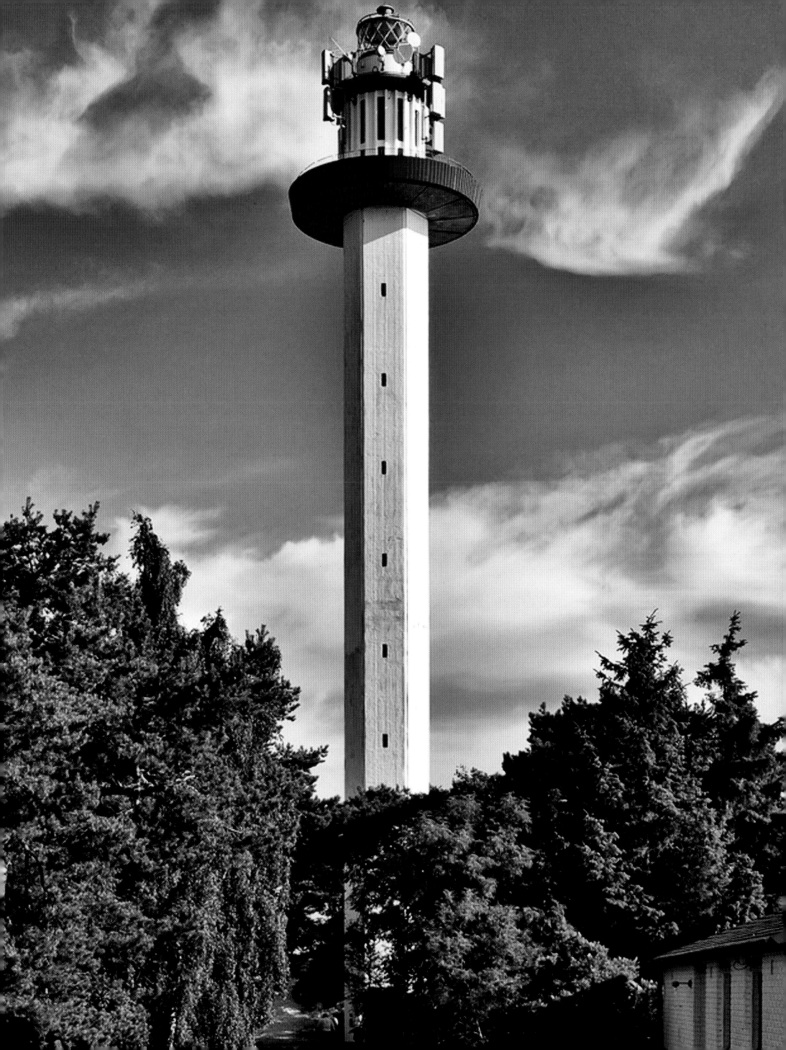

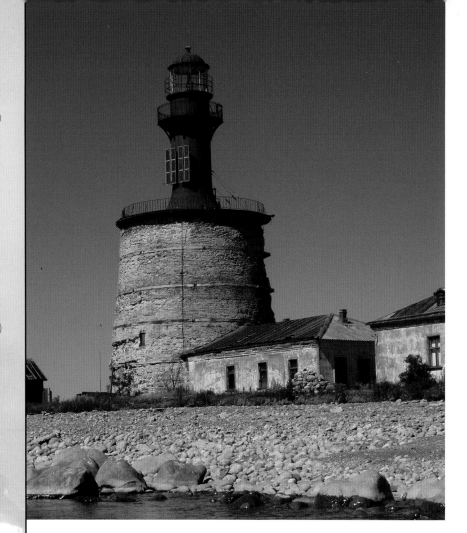

◀ **Keri lighthouse:**

Located on Keri Island in the Gulf of Finland, Keri Lighthouse is a red-metal cylinder topped with a lantern room and balcony, which stands on a cylindrical stone base. From1907 to 1912 it was the only lighthouse in the world to be powered by natural gas. Today, the automated light is powered by solar cells and batteries. In 1990, the stone base began to collapse and steel reinforcements were installed. A weather station was constructed on the site in 2009.

Year first constructed 1948
Height 65m

▶▶**Rubjerg Knude Lighthouse:**

Rubjerg Knude Lighthouse overlooks the North Sea in Rubjerg, in the Jutland municipality of Hjørring in northern Denmark. The lighthouse has a square tower with a red-metal lantern. Coastal erosion presents enormous problems in the region, and shifting sands gradually engulfed the site. The lighthouse stopped functioning in 1968, and although the buildings were employed as a museum for many years, the encroaching sands forced them to close in 2002. The lighthouse itself is expected to collapse within the next decade.

Year first constructed 1899
Height 23m

▶ **The Phare du Cap Leucate:**

The lighthouse is located in the southeastern area of Cap Leucate, Aude, France. It was constructed in 1950 and first lit in 1951. It is an attractive stone-built, pyramidal tower with a railed gallery and orange-domed lantern. Although the light is now automated, a lighthouse keeper still resides in the building adjacent to the tower.

Year first constructed 1950
Height 19.4m

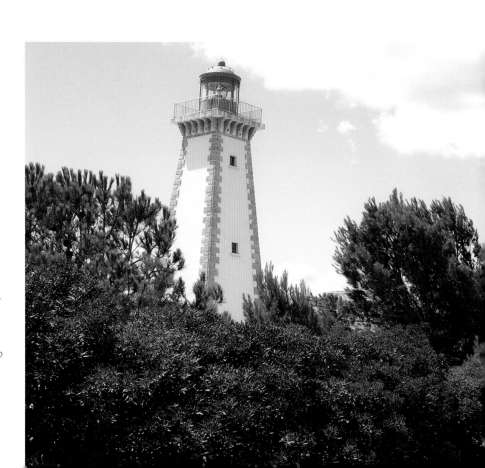

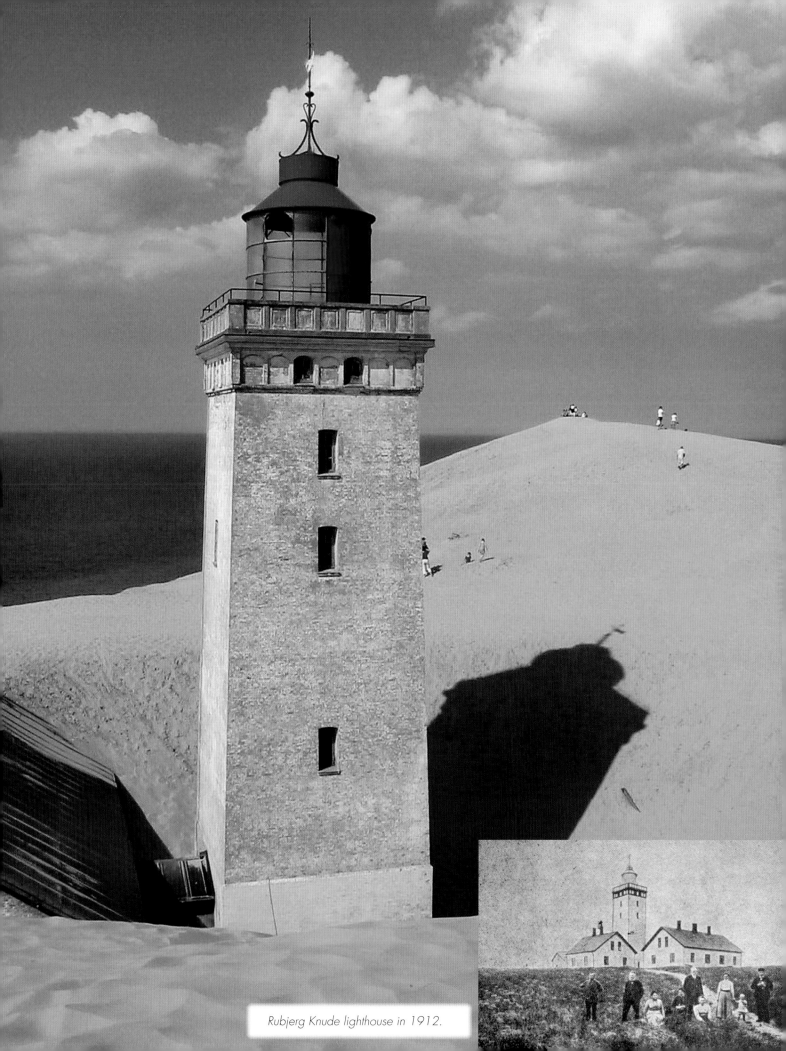

Rubjerg Knude lighthouse in 1912.

Roches-Douvres Light is an active, wave-washed lighthouse in Côtes-d'Armor, France, located on Roches-Douvre, and designed to guide shipping away from a perilous reef between the islands of Brehat and Guernsey in the English Channel. At a height of 197 feet (60m), it is the nineteenth tallest lighthouse in the world, and is famed in Europe as the lighthouse farthest from mainland, about 19 miles (35km) from the French coast.

Year first constructed	1954
Height	60m

▶▶The Ploumanac'h Lighthouse:

The Ploumanac'h lighthouse, also known as the Mean Ruz (Red Brick) Lighthouse in Breton, is an active lighthouse in France's Côtes d'Armor, in Brittany, France. Its Breton name alludes to the pink granite, characteristic of the region, which was used to construct the pyramidal tower with its distinctive castellated balcony. The lighthouse marks the entrance to the channel leading to the port of Ploumanac'h. The first lighthouse in the area dates back to 1860, but this was destroyed in World War II.

Year first constructed	1945
Height	15m

▶ **The Phare d'Eckmühl:**

The Phare d'Eckmühl, also known as Point Penmarc'h Light or Saint-Pierre Light, is an active lighthouse in Brittany, France. At a height of 213 feet it is the eleventh tallest lighthouses in the world. The lighthouse is located at the port of Saint-Pierre at the northwestern entrance to the Bay of Biscay, which is notorious for its deadly winter storms. The massive tower is constructed from gray granite and 227 stone steps, followed by an 80-step iron staircase, lead to the balcony and octagonal lantern.

Year first constructed	1831
Height	65m

Phare d'Eckmühl during construction in 1895.

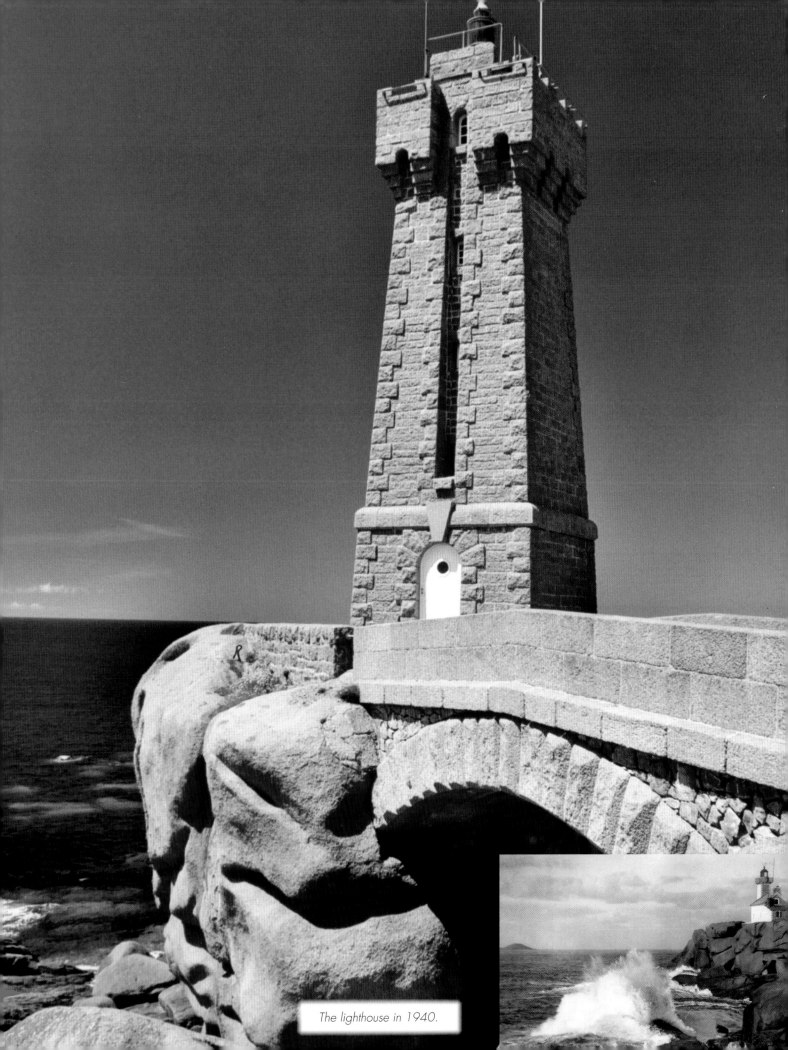

The lighthouse in 1940.

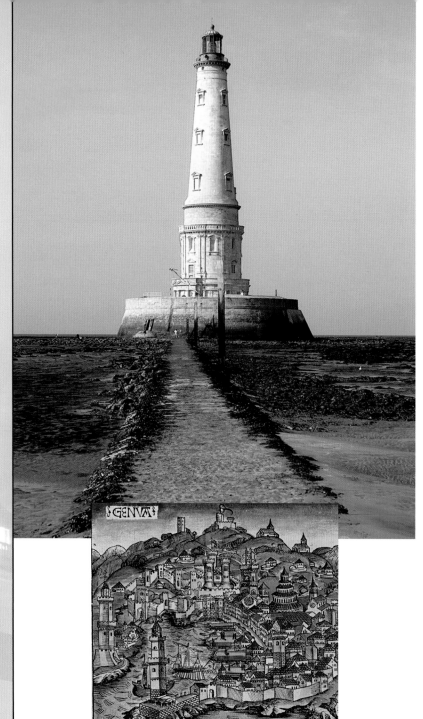

Engraving of the original tower finished in 1611.

Cordouan lighthouse is an active wave-washed lighthouse located at the mouth of the Gironde estuary in France. At a height of 223 feet it is the eighth tallest lighthouse in the world. By far the oldest lighthouse in France, it was designed by the leading Parisian architect Louis de Foix, and was considered to be a Renaissance masterpiece, incorporating the King's Apartment, and a spectacular chapel. Started in 1584 and finished in 1611, the lower two storeys still stand today, topped by a far less elaborate but taller tower added in the late 18th century.

Year first constructed	1611
Height	68m

▶▶ La Vieille Lighthouse:

La Vieille, "The Old Lady," is a wave-washed lighthouse located on the northwest coast of France, in Finistère, Britanny. It stands on the rock known as Gorlebella, which is Breton for "farthest rock," guiding shipping in the Raz de Sein strait, along with its companion lighthouse Tourelle de la Plate, known locally as Petite Vieille, "The Little Old Lady." La Vielle Lighthouse is an imposing tower constructed in gray granite with a black lantern, which resembles a traditional castle or "rook" chess piece.

Year first constructed	1887
Height	27m

▶ Phare du Portzic:

The Phare du Portzic is situated on the northeasternmost point of the Goulet de Brest, in Finistère, France. It was given "historic" status in 1987. On the seaward side of the entrance to the Goulet "bottleneck," the lighthouse faces the Pointe des Espagnols. It was built on military land in 1848, at the same time as the Phare du Petit Minou to the north of the Goulet, and is an octagonal, gray-granite tower with a red lantern. Although the light was automated in 1984, it is still permanently manned.

Year first constructed	1848
Height	35m

◄ **Planier lighthouse:**

Planier Light is an active lighthouse on the little Île du Planier, eight miles (15km) from Marseille, in southern France. At a height of 216 feet (66m) it is the tenth tallest lighthouse in the world. It is a white, cylindrical, stone tower with a red lantern, situated on a massive plinth, overlooking the Mediterranean Sea.

Year first constructed 1959
Height 66m

▼ **Marjaniemi Lighthouse:**

Marjaniemi Lighthouse is situated in the village of Marjaniemi at the westernmost point of Hailuoto island in the Gulf of Bothnia, Finland. The lighthouse is located 30 miles (55km) west of Oulu. The lighthouse was designed by Finnish architect Axel Hampus Dahlström, and was first lit in 1871. The tapering cylindrical tower is constructed in three tiers in brick masonry, and has 110 steps leading directly to the red lantern with its green dome. There were originally two lighthouse keepers and a master until 1962 when the lighthouse was automated. A pilot station was built next to the tower, which currently serves as a hotel. The lighthouse also houses a smaller sector light that is used to guide vessels to and from the fishing harbor.

Year first constructed 1871
Height 25m

▶▶ **Phare de Gatteville:**

Also known as the Pointe de Barfleur Light, the Phare de Gatteville is an active lighthouse near Gatteville-le-Phare at the tip of Barfleur, in Normandy, France. Strong currents and many shipwrecks at the tip of Barfleur, the most famous being the **White Ship**, *necessitated building a lighthouse at the location. The lighthouse has a cylindrical, gray-granite tower with a rectangular keepers' complex at the base. It was first lit on November 1, 1775, and was originally called the Phare de Barfleur.*

Year first constructed 1774
Height 75m

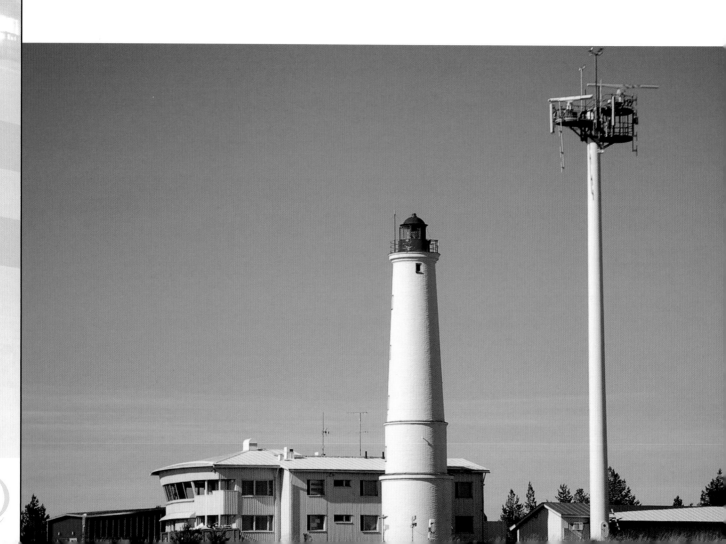

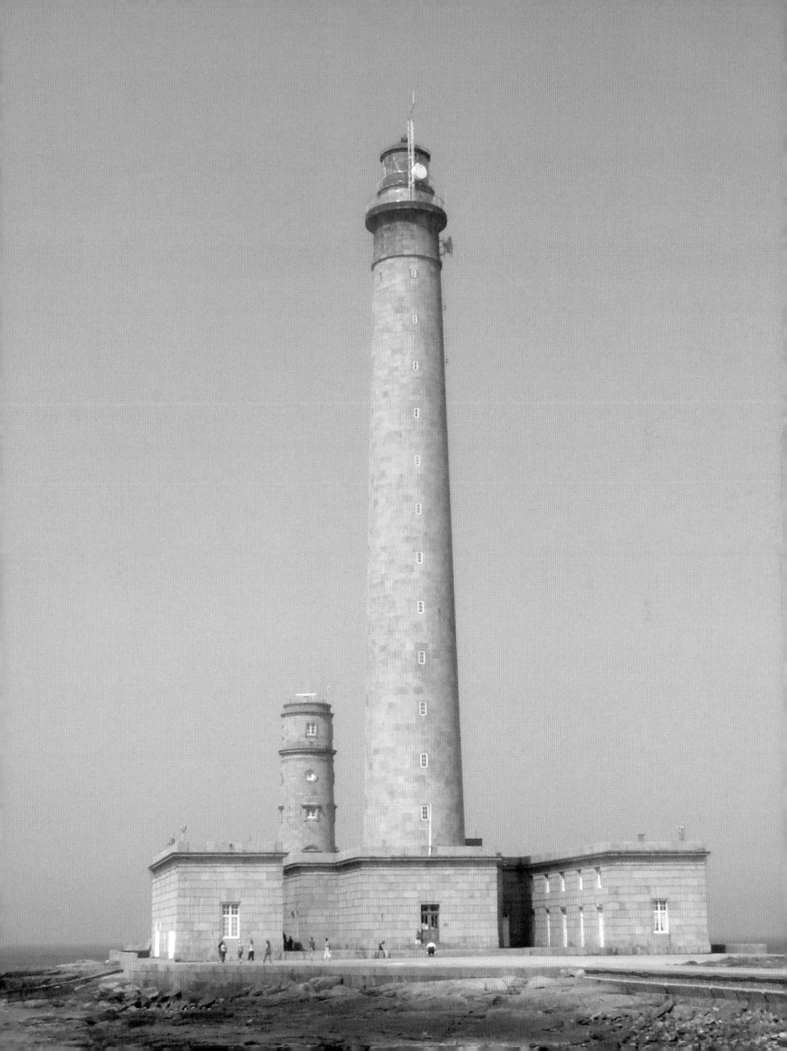

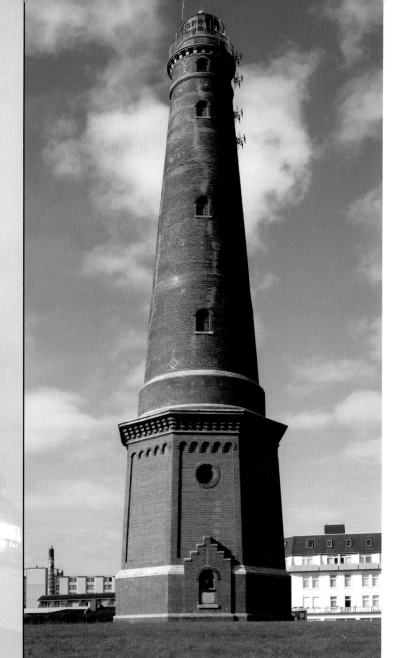

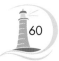

◀ Borkum Großer Lighthouse:

Also known as the Borkum Neuer Light, the Borkum Grober Lighthouse is an active lighthouse on the island of Borkum, in Lower Saxony, Germany. At a height of 197 feet, it is the nineteenth tallest lighthouse in the world, as well as the world's third tallest brick-built lighthouse. The lighthouse is located at the west side of the Borkum island, and is the landfall light for the Ems estuary and the port of Emden, and also serves as a day mark. The current gray tower with its red lantern dome was built in the summer of 1879 in a record time of just six months, to replace the original tower, which was destroyed by fire.

Year first constructed	1817
Height	60m

▸▸Rivinletto Lighthouse:

Rivinletto Light is located on Kaasamatala, a small island at the mouth of the Kiiminkijoki River in Haukipudas, Finland, to guide vessels into the river and Martinniemi harbor. The top half of the concrete, cylindrical tower is painted black and the bottom half is painted white. The steel lantern with its hexagonal top is also painted white.

Year first constructed	1774
Height	7m

▸ Campen Lighthouse:

An active lighthouse in the village Campen in Lower Saxony, Germany, Campen is the eleventh tallest lighthouse in the world and the tallest in Germany. The structure consists of a free-standing, red, pyramidal, skeletal tower with a white, cylindrical stair shaft inside. The lighthouse was built in 1889 and went in service in 1891. The lamp of Campen Lighthouse has a light intensity of 4,500,000 cd, the most powerful lighthouse lamp in Germany. Remarkably, the aperture of its flashing light to the left and right has an angle of only 0.3 degrees. The Campen Lighthouse contains the oldest workable diesel engine in Germany. It was built in 1906 and has a power of 15 kilowatts.

Year first constructed	1889
Height	65m

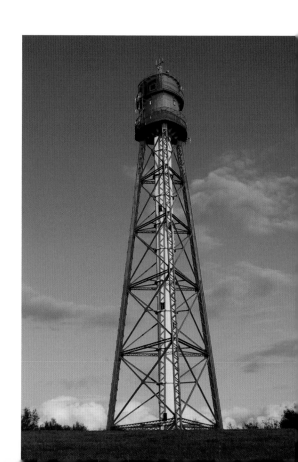

◄ Heligoland Lighthouse:

Constructed during World War II as an anti-aircraft tower, Heligoland Lighthouse is located on Germany's only offshore island, Heligoland. It was converted into a lighthouse in 1952, and houses the most powerful light on the German North Sea coast with a range of 28 nautical miles (52 km). Its light can be seen as far as the Frisian islands and Halligen. The modern square tower with its veneer of brick was constructed around an earlier reinforced concrete structure.

Year first constructed	1841
Height	20m

►► The Amrum Lighthouse:

The Amrum lighthouse was constructed in the southern region of the German island of Amrum, following the loss of several ships in the area in the mid-19th century. The cylindrical tower is constructed in brick and decorated with red and white bands. The lighthouse was automated in 1984.

Year first constructed	1873
Height	42m

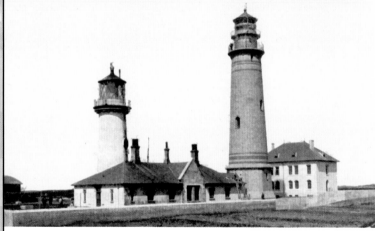

A new lighthouse (right-hand side) was built on Heligoland in 1902 to replace its predecessor the "English lighthouse" (left-hand side).

► Oland Lighthouse:

At just 24 feet (7.4 m) tall, Oland Lighthouse, on the small North Frisian island of Oland, is Germany's smallest lighthouse. It is also Germany's only lighthouse with a thatched roof. It was first lit in 1929 to serve as a cross light for the Föhrer Ley and Dagebüll channels. It is still maintained by a keeper. Until 1954 when it was electrified, the lantern was lit by liquified gas. The optic can be drawn out of the lantern casing on a slide for maintenance purposes. It emits a continuous light, with white, red, and green sectors.

Year first constructed	1929
Height	7.4m

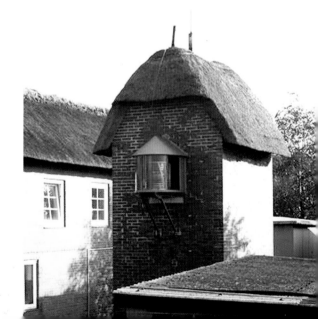

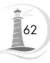

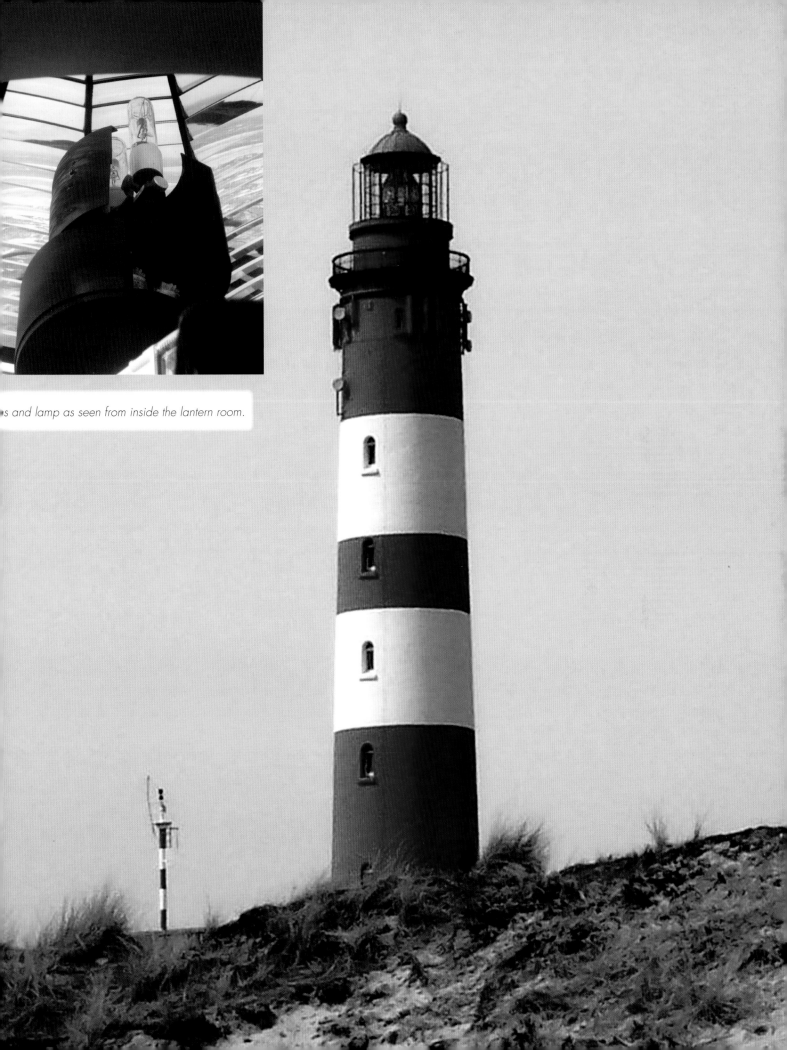

s and lamp as seen from inside the lantern room.

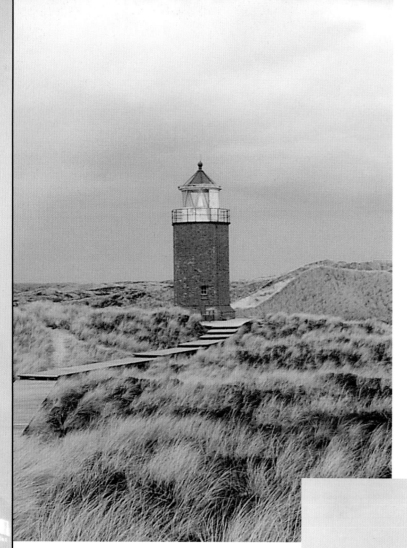

◄ The Rotes Kliff Lighthouse:

Located on a cliffside north of the village of Kampen on the island of Sylt, Germany, the Rotes Kliff Lighthouse served as a sector light to warn ships of a sand bank in the approach to the Lister Tief nautical channel and to provide a supplement to the main light at Kampen, 2.5 kilometres to the south (whose keepers maintained both lights). When Rotes Kliff was deactivated in 1975, the main light at Kampen took over its role with a red section of light. Nowadays, the octagonal, brick-built tower still functions as a day mark without a light. The lighthouse was restored by the Kampen municipality in 1993.

Year first constructed	1913
Height	13m

►►The Bremerhaven Lighthouse:

Also known as the Simon Loschen tower or Loschen-lighthouse, the Bremerhaven lighthouse is the rear light of a pair of Leading lights at the "New Harbour" of Bremerhaven, Germany. It is the oldest operative lighthouse on the mainland along Germany's North Sea shore and its stunning brick-built tower topped by a green lantern is counted among the city's primary landmarks.

Year first constructed	1853
Height	39.9m

► Roter Sand Lighthouse:

Roter Sand is a wave-washed lighthouse in the North Sea, in Germany's Weser estuary. It is a cylindrical tower with a black base, red and white bands, and a white lantern with a black dome. Its most distinctive features are the three oriel windows just below the balcony, which originally housed minor lights. The light was deactivated in 1986 but the tower still serves as a day mark.

Year first constructed	1880
Height	28m

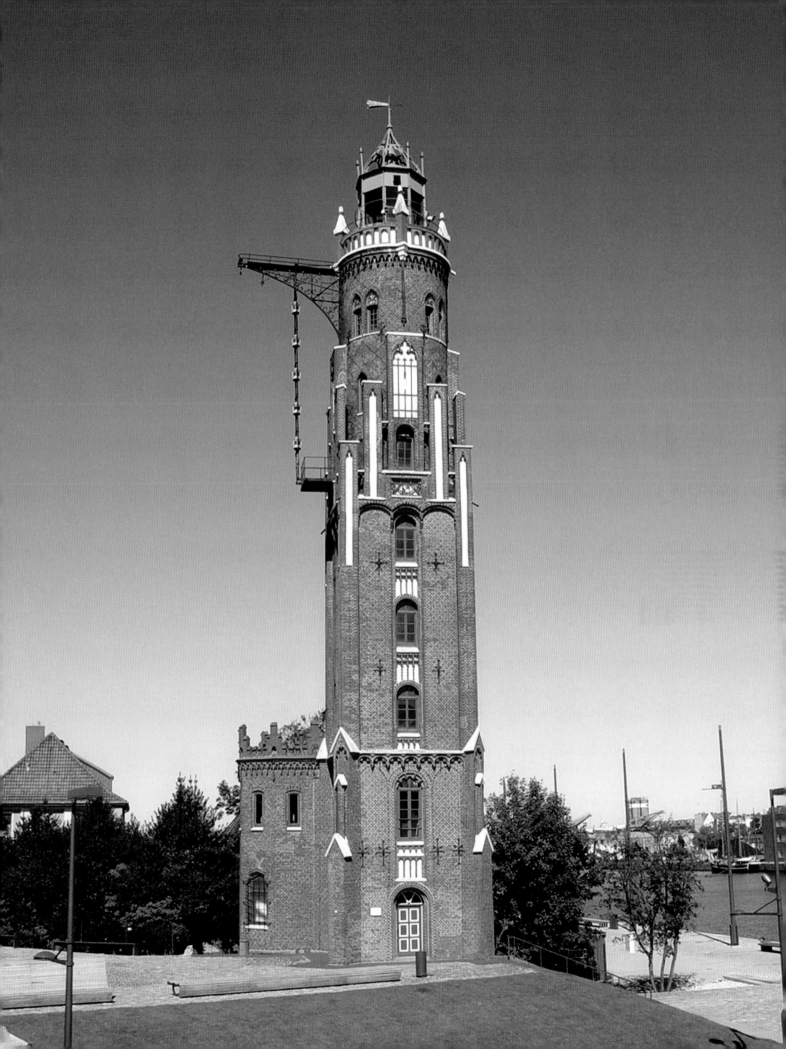

▸▸Europa Lighthouse:

Also known as the Victoria Tower, the foundation stone for the Europa Point Lighthouse in the British Overseas Territory of Gibraltar was laid on April 26, 1838, in the first year of Queen Victoria's long and illustrious reign over the British Empire. The lighthouse was built in the classic British style, "for the protection of Mediterranean commerce, the saving of human life, and the honour of the British name." The lighthouse was first upgraded in 1864, with further technical improvements in 1875 and in 1894. The lighthouse was fully automated in 1994. The stone-built, cylindrical tower is painted white, with a single red horizontal band in the center. Sadly, the lighthouse's beacon may soon be retired if projected plans for a soccer stadium are approved.

Year first constructed	1841
Height	20m

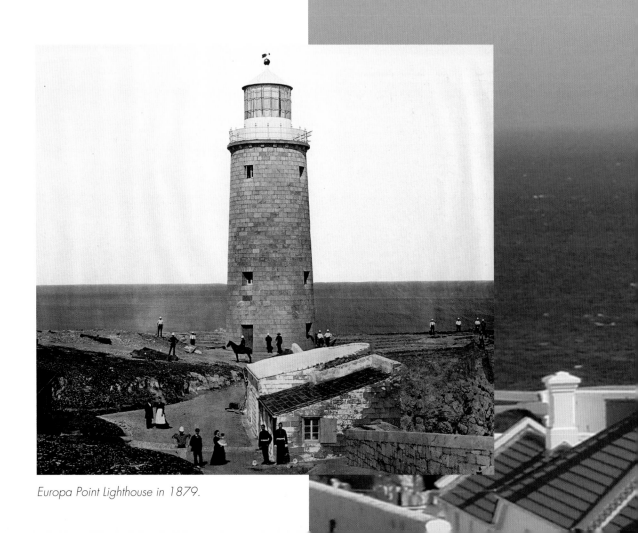

Europa Point Lighthouse in 1879.

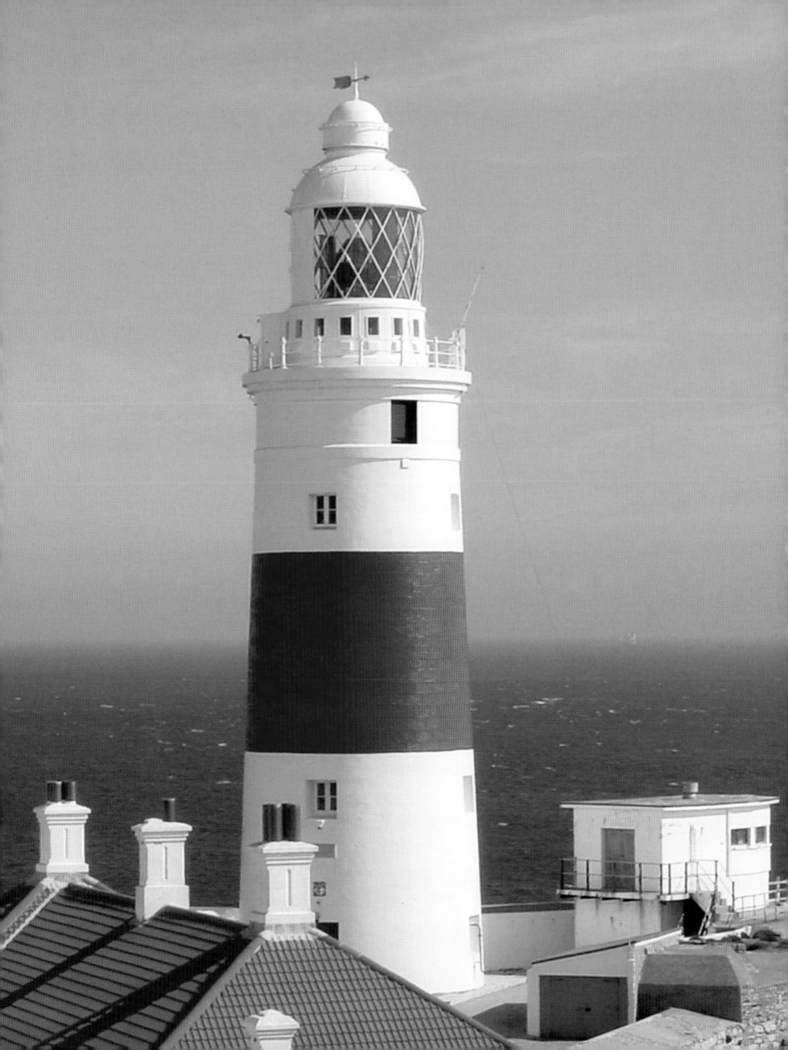

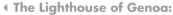

◄ **The Lighthouse of Genoa:**

The Lighthouse of Genoa, known locally as the Lanterna, is one of the oldest standing structures of its kind in the world and the world's third tallest masonry-built lighthouse. As well as being an important aid to nighttime navigation around the city's bustling port, the tower serves as a symbol of Genoa, called "the city in the shadow of the lighthouse," and bears that city's coat of arms on the lower tier. The lighthouse comprises two square portions, each one capped by a terrace accessed by a stone staircase. Remarkably, the tower survived continuous Allied bombing raids during World War II, despite inevitable damage. Today, as more land has been reclaimed from the sea in Genoa, the tower is now further from the shore than it once was, but it still lights up the city's seas every 20 seconds.

Year first constructed	1128
Height	76m

▶▶ **Reykjanesviti Lighthouse:**

Located on the southwestern edge of the Reykjanes peninsula, Reykjanesviti is Iceland's oldest lighthouse and serves as a landfall light for Reykjavík and Keflavík. The original lighthouse was destroyed by an earthquake in 1886. The current buiding is a traditional conical building constructed in concrete in 1929. The lighthouse is painted white with a red lantern.

Year first constructed	1878
Height	31m

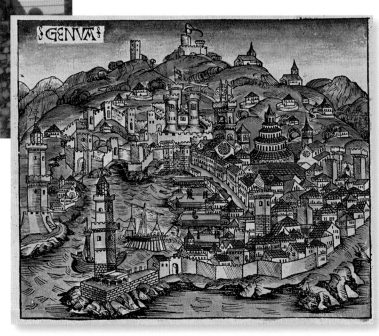

The city of Genoa in a woodcut from the Nuremberg Chronicle, 1493; the Lanterna can be seen in the left edge of the picture.

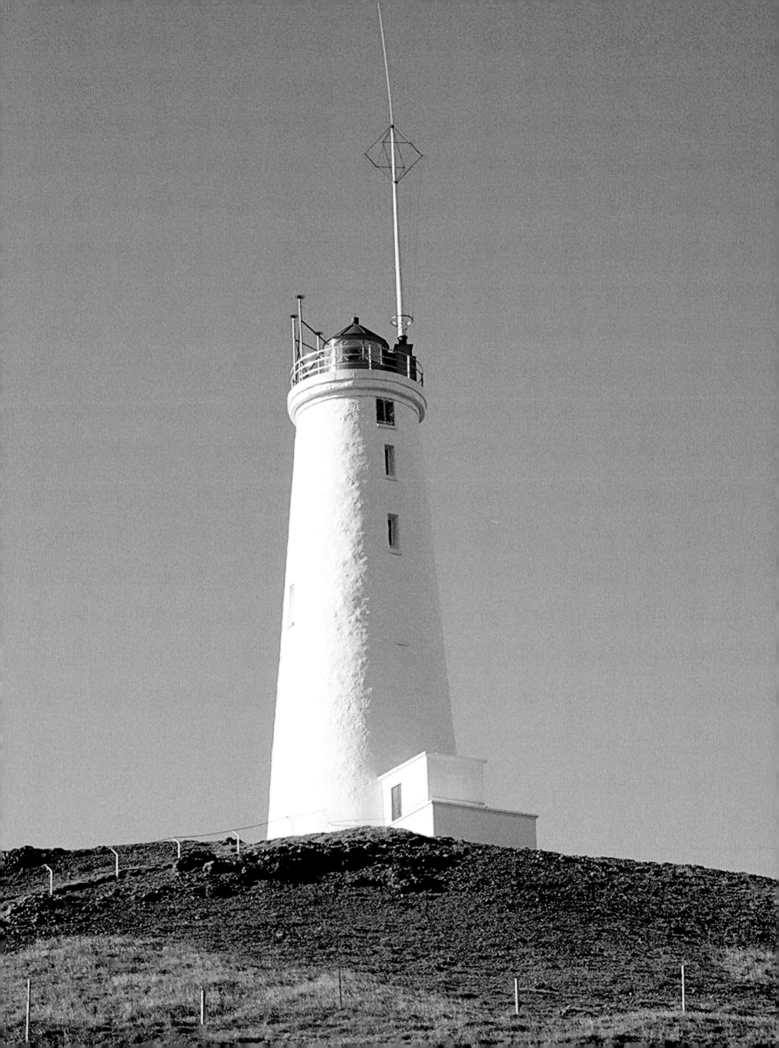

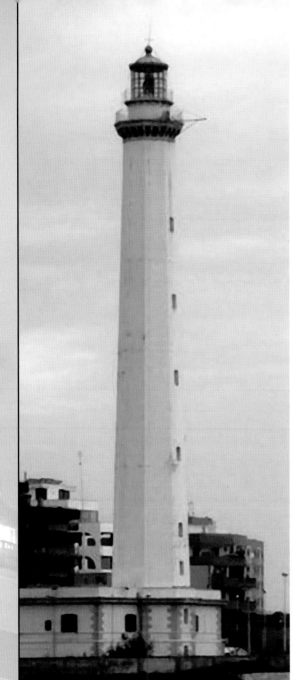

◄ Bari Lighthouse:

Also known as Punta San Cataldo Light, the Bari Lighthouse is an active light Located in Punta San Cataldo, at the base of the Molo San Cataldo, on the west side of Bari Harbor in Italy. At a height of 205 feet (62m) it is the world's sixteenth tallest lighthouse. Situated a the top of the heel of Italy' famous "boot," the lighthouse overlooks the Adriatic Sea and guides ships to the harbor of Bari. The octagonal tower is constructed in stone, which is painted white with a gray lantern. A two-storey keeper's house is built at the base of the tower.

Year first constructed	1869
Height	62m

▸▸ Vittoria Lighthouse:

Also known as the Victory Lighthouse, Vittoria is an active lighthouse situated on the hill of Gretta in Trieste, Italy, on the border of what is now Slovenia. At a height of 223 feet (68m) it is the eighth tallest lighthouse in the world. As well as guiding shipping in the Gulf of Trieste, the lighthouse is also a monument to Italian victories in World War I, notably the Battles of the Isonzo. Designed by Triestine architect Arduino Berlam, the lighthouse is topped by a statue of Winged Victory by Giovanni Mayer. The cylindrical fluted tower, constructed in stone, is also a monument to the sailors who lost their lives during World War I. A statue of a sailor, also by Mayer, adorns the front of the tower, along with the inscription, "Shine in memory of those lost at sea, 1925–1918."

Year first constructed	1927
Height	68m

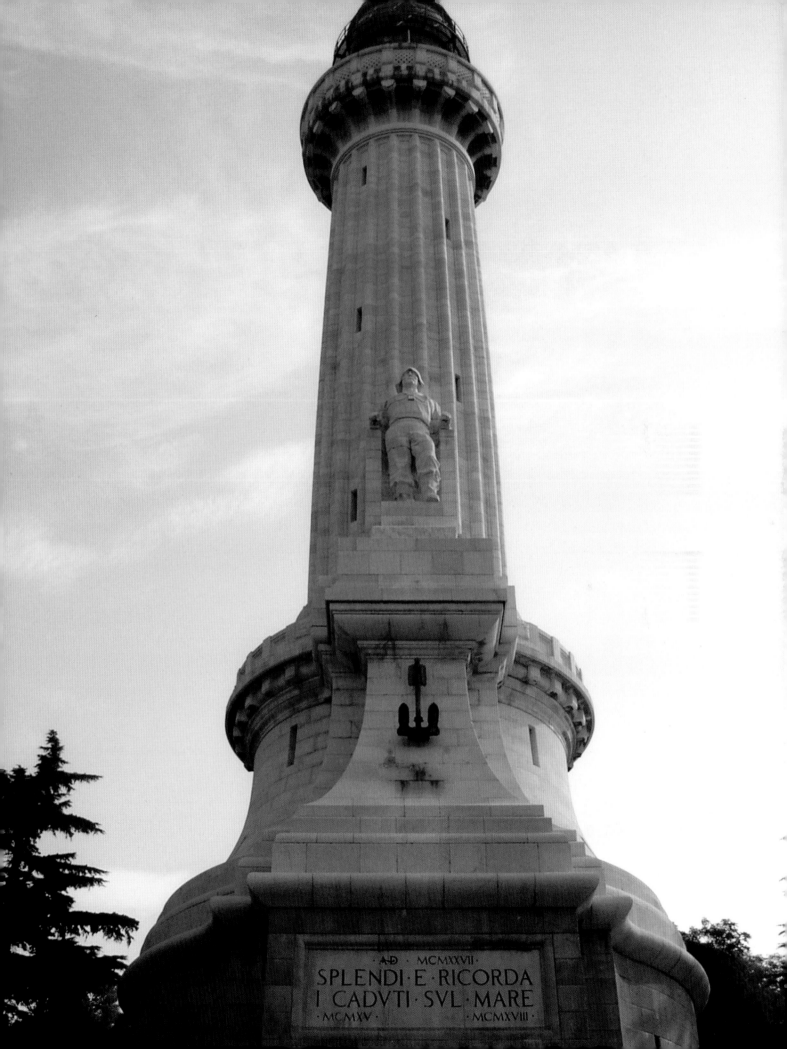

A·D · MCMXXVII
SPLENDI·E·RICORDA
I·CADVTI·SVL·MARE
·MCMXV· ·MCMXVIII·

◂ The J.C.J. van Speijk Lighthouse:

Overlooking the North Sea near Egmond aan Zee, in Bergen, the Netherlands, The J.C.J. van Speijk Lighthouse is a tapering, cylindrical tower constructed in brick and painted white. The lighthouse was designed to guide shipping across the perilous sea near Egmond. The north side of the light is red to warn of dangerous shallows; the end of the danger zone is indicated by a white light. At the base of the lighthouse is a national memorial to Jan Carolus Joseph van Speyk, a Dutch national hero.

Year first constructed	1869
Height	62m

▸▸ Punta Penna Lighthouse:

At a height of 233 feet (70m), the Punta Penna Lighthouse in Abruzzo, Italy, it is the seventh tallest lighthouse in the world, and the second tallest in Italy after the Lighthouse of Genoa. Overlooking the Adriatic Sea, the lighthouse was designed to guide shipping into the port of Vasto. The original lighthouse was demolished in 1944, when the retreating German army destroyed much of the building. Reconstruction began in 1946. Designed by architect Olindo Tarcione, the concrete structure is unusual in that the octagonal tower stands on a two-storey rectangular building that provides accommodation for the lighthouse keeper. The gray, metallic lantern room is accessed via a spiral staircase with 307 steps.

Year first constructed	1906
Height	70m

▸ The Stavoren Lighthouse:

The Stavoren Lighthouse is situated near the historic town of Stavoren on Lake IJsselmeer in the Netherlands. The lighthouse has a red, cast-iron, skeletal tower with a helical staircase leading up to the white lantern house with a red domed roof. In conjunction with a red and a green light beacon on two adjacent piers, the lighthouse guides shipping bound for Stavoren harbor. All three beacons were built in 1885, probably by Quirinus Harder, and were designated as Rijksmonuments (national heritage sites) in 1999. The lighthouse was restored in 2001.

Year first constructed	1885
Height	15.7m

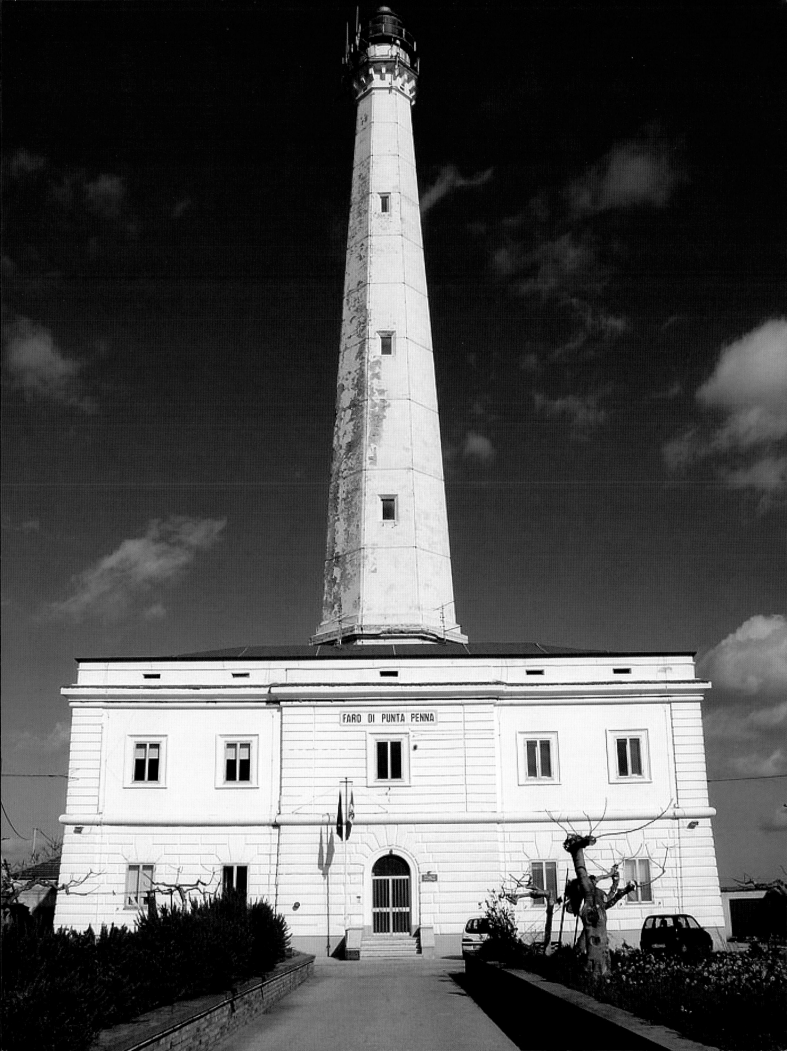

◄ The Brandaris Lighthouse:

The oldest lighthouse in the Netherlands, located in Terschelling, the first Brandaris Lighthouse was constructed in 1323 to guide shipping through the narrow stretch between Vlieland and Terschellingon en route to Amsterdam. As the land eroded, however, the original lighthouse collapsed into the sea in the late 16th century. The present tower dates from 1594 and is now fully automated. Constructed in stone, the rectangular tower has six floors with a staircase of 225 steps to reach the red lantern house, although a lift was installed in 1977. The Lighthouse is listed as a Rijksmonument, a national heritage site.

Year first constructed 1594
Height 52m

►► The Kjeungskjær Lighthouse:

The Kjeungskjær lighthouse is located on a tiny island at the mouth of the Bjugnfjorden about 2 miles (3.5 km) west of the village of Uthaug, in Norway. It was constructed in 1880, and prior to its automation in 1987, the lighthouse keepers lived on the lower floors of the building. The distinctive red lighthouse, with its octagonal tower, is known locally as the "red sailor." It is lit from July 21 until May 16 each year.

Year first constructed 1880
Height 20.6m

► The Eierland Lighthouse:

The Eierland Lighthouse, designed by the Dutch architect Quirinus Harder, is located on the northernmost tip of the Dutch island of Texel. Construction began on July 25, 1863, on top of a 66 foot (20m) high sand dune, and it was first lit on November 1, 1864. The lighthouse is a British-style cylindrical tower, painted red, with a white lantern room.

Year first constructed 1864
Height 34.7m

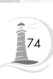

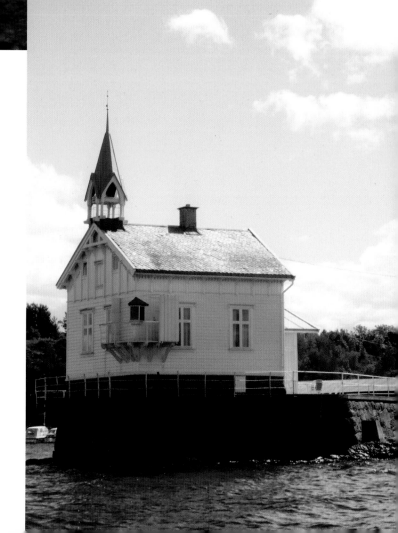

◀ The Lista Lighthouse:

Lista Lighthouse is situated on the western side of the Lista peninsula in the small but important shipping town of Farsund, in the southernmost region of Norway. The granite-built, cylindrical lighthouse was first lit in 1836, to guide vessels into port from the North Sea. 132 steps lead up to the lantern room, which is painted white with a red dome and finial.

Year first constructed	1836
Height	34m

▶ Lindesnes Lighthouse:

The oldest lighthouse station in Norway, Lindesnes is located on the southernmost tip of mainland Norway, on the Neset peninsula. It was first lit in 1655 to guide vessels sailing between the North Sea and the Baltic. Today it also houses a lighthouse museum, exploring the development and history of lighthouses and maritime culture. The white, cylindrical, cast-iron tower is relatively squat with a red lantern house.

Year first constructed	1655
Height	16.1m

▶ Heggholmen Lighthouse:

An active lighthouse located in the Oslofjord, the Heggholmen lighthouse was first lit in 1827 to mark a secondary channel approaching the capital city of Oslo, Norway. The lighthouse stands on a short jetty on the island of Heggholmen. Automated in 1972, the lighthouse was listed as a protected site in 1998. The wooden, Swiss-chalet style keeper's house is topped by an attractive bell tower. The light itself is mounted in a small lantern above a balcony on the front corner of the white-painted building.

Year first constructed	1827

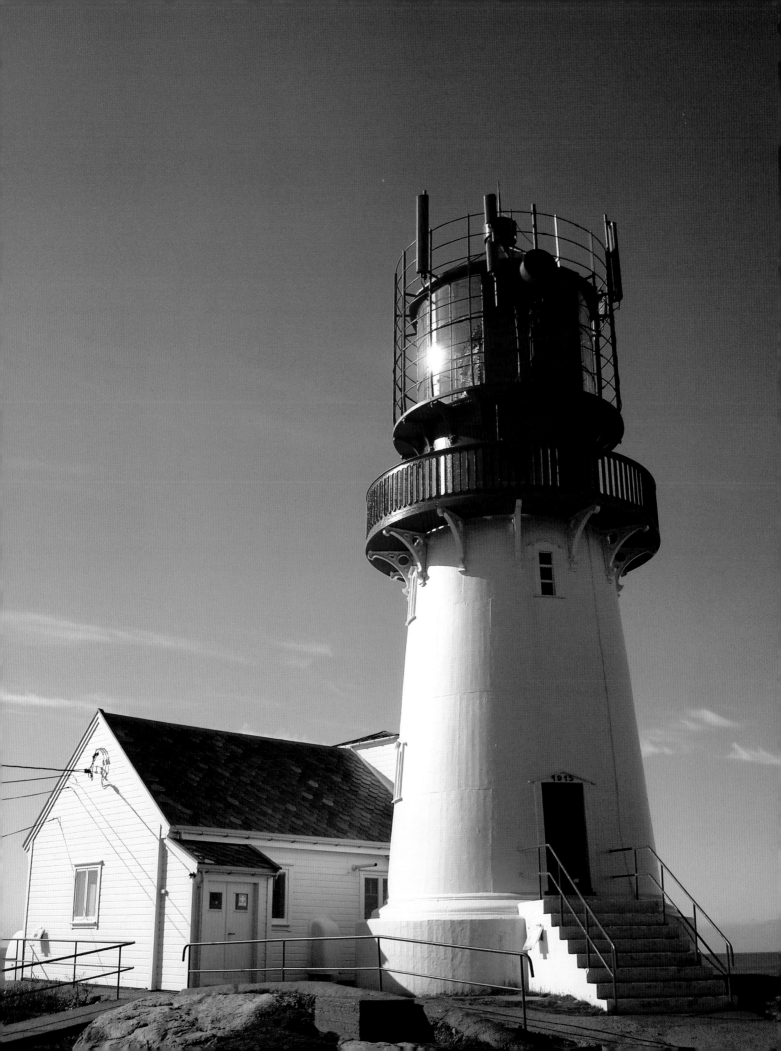

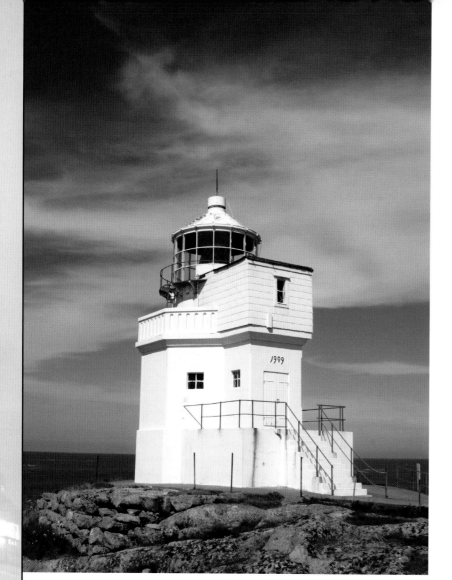

◄ Sula Lighthouse:

Sula lighthouse is located on the island of Sula in Frøya, Sør-Trøndelag, Norway. The first lighthouse on this spot was constructed in 1793 to guide fisherman back to port; the current tower was built in 1904. It is one of a series of lighthouses situated in Frøya, including the Finnvær, Vingleia, and Halten lighthouses. Painted entirely in white, the octagonal concrete tower is lit from July 21 until May 16 each year. It is not lit during the summer due to the midnight sun of the region. The flashing white light is visible for 18 nautical miles.

Year first constructed	1793
Height	13m

►► Alnes Lighthouse:

Alnes lighthouse was first lit in 1852 to guide trawlers safely to the harbor of the small fishing community of Alnes on Godøy island on the west coast of Norway. It is located on the north side of the island in the municipality of Giske, about 2.5 miles (4km) northwest of Leitebakk. The current lighthouse was built in 1876 and automated in 1982. The pyramidal tower is constructed in wood and is painted white with red bands and a red lantern house.

Year first constructed	1876
Height	26.5m

► Halten Lighthouse:

Located in the now uninhabited fishing village of Halten in Frøya, in Sør-Trøndelag county, Norway, the lighthouse was first lit in 1875, and is the northernmost of a chain of four beginning with Sula Lighthouse in south, through Vingleia and Finnvær Lighthouses and finally Halten Lighthouse. The cylindrical tower is made of stones transported from the Lista lighthouse and is painted white with black bands. It has a luminous intensity of 1,080,000 cd and a visibility of 17.5 nautical miles (32.4km). The station has been declared a historic preservation site and is still used as a base station by the Norwegian Coastal Administration.

Year first constructed	1875
Height	29.5m

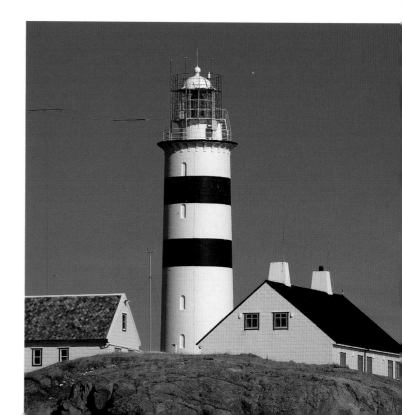

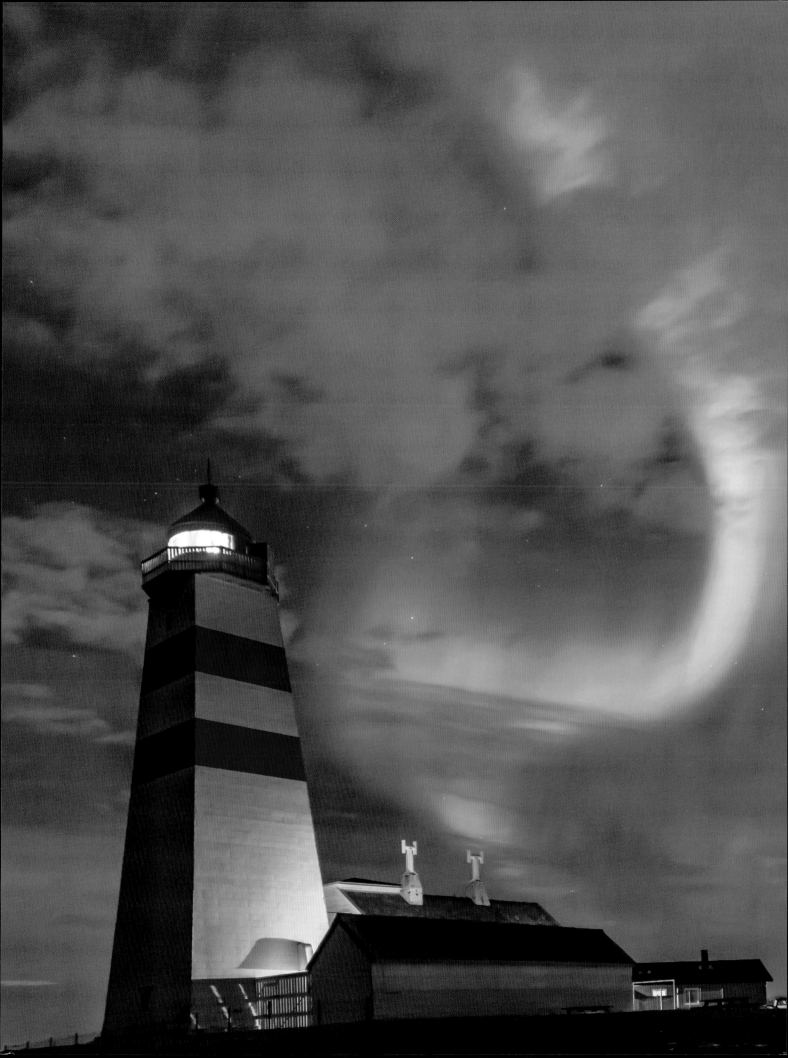

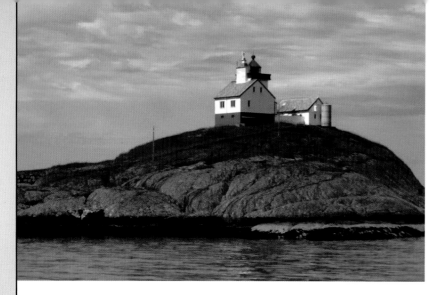

◀ Asenvågøy Lighthouse:

Asenvågøy Lighthouse is located in the municipality of Bjugn in Sør-Trøndelag county, Norway. First constructed in 1921, the lighthouse is situated on the eastern edge of the tiny island of Asen in the Norwegian Sea at the entrance to the Lauvøyfjorden, which is about half a mile (7km) west of the island of Lauvøya. It was built to aid fishermen on the way in from the great herring fisheries in Frohavet. The wooden tower is attached to the keeper's house and is painted white with a red gallery. It was automated in 1975.

Year first constructed	1921
Height	14m

▶▶ Świnouście Lighthouse:

Also known as the Swinemünde Lighthouse, this active lighthouse in Świnoujście, Poland, is the twelfth tallest lighthouse in the world, as well as being the world's tallest brick-built lighthouse. It is situated at the mouth of the Świna River on the east bank. The first lighthouse was built on this spot in 1828, and the current structure dates from 1857. The tower was originally octagonal, but it was restored at the turn of the 20th century and converted to its current round shape above the first gallery. During World War II, the tower was damaged by retreating German troops. An order was given to destroy the lighthouse, but the German keeper refused the command and the tower survived. The damage was repaired in 1959.

Year first constructed	1828
Height	65m

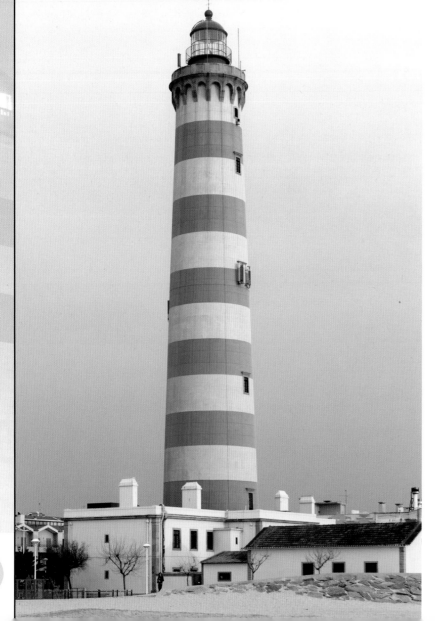

◀ Aveiro Lighthouse:

Also known as the Barra Light, Aveiro Lighthouse is located in Aveiro, which is known as "the Portuguese Venice." It is the seventeenth tallest lighthouse in the world, and the tallest in Portugal. The lighthouse is situated on the south side of the entrance to the Aveiro lagoon, in Barra. The stone-built tower is painted with red and white bands with a red lantern house. The location is exposed to ferocious Atlantic storms and a sea wall was constructed to protect the lighthouse after a storm in 1935 washed away the fog signal. The lantern house can be reached via 291 steps, although an elevator to the midpoint was installed in 1958.

Year first constructed	1875
Height	29.5m

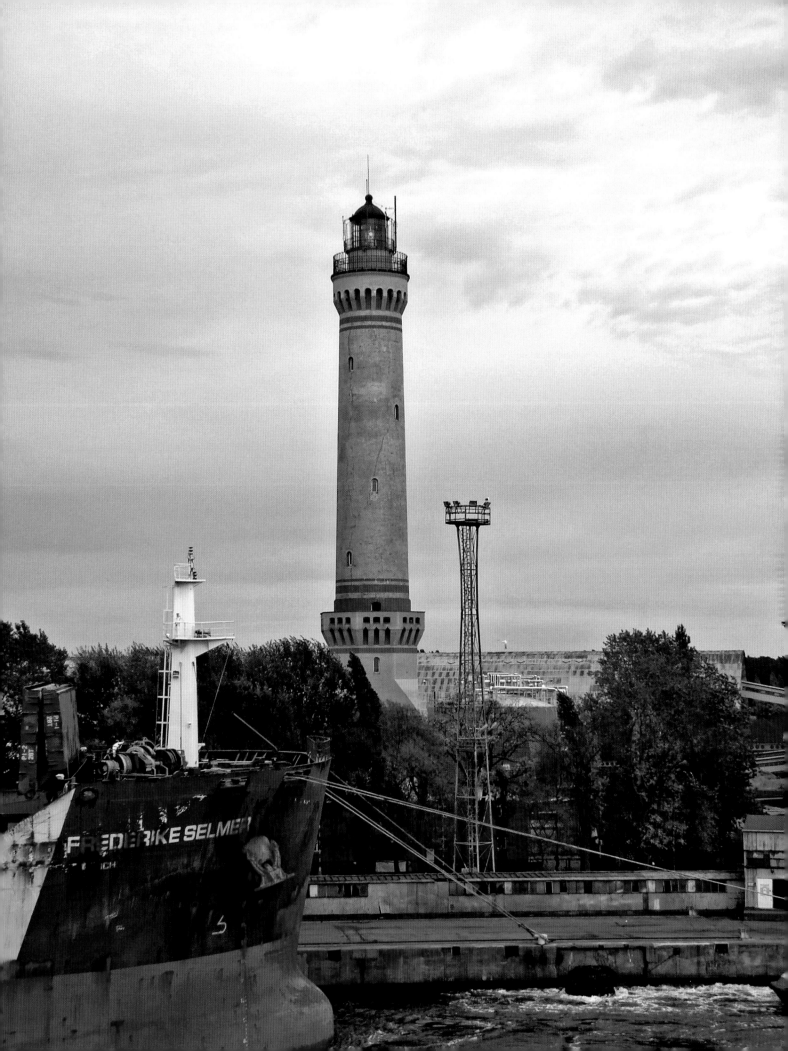

▸ Almagrundet Lighthouse:

Almagrundet Lighthouse is located southeast of Sandhamn outside the Stockholm archipelago and alerts shipping to submerged rocks in the area at depths between 10 and 45 feet (3 and 14m). The shoal was named after the Norwegian brig Alma, which ran aground in a heavy storm in 1866. A lightship was anchored in the area as a warning in 1896. In 1964 a modern, remote-controlled, concrete caisson lighthouse replaced the ships and is fitted with solar-powered lights, fog horns, a helipad, and floodlighting. There is also a kitchenette and two sleeping berths. The cylindrical tower also acts as a day mark and is painted black with a red band.

Year first constructed	1896
Height	30m

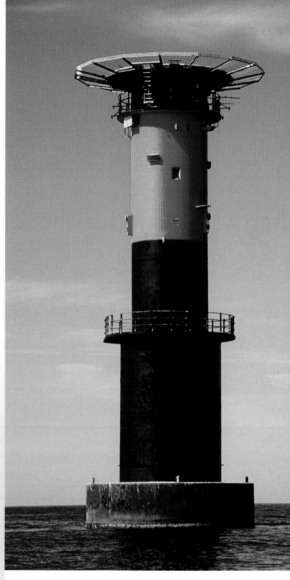

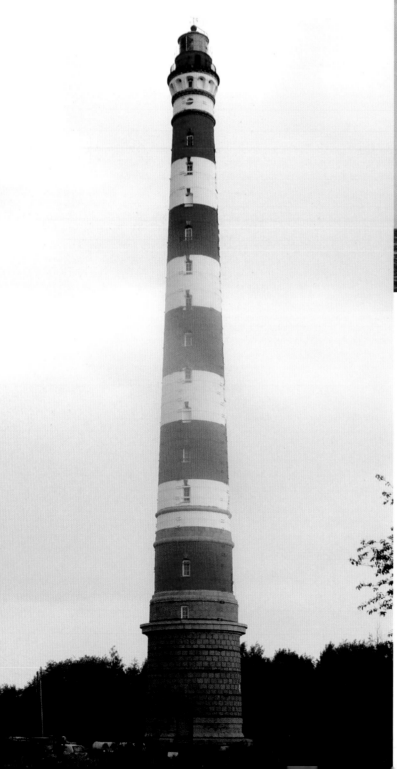

▸▸ Chipiona Lighthouse:

Also known as the Punta del Perro Light, the Chipiona Lighthouse is located in Chipiona, in the province of Cádiz, Spain. At a height of 205 feet (62m) it is the tallest lighthouse in Spain, and the fifteenth tallest lighthouse in the world. The lighthouse stands on the Punta del Perro, "Dog Point," a projection of land into the Atlantic Ocean, about 3.5 miles (6.5km) southwest of the mouth of the Guadalquivir river with its treacherous reefs, and serves as the landfall light for Seville. The sandstone lighthouse has a four-storey, rectangular base and a conical tower leading to the gallery and lantern.

Year first constructed	1867
Height	62m

◂ Storozhenskiy Lighthouse:

Also known as the Storozhno Light, Storozhenskiy Lighthouse is an active lighthouse in Lake Ladoga, in the Leningrad Oblast, Russia. It is situated on a headland on the eastern side of the lake, separating the Svirsky lip of the lake from the Volkhov Bay. At a height of 233 feet (71m) it is the seventh tallest lighthouse in the world, and the world's fourth tallest stone lighthouse. It is a twin of the slightly shorter Osinovetsky Light.

Year first constructed	1907
Height	71m

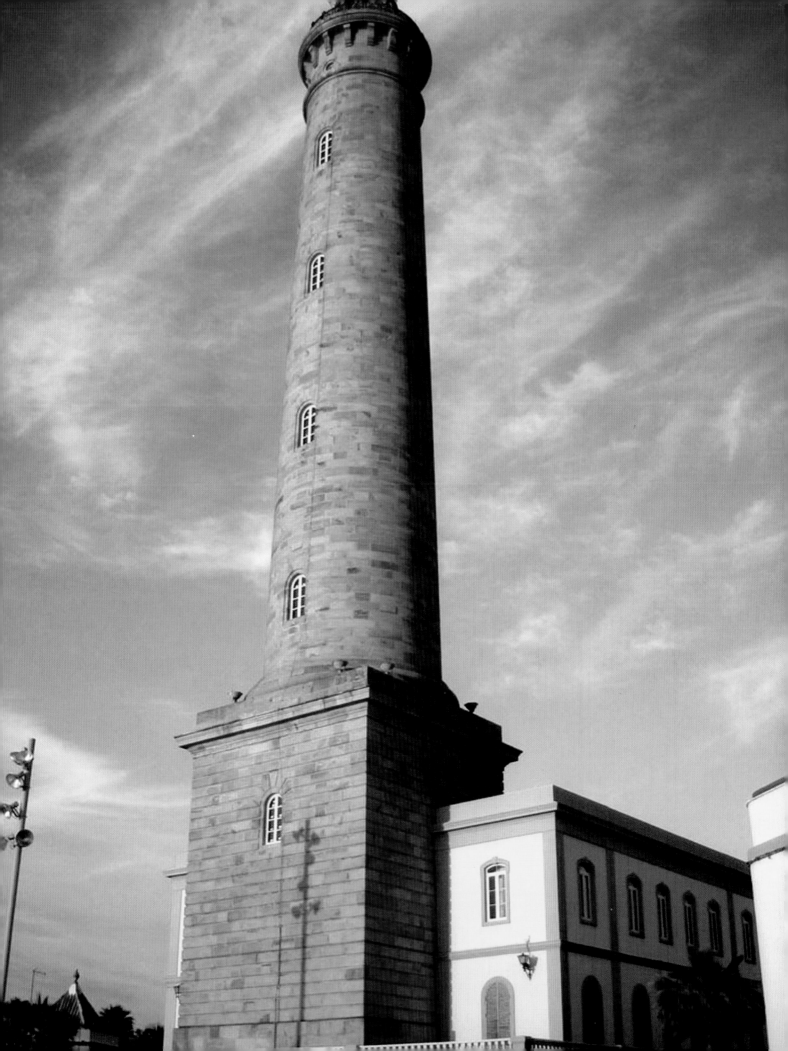

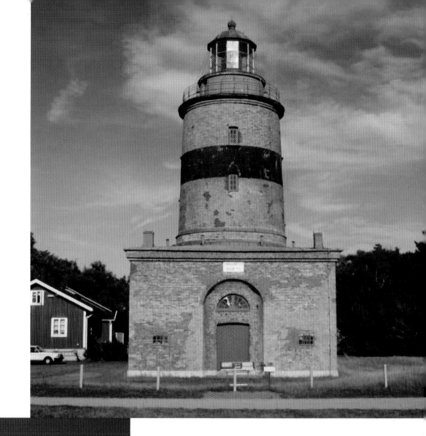

▸ Falsterbo Lighthouse:

Constructed close to the site of the oldest known beacon in Scandinavia, in Falsterbo, Scania, Sweden, the Falsterbo Lighthouse was first lit in 1793 to alert seafarers to the dangerous shifting sand banks under the Falsterbo headland, which have claimed many ships over the centuries. The lighthouse was automated in 1972. It is a brick-built, cylindrical tower with a black band, constructed on top of a rectangular base.

Year first constructed 1793
Height 25m

▸▸The Tower of Hercules:

An ancient Roman lighthouse located on a peninsula about 1.5 miles (2.4km) from the center of A Coruña, Galicia, in northwestern Spain, the Tower of Hercules serves as a landmark to guide shipping into La Coruña Harbor. The tower is 180 feet (55m) tall and overlooks the North Atlantic coast of Spain. The lighthouse is almost 1,900 years old and is the oldest Roman lighthouse in use today. The tower was restored by the architect Eustaquio Giannini in the 18th century, who augmented the Roman rectangular tower with two octagonal tiers. The site houses a magnificent sculpture garden featuring works by Pablo Serrano and Francisco Leiro. A National Monument of Spain, the tower has been listed as a UNESCO World Heritage Site since June 27, 2009. It is the second tallest lighthouse in Spain, after Chipiona Lighthouse.

Year first constructed 2nd century
Height 57m

◂ Hallands Lighthouse:

The Hallands Lighthouse is located on Hallands Island in the northwest corner of the Scania province, overlooking the Kattegatt Sea in Sweden. It was constructed on the northwestern tip of the island in 1884 and was fully automated in 1965. The white, cylindrical tower is built in cast iron and is connected to a small lighthouse-keeper's cabin. The lantern house is also white with a green dome and finial.

Year first constructed 1884
Height 13m

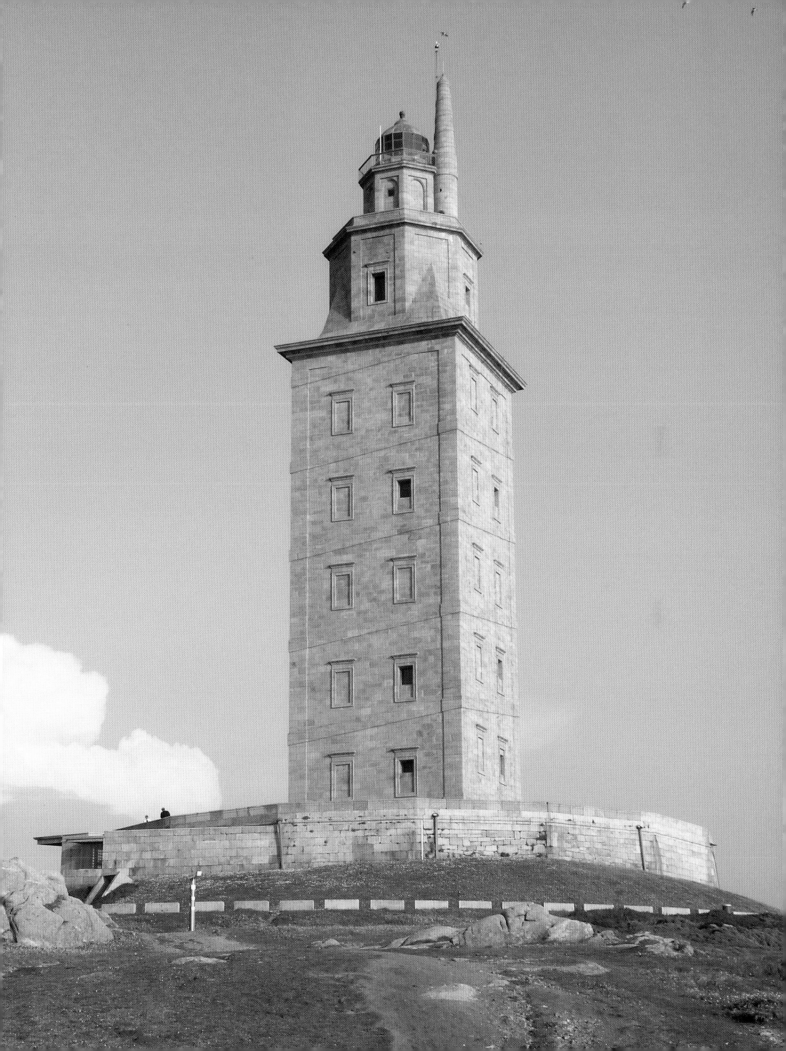

▸ Landsort Lighthouse:

Landsort Lighthouse is located in Gabrielstorp on the southern tip of the island of Öja, Sweden, overlooking the Baltic Sea. Sweden's oldest lighthouse station, the cylindrical tower was constructed from stone in 1689, with a conical, iron upper section added in 1870. The stone section of the tower is painted white and the iron section is red. The lighthouse was automated in 1963 and is still employed as an active aid to navigation in the region.

Year first constructed	1689
Height	25m

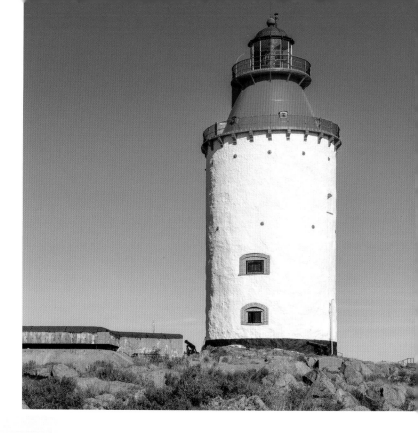

▸▸ Långe Erik:

Långe Erik, "Tall Erik," also known as Ölands norra Udde, was built in 1845 and is located in Grankullaviken Bay at the north point of Öland, the second largest island in Sweden. The lighthouse is sited on a tiny islet that was connected to the main Öland by a bridge in 1965. The white, cylindrical tower is constructed in limestone with a gray lantern house, which was automated in 1976.

Year first constructed	1845
Height	32m

◂ The Kullen Lighthouse:

The Kullen Lighthouse is an active lighthouse in Scania, located at the mouth of the Öresund strait on the tip of the Kullaberg peninsula, in Höganäs, Sweden. One of the most prominent landmarks along the Swedish coast, Kullen is also the most powerful lighthouse in Scandinavia with its 1,000 Watt electric bulb in an enormous lenshouse. The granite and brick tower guides shipping through one of the world's most heavily trafficked waters.

Year first constructed	1898
Height	15m

The lens assembly at the Kullen lighthouse, the most powerful lighthouse in Scandinavia.

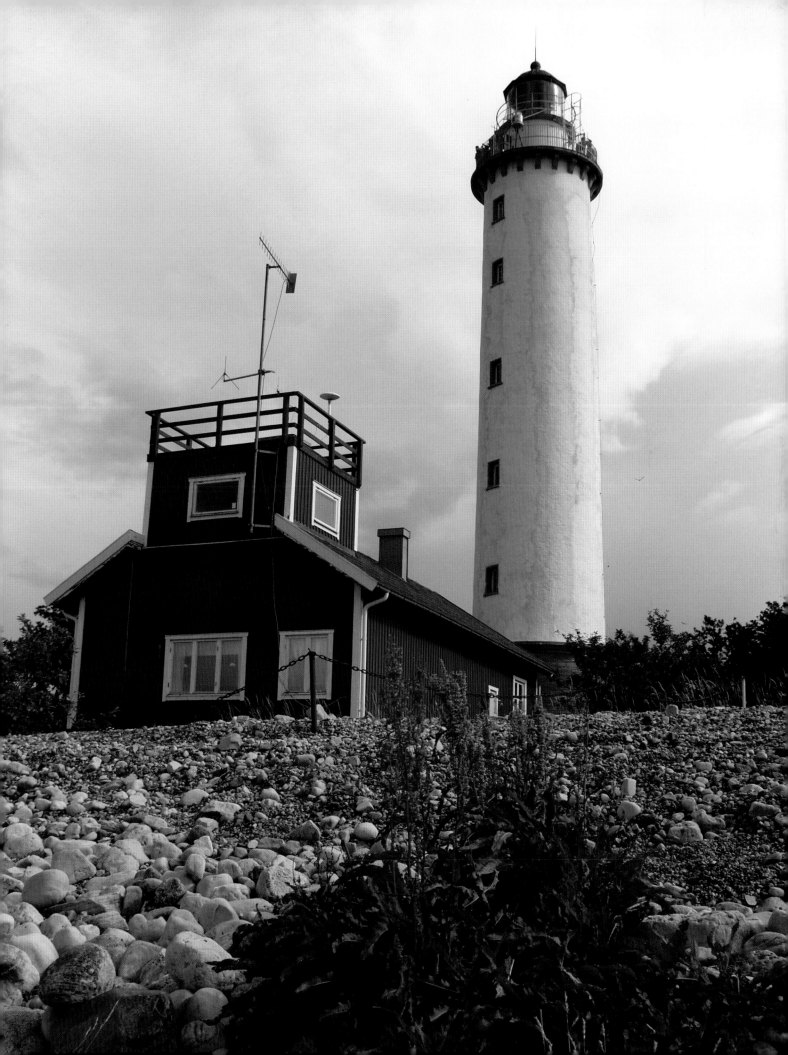

▶ Smygehuk Lighthouse:

Smygehuk Lighthouse is located approximately a mile (1.5km) west of Smygehamn to mark the southernmost tip of Sweden and the Scandinavian peninsula. It was first lit in 1883, but it was taken out of service in 1975 to be replaced by the offshore Kullagrundet Lighthouse. It was relit in April 2001 and is still active today. The tower is constructed in iron and painted white.

Year first constructed	1883
Height	17m

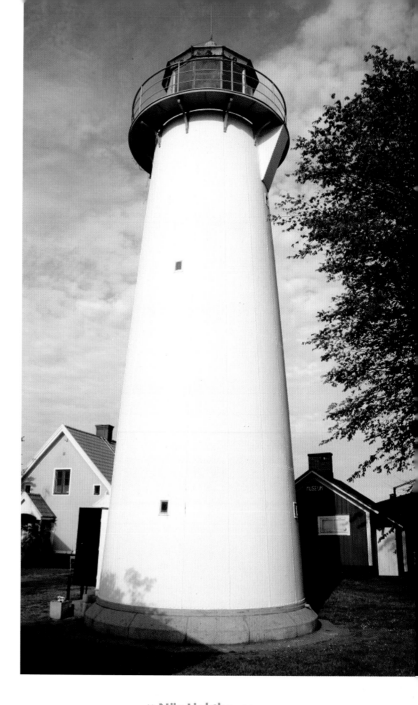

▼ Pater Noster Lighthouse:

A conical, skeletal, iron tower with a green lantern, the Pater Noster Lighthouse is located in Hamneskär, Skagerrak, west of Marstrand, in Sweden. The lighthouse was automated in 1964 but it was deactivated in 1977 in favor of a more modern lighthouse. Pater Noster Lighthouse fell into disrepair but was shipped to Gothenburg in 2002 for restoration. The lighthouse was transported back to Hamneskär and reactivated in 2007.

Year first constructed	1898
Height	15m

▶▶ När Lighthouse:

När Lighthouse is located outside the village of När on the southeast side of the island of Gotland, in Sweden. Designed by the architect John Höjer, It was constructed in cast iron in 1872 in a classic conical shape. The tower is painted red with white bands and has a red gallery surrounding the green lantern dome and finial. It is situated in a nature reserve and bird sanctuary.

Year first constructed	1872
Height	16m

The lighthouse is shipped after renovation o Arendals warf, Gothenburg.

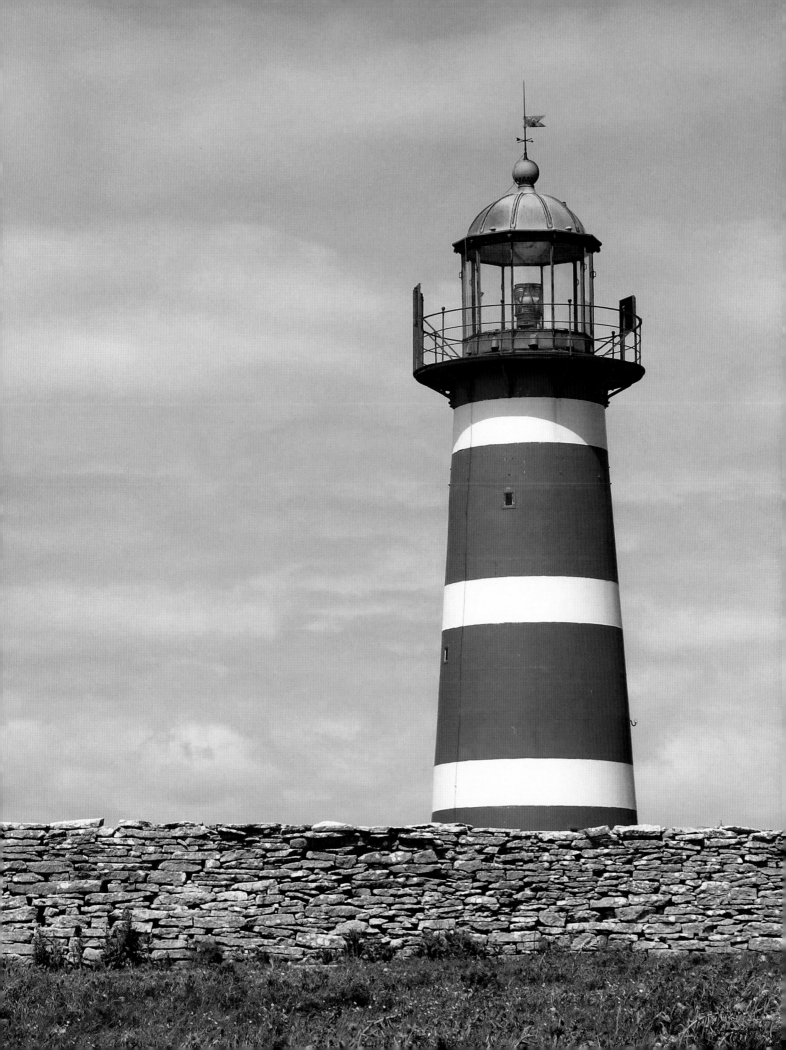

▶ Väderöbod Lighthouse:

Väderöbod Lighthouse is situated on Väderöbod island in the southern part of the Väderöarna archipelago, in Bohuslän, Sweden. The original lighthouse on the site was a cast-iron, skeletal tower with a central cylinder to house a ladder providing access to the lantern house. This lighthouse was deactivated in 1965, and was replaced by the current red, cylindrical, concrete tower.

Year first constructed	1867
Height	19m

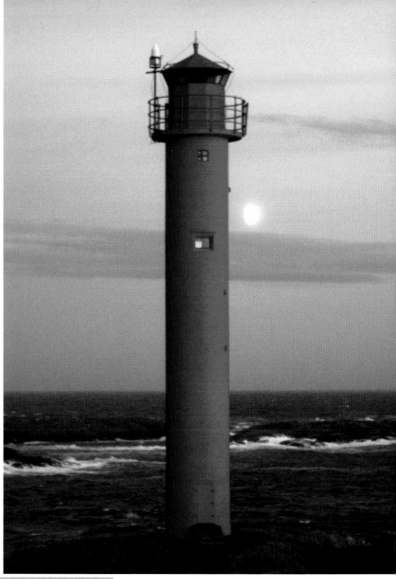

▼ Tjärven Lighthouse:

Tjärven Lighthouse is located on a small island of the same name in the Sea of Aland, in Sweden, serving as an important mark in the heavily trafficked waters between Sweden and Finland. The lighthouse marks the entrance to the shipping route to the ports of Kapellskär, Norrtärge, and Stockholm. The cylindrical tower is constructed in stone and attached to a fortified rectangular building. The lighthouse was automated in 1945. It was renovated in 2008, and solar power was installed.

Year first constructed	1903
Height	13m

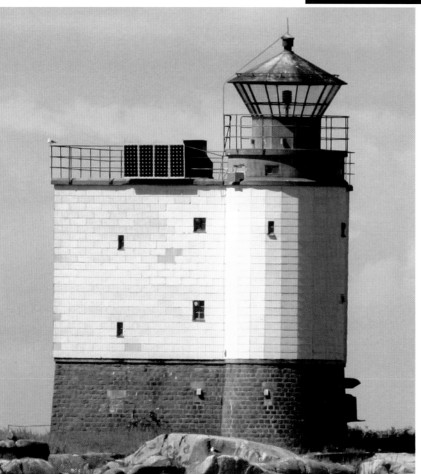

▶ Sile Feneri:

The Sile Feneri Lighthouse overlooks the Black coast in the Town of Sile in Turkey, and is situated on a cliff top at Cape Sile in the northeast of the town. Commissioned by the Ottoman sultan Abdülmecid I, it was built in 1859 by French engineers. The imposing octagonal tower is constructed in stone and is white with narrow black bands. A lighthouse-keeper's house is attached to the base of the tower. The Turkish post issued a stamp to commemorate the 150th anniversary of the tower in 2010.

Year first constructed	1859
Height	19m

▶ The Maiden's Tower Lighthouse:

Also known as Leander's Tower, the Maiden's Tower is located on a small islet at the southern entrance to the Bosphorus strait that serves as a passage between the Black Sea and the Sea of Marmara and the Mediterranean. The islet is situated just 680 feet (200m) from the coast of Üsküdar in Istanbul, the largest city in Turkey. The tower takes its name from the Greek legend of Hero and Leander. In 1110, Byzantine Emperor Alexius Comnenus built a wooden tower protected by a stone wall on the islet, which was at that time connected to the Asiatic shore via a fortified wall, whose remains are still visible under the sea. During the Siege of Constantinople in 1453, the tower held a Byzantine Garrison commanded by the Venetian admiral Gabriele Trevisano. After the conquest of the city, Sultan Mehmet II used the structure as a watchtower. The tower was destroyed during the earthquake of 1509, and another was burned in 1721. In 1763 the first stone tower was built at the site and, in 1857, a lantern was added to the top tower. The lighthouse was restored by the harbor authority in 1945, and the most recent restoration took place in 1998. Steel supports were added around the tower as a precaution following an earthquake in the summer of 1999. Today, the interior of the tower has been transformed into a popular restaurant.

Year first constructed	1110
Height	23m

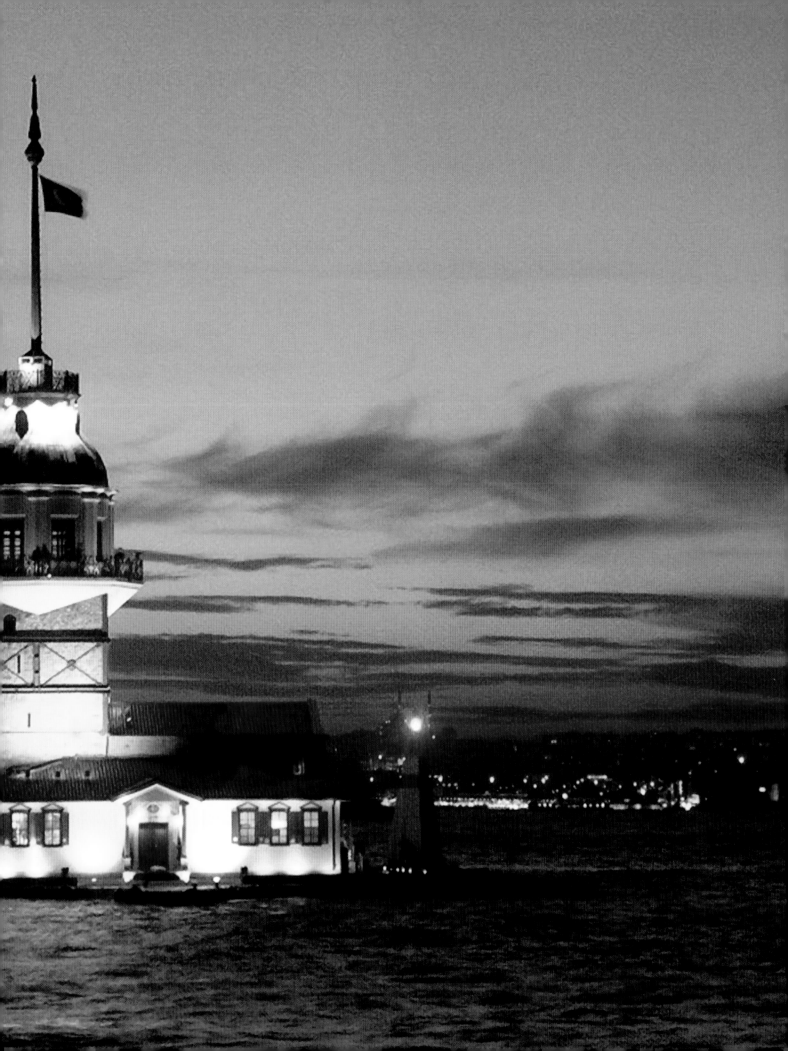

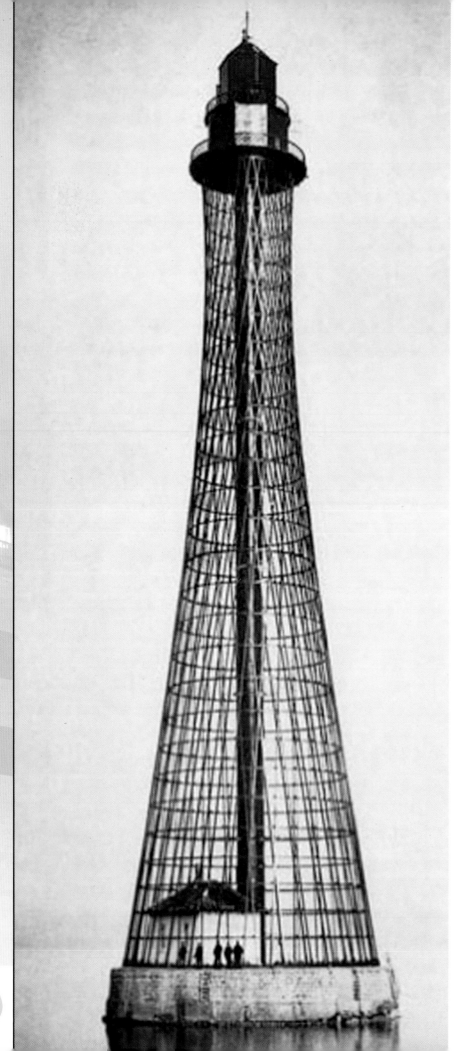

◀ **Adziogol Lighthouse:**

Also known as the Stanislav-Adzhyhol Lighthouse or Stanislav Range Rear Light, the Adziogol Lighthouse is one of two skeletal steel towers serving as active lighthouses in Dnieper Estuary, Ukraine. The wave-washed tower is located about 19 miles (30km) west of Kherson city. At a height of 211 feet (64m) it is the thirteenth tallest lighthouse in the world as well as being the tallest lighthouse in Ukraine.

Year first constructed	1911
Height	64m

▸▸ **Yesilköy Feneri:**

Located on the northern coast of the Sea of Marmara at Yesilköy in Istanbul, Turkey, Yesilköy Feneri lighthouse was commissioned by the Ottoman sultan Abdülmecid I to aid navigation around the shallow waters around the Yesilköy Point for ships sailing to Istanbul along the northwestern coast of the Sea of Marmara. First constructed in 1856 by French engineers, it is situated approximately nine miles (14km) southwest of the southern entrance to the Bosporus strait. The masonry-built octagonal Tower has two stages. The structure is painted entirely white, and a two-storey building is attached to the base of the tower, which originally served as the lighthouse keeper's accommodation but is now converted into a restaurant.

Year first constructed	1856
Height	23m

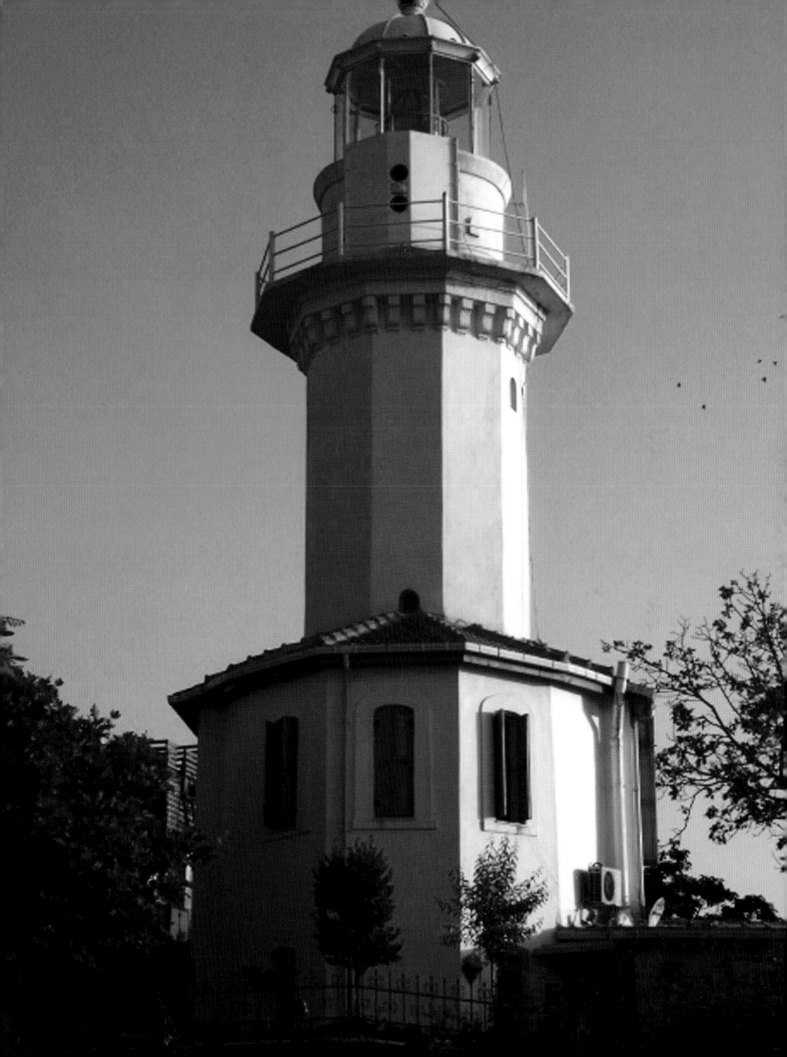

▸▸ The Eddystone Lighthouse:

Eddystone Lighthouse is probably the most famous lighthouse in the British Isles. It is located on the treacherous Eddystone Rocks, 13 miles (21km) south of Rame Head, on the southwest coast of England. The rocks form part of a reef that is submerged at high spring tides, and which was greatly feared by sailors entering the English Channel. The original tower was destroyed in a storm and a second was erected in 1709, a cone-shaped structure built in wood, which stood for 47 years before being destroyed by fire. The third tower was built by John Smeaton in 1759, and was world renowned for its ingenuity. The current lighthouse was built in 1882 by James Nicholas Douglass, who had built other lighthouses based on Smeaton's design. Douglass received a knighthood shortly afterward for his services to engineering. The lighthouse was automated in 1982, and a helipad was constructed above the lantern to allow access for maintenance.

Year first constructed	1856
Height	23m

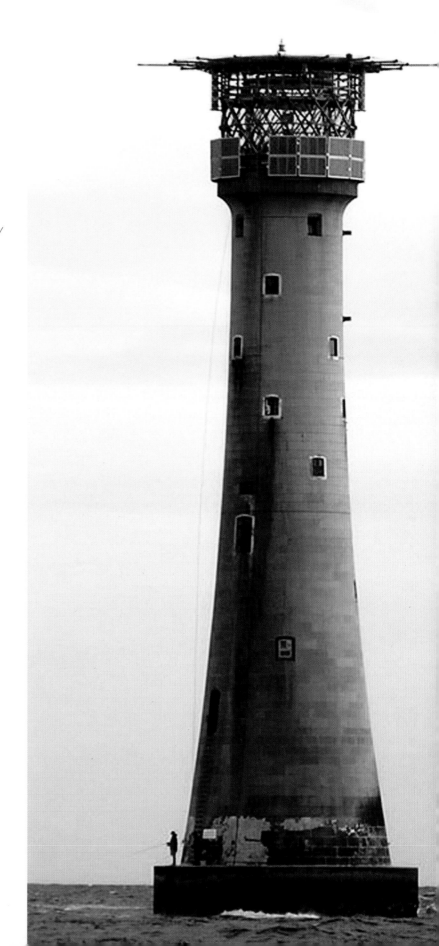

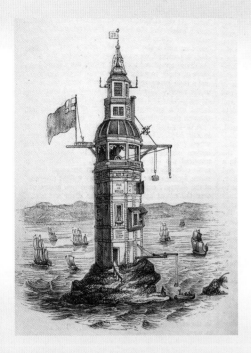

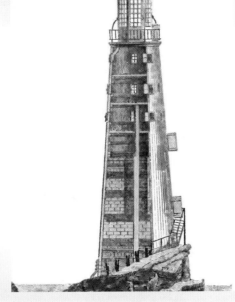

Winstanley's lighthouse:

The first lighthouse on Eddystone Rocks was an octagonal wooden structure built by Henry Winstanley. The project was remarkable in that the tower was the world's first wave-washed lighthouse, built on a small rock in the open sea. Building began in 1696 when England was at war with France and, during construction, a French privateer took Winstanley prisoner. However, King Louis XIV of France ordered Winstanley's release saying, "France is at war with England, not with humanity," which is testament to the importance of the project to all sailors. The light was lit on November 14, 1698. The tower survived its first winter but was in need of repair, and was subsequently changed to a stone clad tower in a timber framed construction as shown in the drawing above. This lighthouse lasted until the Great Storm of 1703 when Winstanley, who was working on renovations to the lighthouse at the time the storm broke, disappeared without trace along with the lighthouse and five of his men.

Rudyard's lighthouse:

Following the destruction of the first lighthouse, a Captain Lovett acquired the lease of the rock and by Act of Parliament was allowed to charge a toll on passing vessels. Lovett commissioned John Rudyard to design the new tower, which was constructed as a conical wooden structure encasing a core of brick and concrete. The tower was completed in 1709, and survived for almost fifty years until December 2, 1755, when the top of the lantern caught fire. The three keepers fought desperately to extinguish the fire but were continuously beaten back by the flames and were eventually forced onto the rocks to await rescue. Tragically, the head lighthouse keeper died five days later because molten lead from the lantern roof had dropped into his open mouth as he battled the flames.

Smeaton's Lighthouse:

A light vessel was placed at the site following the destruction of the second tower. The third tower, by civil engineer John Smeaton, marked a major innovation in lighthouse design. Smeaton modeled the tower on the shape on an oak tree, constructed from granite blocks secured with dovetail joints and stone dowels. Most importantly perhaps, he pioneered "hydraulic lime," a concrete that sets under water and which is still used today. Construction began in 1756 and the light was first lit on October 16, 1759. Although major renovations were made in 1841, Smeaton's tower remained in use until 1877 when erosion to the rocks below the lighthouse made the tower unstable in heavy weather. Smeaton's lighthouse was rebuilt on Plymouth Hoe as a memorial, which is now a popular tourist attraction in Plymouth. The foundations and stub of Smeaton's tower remain, close to the more solid foundations of the fourth Eddystone Lighthouse.

◄ Pendeen Lighthouse:

Also known as Pendeen Watch, Pendeen Lighthouse is situated 1.2 miles (2km) to the north of the village of Pendeen in west Cornwall, England, which was notorious for smugglers. The site is designated as an Area of Outstanding Natural Beauty, which enjoys the same status as a National Park. The lighthouse, designed by Trinity House engineer Sir Thomas Matthews, was constructed in 1891. The cylindrical concrete tower is painted white with a green band around the base and an attractive latticed window in the lantern house. The light was automated in 1995, and the keepers' residences on the site are now used as holiday cottages.

Year first constructed	1891
Height	17m

►►St Anthony's Lighthouse:

St Anthony's Lighthouse located on St Anthony Head at the eastern entrance to Falmouth Harbour, in Cornwall, one of the world's largest natural harbors. The octagonal lighthouse was built in 1835 to guide vessels clear of the notorious Manacles rocks, south of the harbor entrance. Electricity was connected in 1954 and a modern foghorn replaced the huge bell that originally hung outside the tower. The granite lighthouse, which is painted white with a black lantern-house roof, was fully automated in 1987.

Year first constructed	1835
Height	19m

► The Lizard Lighthouse:

Located at Lizard Point in Cornwall, England, the Lizard Lighthouse is a landfall and coastal mark guiding vessels passing through the English Channel and alerting sailors to hazardous waters off Lizard point, the most southerly point of mainland Britain. A light was first lit on the site in 1619, thanks to the efforts of Sir John Killigrew, but the original tower was demolished in 1630 because of difficulties in raising funds for its upkeep. The current lighthouse, consisting of distinctive twin octagonal towers with cottages built between them, was constructed in 1751. Originally both towers were lit, but since 1903 only the eastern Tower has remained in service. Trinity House took responsibility for the lighthouse in 1771, and it was fully automated in 1998.

Year first constructed	1619
Height	19m

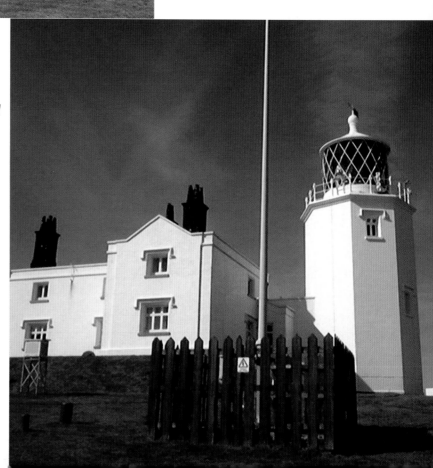

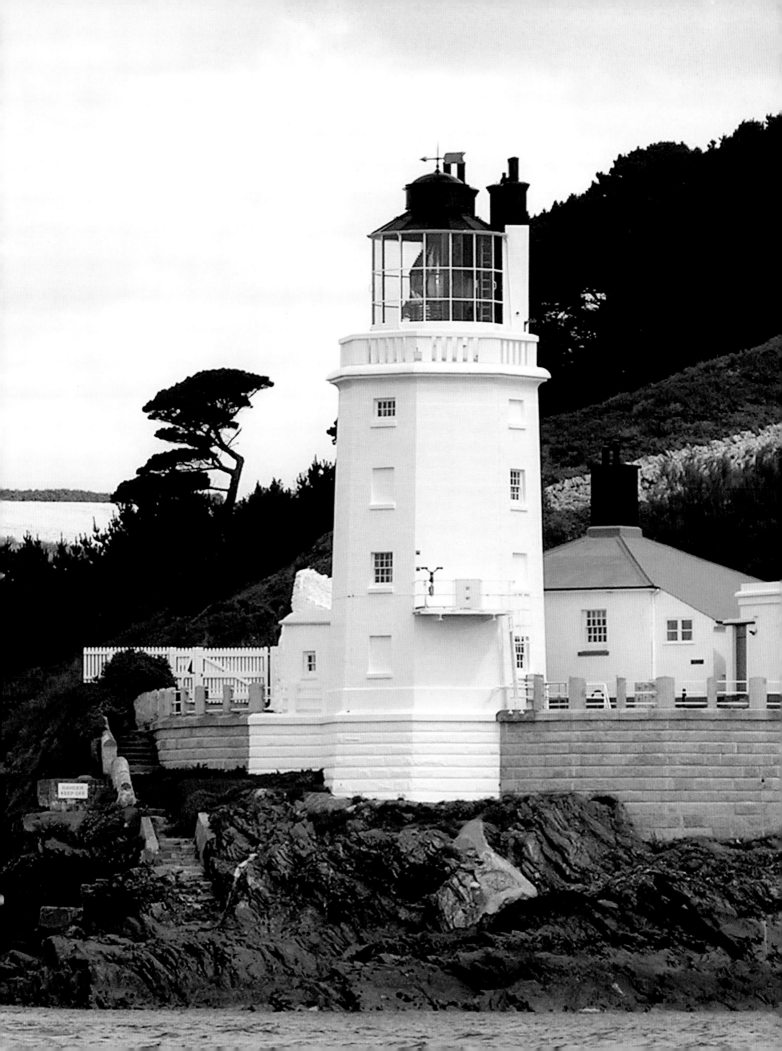

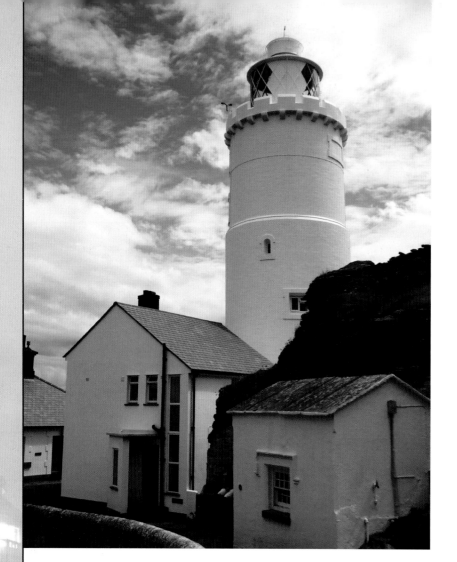

◄ Start Point Lighthouse:

Start Point lighthouse was built in 1836 to protect shipping off Start Point, one of the most exposed peninsulas on the English coast, in south Devon. One of almost thirty lighthouses designed by James Walker, the tiered tower is design in gothic style, with a castellated balcony and cast-iron lantern house with a copper roof. The conical tower and surrounding cottages are painted white. Coastal erosion caused part of the site to collapse in 1989 and retaining walls have since been erected. The light was automated in 1993.

Year first constructed	1836
Height	28m

►►Tater Du Lighthouse:

Tater Du Lighthouse in Penzance, England, is Cornwall's newest lighthouse. It was built following the loss of the on October 23, 1963, when the Spanish coaster capsized at Boscawen Point, with the loss of 11 lives. This was also the point where the was lost in 1868. Designed by Michael H. Crisp, the concrete, cylindrical lighthouse was built as an automatic installation in 1965 to warn shipping of the treacherous Runnelstone Rocks close to the headland.

Year first constructed	1965
Height	15m

► Wolf Rock Lighthouse:

Wolf Rock is a wave-washed lighthouse located eight nautical miles (15km) off Land's End in Cornwall, England. The tapering cylindrical tower is 135 feet (41m) tall and constructed from Cornish granite that was prepared on the mainland. It took nine years to build, between 1861 and 1869, due to the volatile and perilous weather conditions typical in those waters. The light can be seen from Land's End by day and night, and is almost precisely halfway between the Lizard and the Scilly isles. It has a range of 23 nautical miles (43km) and was automated in 1988. The lighthouse was the first in the world to be fitted with a helipad.

Year first constructed	1861
Height	41m

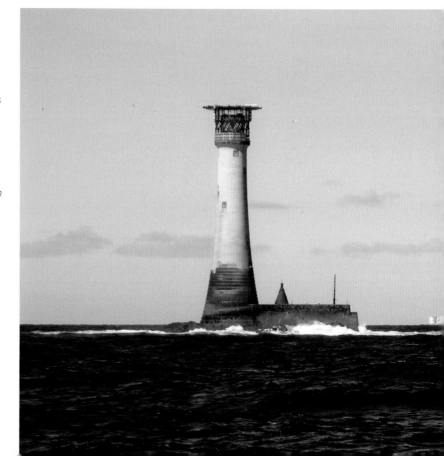

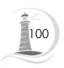

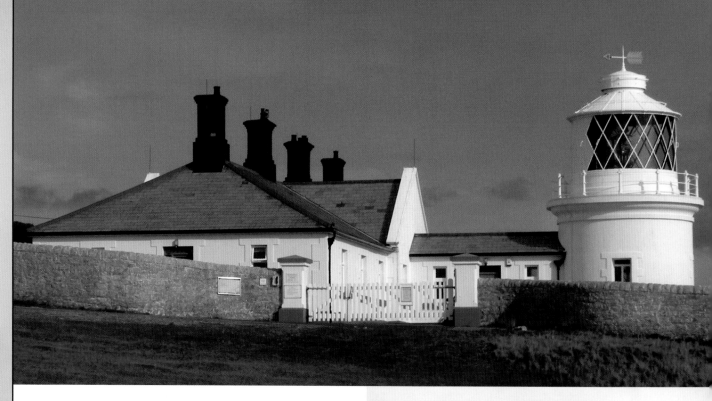

▲ Anvil Point Lighthouse:

Situated near Swanage in Dorset, England, the Anvil Point Lighthouse is a white, conical lighthouse constructed in local stone and first lit in 1881 to provide a waypoint for vessels passing along the English Channel coast. The lighthouse tower is 40 feet (12m) tall, and the height of the light above the high-water mark is 148 feet (45m). The light was fully automated in 1991.

Year first constructed	1881
Height	12m

▶▶ The Beach Lighthouse:

Also known as the Lower Light, the Beach Lighthouse is a sandstone lighthouse located in Fleetwood, Lancashire, England, overlooking the Wyre Estuary. The lighthouse was designed in 1839 by Decimus Burton Captain Henry Mangles Denham. Burton had been commissioned three years previously by Sir Peter Hesketh Fleetwood as the architect of the new town of Fleetwood. It is a highly unusual lighthouse in the neoclassical style with a square colonnaded base, square tower, and octagonal lantern. It is the sibling of the Pharos Lighthouse (see below).

Year first constructed	1840
Height	13m

▶ The Pharos Lighthouse:

Though officially named the Upper Lighthouse, this imposing sandstone tower has been known as the "Pharos" since its construction in 1840, after the celebrated ancient lighthouse Pharos of Alexandria. Unusually for an active British lighthouse, it is sited in a residential area in Pharos Street, in Fleetwood, Lancashire, England. The lighthouse was designed by Decimus Burton and Captain Henry Mangles Denham to aid shipping entering the River Wyre (and Fleetwood Harbour) from the Irish Sea.

Year first constructed	1861
Height	41m

▲ Old Hunstanton Lighthouse:

Located at St Edmund's Point in Norfolk, England, the Old Hunstanton ighthouse is a conical stone tower that was first lit in 1840. There was originally a wooden structure at the site with a coal-fueled light. Old Hunstanton is famed for having the world's first parabolic reflector, which was installed in 1776. The current lighthouse is no longer active, although it still serves as an important day mark. The building has been a private residence since 1922.

Year first constructed	1881
Height	12m

▶ Bishop Rock Lighthouse:

Bishop Rock is a wave-washed, conical lighthouse at the westernmost tip of the Scilly Isles in Cornwall, England. The rock itself is listed in the Guinness Book of Records as the world's smallest island with a building on it. The notorious rocks around the Scilly Isles rise from a depth of 150 feet (45m) and are battered by the full force of the Altlantic, making this an extremely hazardous region for shipping and an exceptionally hazardous place to build a tower. The area has been littered with wrecks over the centuries, including the destruction of Sir Cloudesley Shovel's entire squadron in 1707 with the loss of over 2,000 lives. Construction of the original lighthouse, in cast iron, began in 1847, but it was destroyed by storms before completion. A granite tower was finally lit on September 1, 1858. In 1881, Sir James Douglass restored the tower and raised the elevation of the light by 40 feet (12m). The lighthouse was fully automated in 1991.

Year first constructed	1851
Height	49m

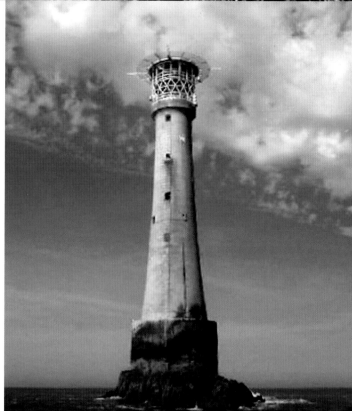

▶▶ Trwyn Du Lighthouse:

Trwyn Du Lighthouse is located at Trwyn Du, "Black Point," between Dinmor Point near Penmon and Puffin Island, in southeast Anglesey, Wales, at the north entrance to the Menai Strait and marks the passage between the two islands. The lighthouse is situated on a low-lying rock surrounded by shingle beaches. The wave-washed, cylindrical tower is painted white with three black bands. It has a distinctive castellated parapet where the gallery is usually situated and a white lantern house. The lighthouse was automated in 1922 and converted to solar power in 1996.

Year first constructed	1838
Height	29m

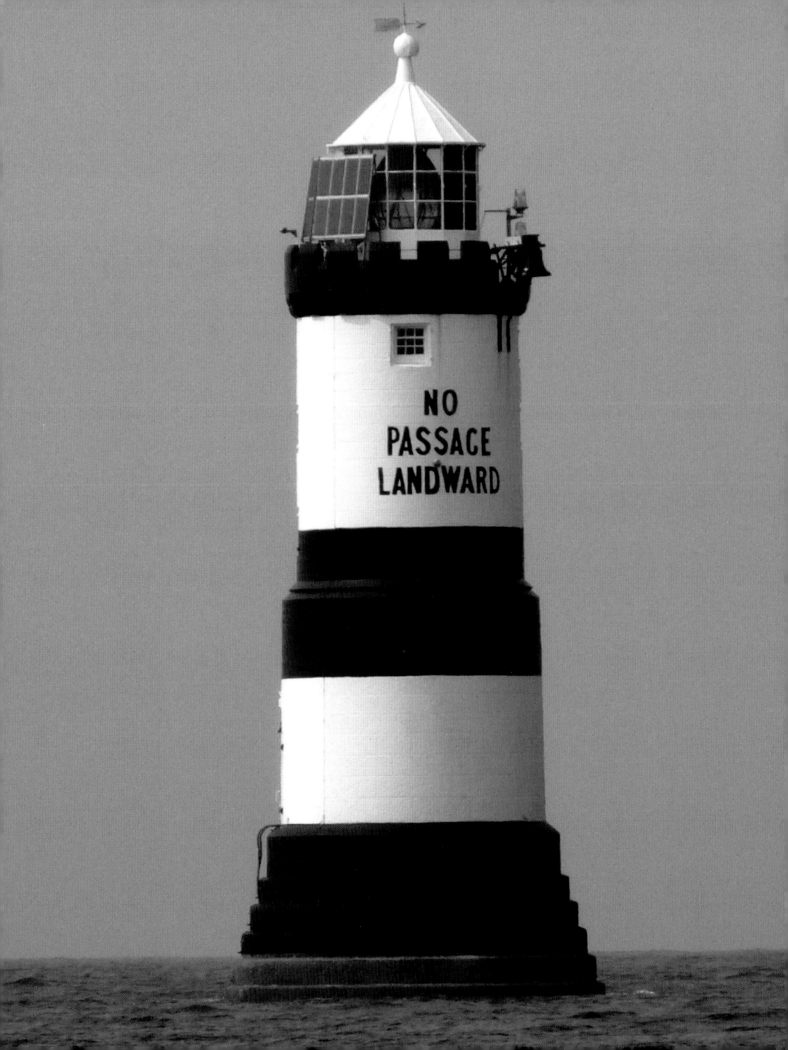

▲ The Amlwch Lighthouse:

The Amlwch lighthouse is located on the outer pier of Amlwch, at the northeast tip of Anglesey, Wales. The existing lighthouse, a pyramidal tower with a square lantern house is the fourth tower to be built on this site. First lit in 1853, the pyramidal portion of the lighthouse is constructed in the original fine, but weathered, ashlar masonry; the present lantern house was added at a later date.

Year first constructed	1853
Height	4.6m

▶ Southerness Lighthouse:

Located at the village of Southerness in South West Scotland, Southerness lighthouse is the second oldest lighthouse in Scotland. It was commissioned in 1748 to assist in the safe passage though the Solway Firth of vessels heading to the Nith Estuary. In the mid-18th century, serviceable roads in southwest Scotland were still quite rare so the bulk of commerce, even between local villages, was conducted by seas and inland waterways. Dumfries was an important and thriving port with regular connections to Liverpool and, most notably, Ireland, across the Irish Sea. The lighthouse, with its white, rectangular tower and black lantern house, was deactivated in 1931.

Year first constructed	1749
Height	17m

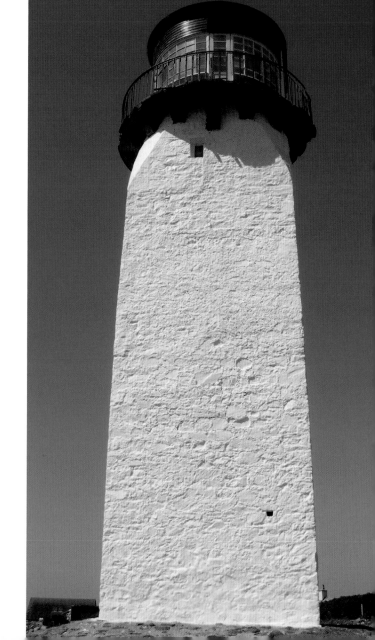

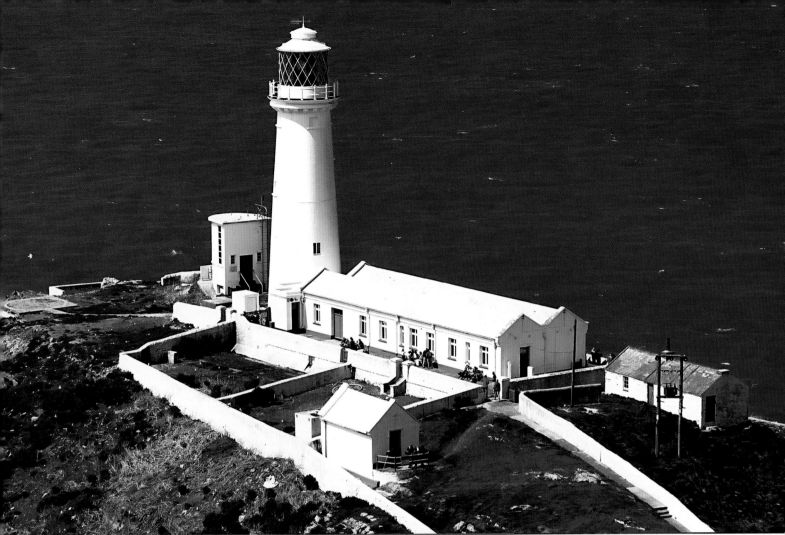

▲ The South Stack Lighthouse:

The South Stack Lighthouse is located on Holy Island, in Anglesey, Wales. The classical tapering, cylindrical tower was designed by Daniel Alexander, and its main light is visible for 24 nautical miles (44km). It was first lit in 1809 to alert shipping to the perilous rocks below and to aid safe passage for ships on the treacherous sea route from Dublin to Liverpool. It provides the first beacon along the northern Anglesey coast for eastbound ships. The lighthouse has been operated remotely by Trinity House since it was first automated in 1983.

Year first constructed	1809
Height	28m

◀ Rubha nan Gall lighthouse:

Rubha nan Gall, "Stranger's Point" in Gaelic, is situated north of Tobermory on the Isle of Mull. The cylindrical tower, which is painted white with a yellow lantern house and black dome, was constructed in 1857 by David and Thomas Stevenson and is currently operated by the Northern Lighthouse Board. The light was automated in 1960 and is now powered by solar panels. The keeper's cottage nearby is now a private residence.

Year first constructed	1857
Height	18.9m

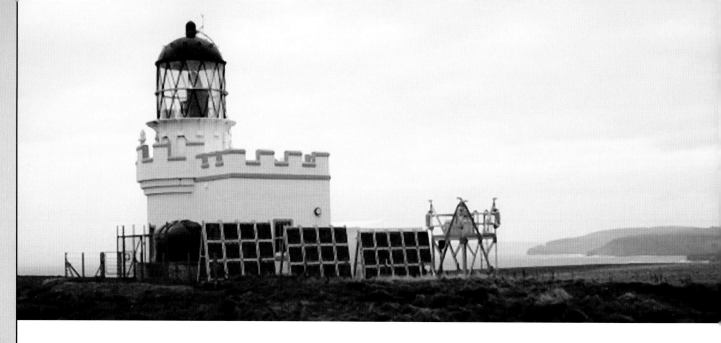

▲ Brough of Birsay Lighthouse:

The Brough of Birsay Lighthouse is located on an uninhabited tidal island off the northwest coast of Mainland in Orkney, Scotland. The distinctive lighthouse was built in 1925 by David A. Stevenson. It has a white conical tower, castellated gallery, and black-domed lantern house. The light is fully automated and was converted to solar power in 2002.

Year first constructed 1925
Height 11m

▶▶ The Tarbat Ness Lighthouse:

Located at the northwest tip of the Tarbat Ness peninsula near the fishing village of Portmahomack on Scotland's east coast, the Tarbat Ness Lighthouse was built by Robert Stevenson in 1830. The light was commissioned following a storm in the winter of 1826 that destroyed 16 vessels in the Moray Firth. The cylindrical tower is constructed in brick and is painted white with two red bands. The lantern house with its black dome is accessed via a staircase with 203 steps leading to the top of the tower.

Year first constructed 1830
Height 41m

◀ The Bell Rock Lighthouse:

Located off the coast of Angus, Scotland, the Bell Rock Lighthouse is the world's oldest surviving wave-washed lighthouse. It was constructed between 1807 and 1810 by Robert Stevenson on Inchcape, also known as the Bell Rock, 11 miles (18km) east of the Firth of Tay in the North Sea, to alert sailors to the treacherous submerged rocks that wrecked half a dozen ships each winter. However, it was the loss of HMS York in 1804 with no survivors that led to the lighthouse's commission. The challenges faced in building the lighthouse led to it being hailed as one of the Seven Wonders of the Industrial World. Constructed in Aberdeen granite, the masonry foundations were built to such a high standard that it has not been replaced in 200 years. Its light is visible from 30 nautical miles (56km) and is operated in partnership with the Bell Rock Signal Tower, built in 1813 at the mouth of Arbroath Harbour, which now houses the Signal Tower Museum. The Bell Rock Lighthouse is a white conical tower with a brown band around the base. It has been automated since 1988.

Year first constructed 1810
Height 35.3m

Illustration of the Bell Rock Lighthouse. Engraving by John Horsburgh after a drawing by J. M. W. Turner, 1824

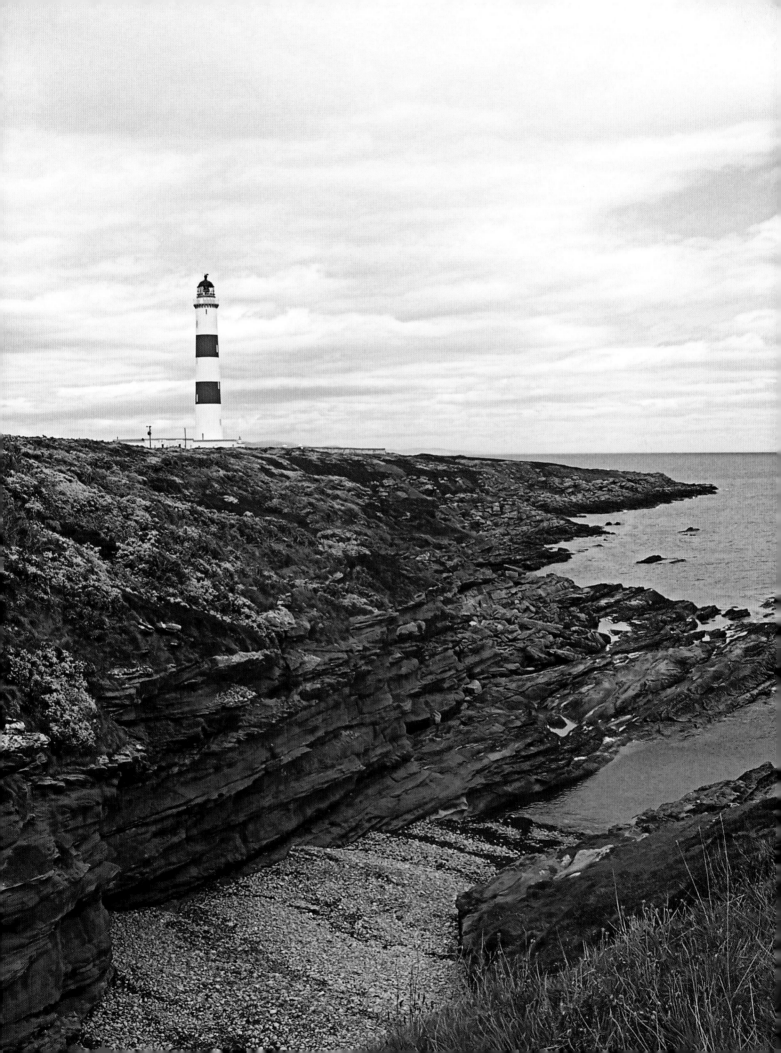

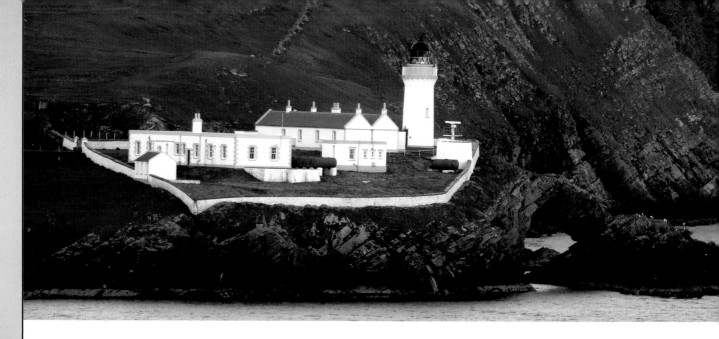

▲ Bressay Lighthouse:

Located on the island of Bressay at Kirkabister Ness overlooking Bressay Sound in the Shetland Islands, Scotland, Bressay Lighthouse was commissioned to guide shipping to Lerwick Harbour. It was one of four lighthouses constructed in Shetland between 1854 and 1858 that were designed by David Stevenson and his brother Thomas. The lighthouse has a white cylindrical tower with a black-domed lantern house and is located in a walled enclosure with the original keeper's cottage and several other buildings. The lighthouse was automated in 1989 and the light was decommissioned in September 2012.

Year first constructed	1856
Height	16m

▼ The Baily Lighthouse:

The Baily Lighthouse is located on the southeastern point of Howth Head to guide shipping into Dublin Bay, Dublin, Ireland, whose shallow waters and rocky outcrops had wrecked innumerable ships. The first lighthouse on this site was constructed in 1667 by Sir Robert Reading, and consisted of a small square tower with a coal-fired beacon. Parts of the original buildings remain today and the conical tower with its red gallery and white lantern house enjoy iconic status. From 1978, the light was operated only in poor visibility, and the fog signal was discontinued in 1995. The lighthouse was automated in 1996.

Year first constructed	1667
Height	13m

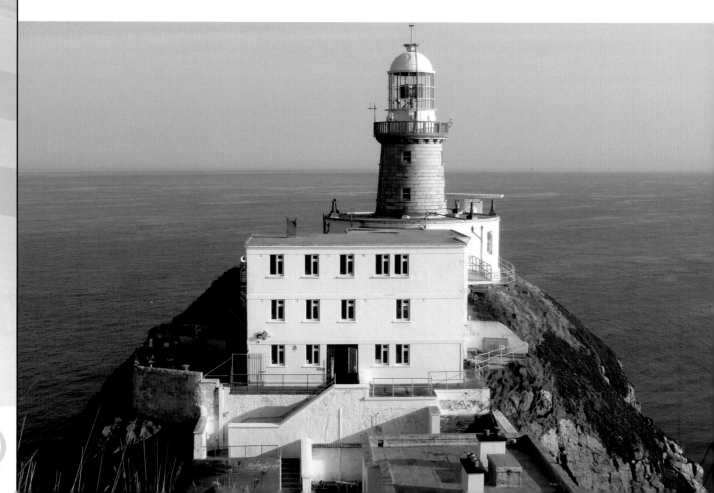

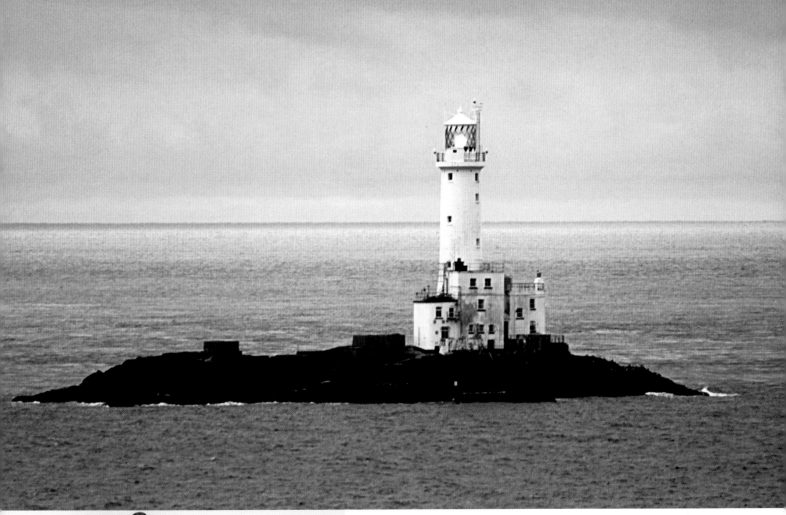

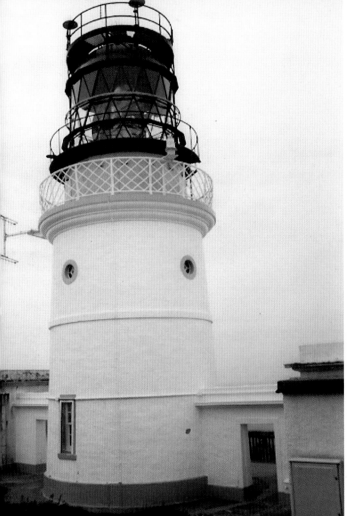

▲ Tuskar Rock:

Tuskar Rock Lighthouse is located on a rock off the southeast coast of County Wexford, Ireland, and was constructed to warn shipping of the perilous shoal, which has probably wrecked more ships than any other Irish coastal feature. The Tuskar Rock lighthouse is a white cylindrical tower built from granite and standing 120 feet (34m) tall. During construction in October 1812, a storm struck and washed away temporary barracks that housed the workmen, killing fourteen men, which was the worst such disaster in Ireland's history. Surviving workers clung to the island's slippery rocks for two days before a rescue party arrived. The light was automated in March 1993.

Year first constructed	1812
Height	34m

◀ Sumburgh Head Lighthouse:

Located on Sumburgh Head at the southern tip of the Mainland of Shetland, Sumburgh Head Lighthouse was built by Robert Stevenson in 1821. The site contains the cylindrical lighthouse tower, keepers' cottages, a workshop, and other buildings. Today, the lighthouse complex also has offices for the RSPB who look after the bird sanctuary in the vicinity. The light was automated in 1991 and the keepers' cottages were converted into holiday accommodation. The lighthouse complex underwent major restoration work in 2012.

Year first constructed	1821
Height	17m

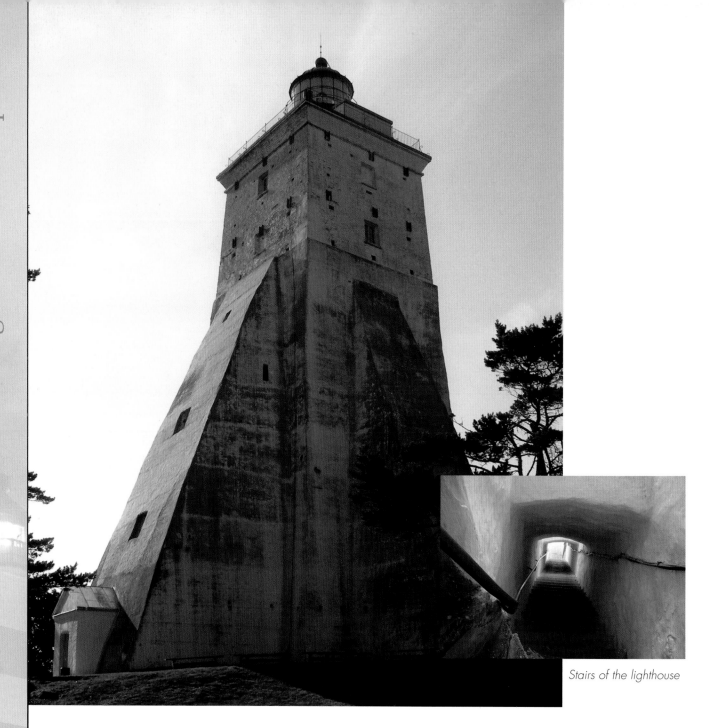

Stairs of the lighthouse

▲ Kõpu Lighthouse:

Located on the summit of the highest hillock of Hiiumaa island, Tornimägi, Estonia, the Kõpu Lighthouse is the highest coastal light on the Baltic Sea. It is one of the oldest lighthouses in the world, having been in continuous use since its completion in 1531, and enjoys iconic status in Estonia. The lighthouse marks the treacherous Hiiu sandbank and the light is visible from 26 nautical miles (48 km), although a radar replaced the lighthouse as the principal navigation aid in 1997. Kõpu Lighthouse has a rectangular, stone tower, with massive buttresses on all four sides. The tower is laid solely of stone up to the height of 79 feet (24m). The lantern house was originally reached using external wooden stairs, which were replaced with a stairway that was cut into the tower during restoration work in the 19th century.

Year first constructed	1531
Height	36m

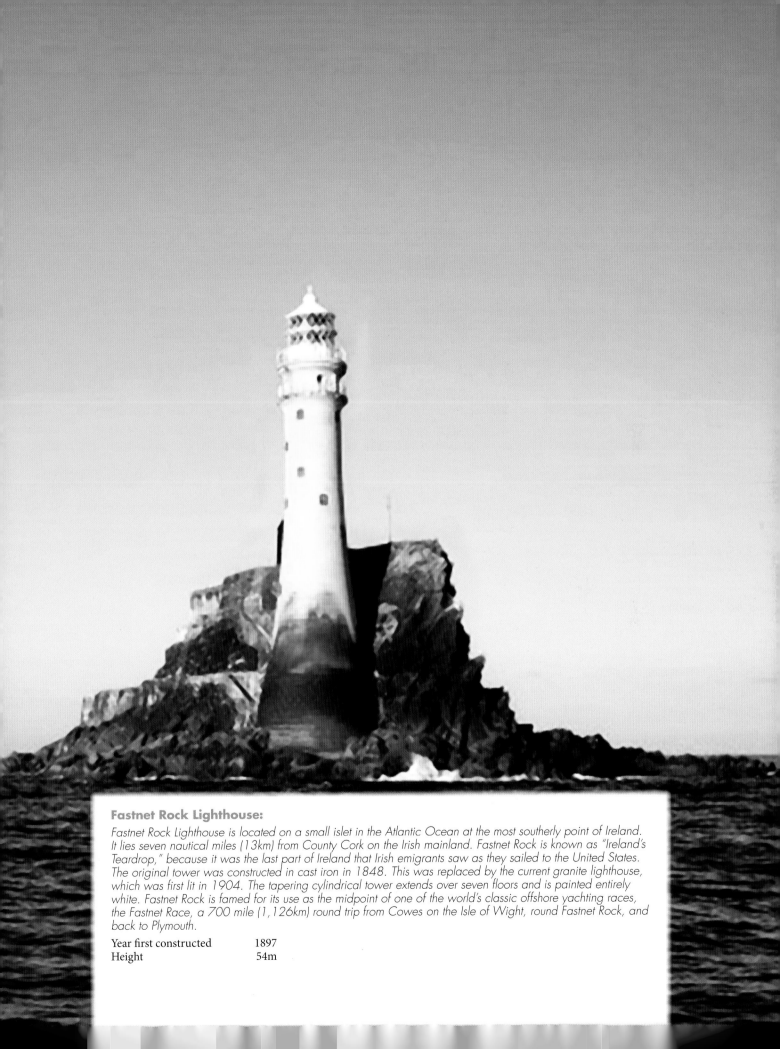

Fastnet Rock Lighthouse:

*Fastnet Rock Lighthouse is located on a small islet in the Atlantic Ocean at the most southerly point of Ireland.
It lies seven nautical miles (13km) from County Cork on the Irish mainland. Fastnet Rock is known as "Ireland's
Teardrop," because it was the last part of Ireland that Irish emigrants saw as they sailed to the United States.
The original tower was constructed in cast iron in 1848. This was replaced by the current granite lighthouse,
which was first lit in 1904. The tapering cylindrical tower extends over seven floors and is painted entirely
white. Fastnet Rock is famed for its use as the midpoint of one of the world's classic offshore yachting races,
the Fastnet Race, a 700 mile (1,126km) round trip from Cowes on the Isle of Wight, round Fastnet Rock, and
back to Plymouth.*

Year first constructed 1897
Height 54m

Lighthouses of
SOUTH
AMERICA

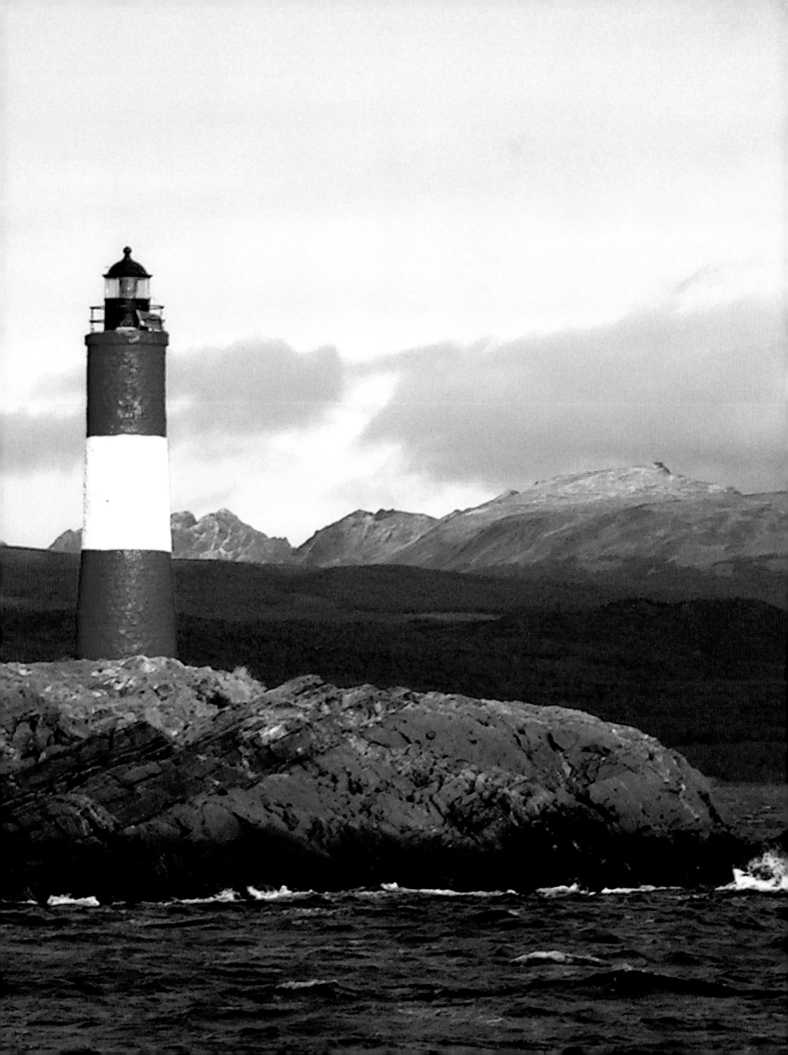

Also known as Touros Lighthouse, Calcanhar Lighthouse is an active lighthouse in Touros, Rio Grande do Norte, Brazil. It is the joint-seventeenth tallest lighthouse in the world, as well as the tallest in Brazil. The lighthouse is located on the beach of the Ponta de Calcanhar, near Touros, near the northern end of the cape of São Roque. It warns shipping of a coral reef located about four miles (7km) offshore. The reinforced concrete lighthouse has a tapering cylindrical tower strengthened by four vertical ribs. It is painted white with black bands, and a spiral staircase of 277 steps leads to an observation platform, from which a ladder provides access to the lantern house. The site also includes several lighthouse keepers's cottages and the station still has a resident keeper.

Year first constructed 1912
Height 62m

▲ El Rincón Lighthouse:

Located about 30 miles (48km) northeast of Pedro Luro on the Península Verde, El Rincón guards a principal entrance to the seaport of Bahía Blanca in Buenos Aires, Argentina. At a height of 203 feet (62m), it is the joint-seventeenth tallest lighthouse in the world, and the world's seventh tallest concrete lighthouse. The lighthouse has a tapering cylindrical, which is painted white with black bands, and has a double gallery.

Year first constructed 1925
Height 62m

▶ Recalada a Bahía Blanca Lighthouse:

Also known as the Monte Hermoso Light, the Recalada a Bahía Blanca Light is an active lighthouse in Monte Hermoso, Buenos Aires Province, Argentina, which marks the entrance to the port of Bahía Blanca. The skeletal, cast-iron tower, with its central cylinder, was prefabricated in France by the same company that built the Eiffel Tower in Paris. It was first lit on January 1, 1906. At a height of 220 feet (67m) it is the ninth tallest lighthouse in the world, and the tallest lighthouse in the southern hemisphere.

Year first constructed 1906
Height 67m

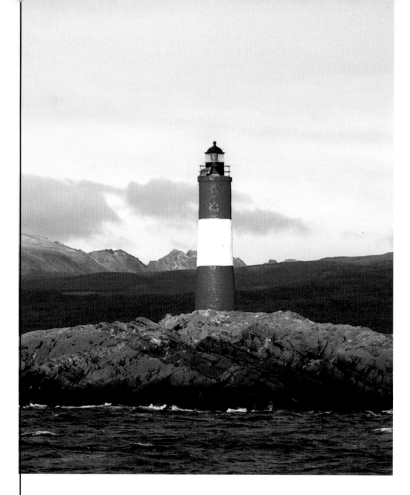

Preguiças Lighthouse:

Also known as the Mandacaru Lighthouse, Preguiças Lighthouse is located in the village of Mandacaru on the banks of the Preguiças River in Maranhão, Brazil. It was built to replace a deteriorated 85 foot (23m) skeletal lighthouse. The lighthouse has a tapering cylindrical tower strengthened by four vertical ribs. The tower is painted white with four black bands, and has a double gallery below the white lantern house. The lighthouse is situated within the grounds of the Lençois National Park, and is adjacent to two keeper's cottages, which are still occupied.

Year first constructed	1920
Height	35m

◂ Les Eclaireurs Lighthouse:

Les Eclaireurs Lighthouse is a tapering cylindrical lighthouse standing on the northeasternmost islet of the Les Eclaireurs islets, in the Beagle Channel, Tierra del Fuego, southern Argentina. The light was first lit on December 23, 1920, to mark the entrance to Ushuaia, which is commonly regarded as the southernmost city in the world. The brick-built tower is painted red with a thick white band and topped by a black lantern house and gallery. The active light has a range of 7.5 nautical miles (14km) and is now automated and powered by solar panels.

Year first constructed	1920
Height	10m

▸ Lighthouse of La Serena:

Known locally simply as El Faro, the Lighthouse of La Serena, north of Santiago, Chile, was built in 1950 as part of President Gabriel González Videla's administration's plan to revitalize the city of Serena, Chile's second oldest city after Santiago. The attractive tower was constructed in the neocolonial style and is enclosed by a square, castellated wall with turrets on each corner. By the turn of the millennium the lighthouse had fallen into a state of disrepair due to weathering and vandalism. Fortunately, a plan to restore the lighthouse was given the green light in 2011, when the lighthouse was declared a national monument.

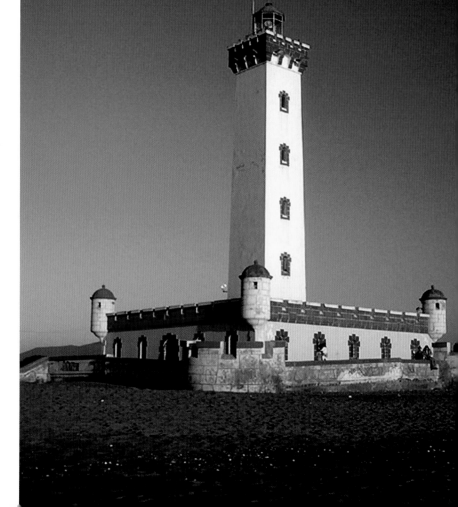

Year first constructed	1950
Height	28m

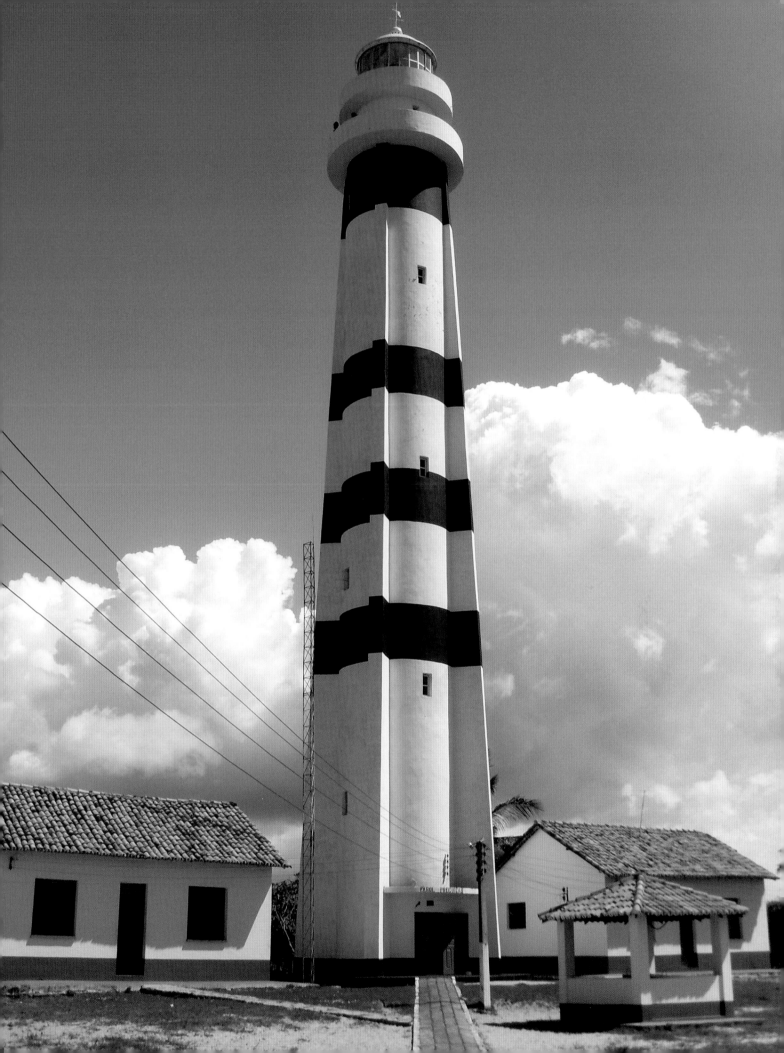

Lighthouses of
NORTH
AMERICA

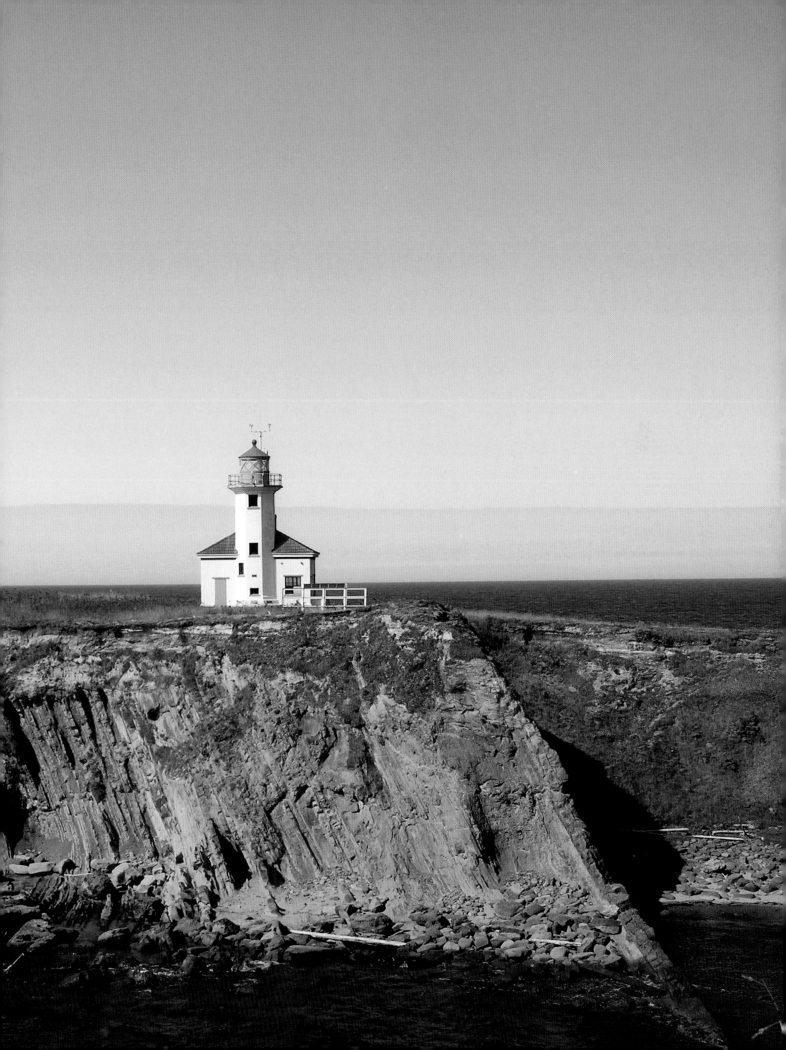

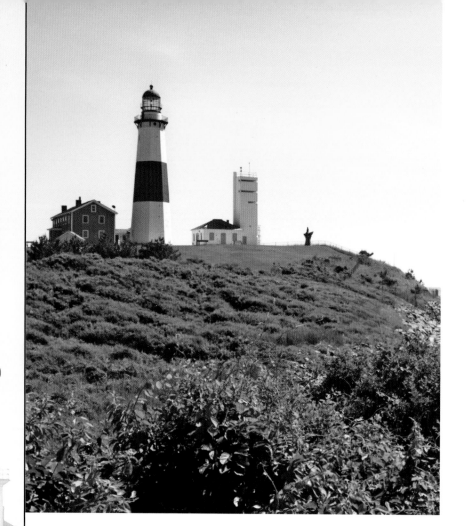

◄ Montauk Point Lighthouse:

Montauk Point Light is located at the tip of Long Island, New York, on a tortoise-shaped mound known as Turtle Hill. President George Washington and the Second Congress authorized construction on that sight in 1792. The first glimpse of America for many immigrants, Montauk Point Light has served as a beacon of hope for sailors and passengers alike. Strong walls, 7 feet thick at the base, and a deep foundation have fortified this monument against the ravages of storms.

Year first constructed	1796
Height	33.5m
Location	New York

►► Peggy's Point Lighthouse:

The town bordering on St. Margaret's Bay became known as Peggy's Cove, perhaps as an affectionate nickname for the bay or, as the region's tales suggest, because of an inspiring shipwrecked girl who swam her way to safety on the coast many years earlier. In any case, the sturdy octagonal tower built there in 1914 and the lively local folklore of the surrounding community attract throngs of visitors following the scenic Lighthouse Route that runs along the south shore of Nova Scotia from Halifax to Yarmouth.

Year first constructed	1868
Height	13m
Location	Nova Scotia

► Alcatraz Island Lighthouse:

The U.S. government commissioned Francis Gibbons to build a lighthouse on the island because it was directly in line with the Golden Gate and could guide vessels through the strait into San Francisco Bay. The short tower of the Cape Cod–style lighthouse rose from the center of the keeper's quarters, and its light provided guidance to the booming maritime traffic of the Gold Rush. Later demolished to build a military fortification, and then a federal prison, the original Alcatraz Island Light was the first lighthouse on the Pacific coast. Its successor, an 84-foot concrete tower, stands next to the now-abandoned cells of the infamous penitentiary.

Year first constructed	1854
Height	65m
Location	California

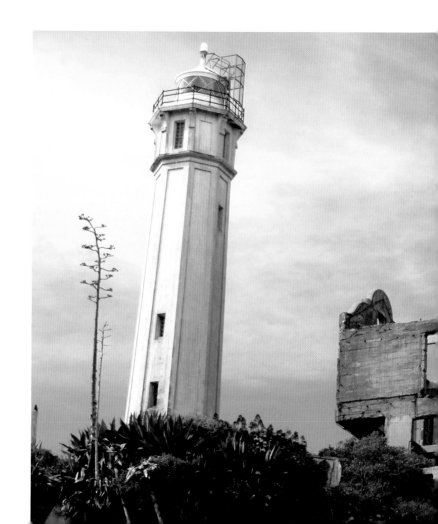

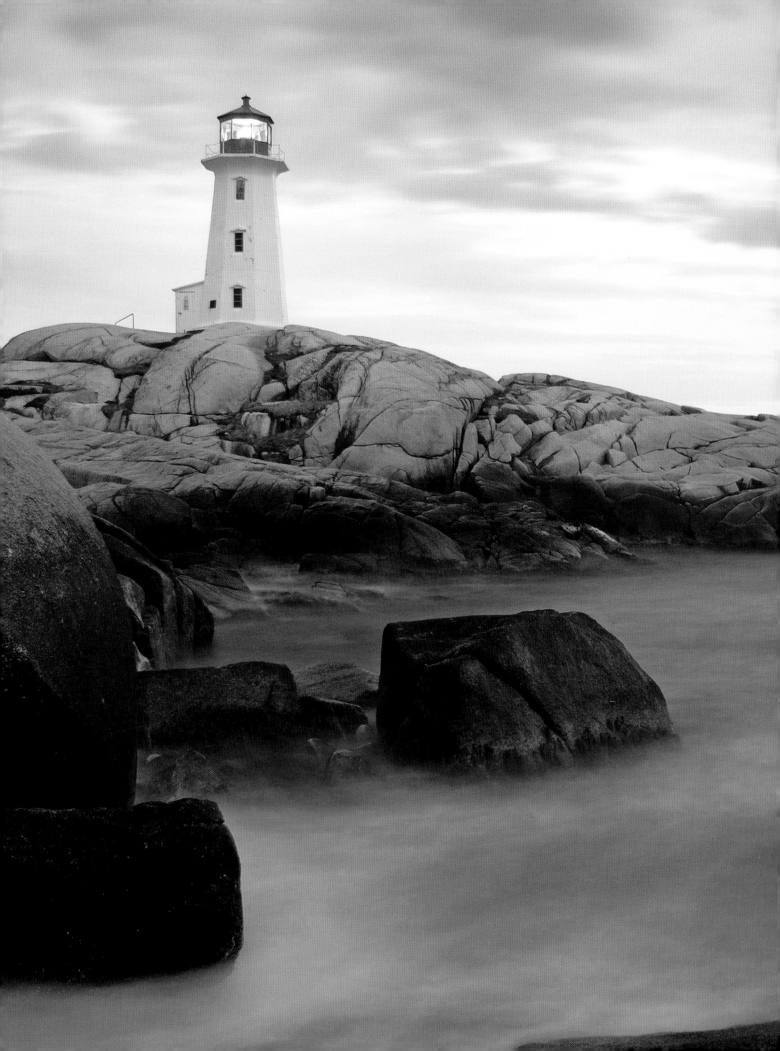

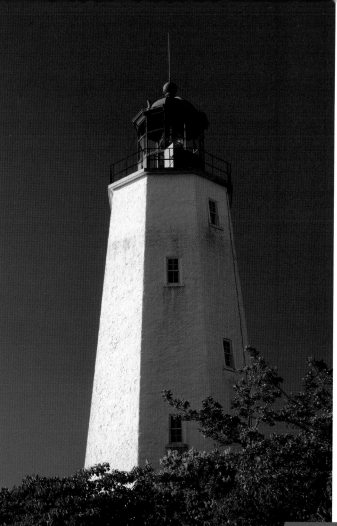

◀ Sandy Hook Lighthouse:

The oldest functioning lighthouse in the United States, the beacon at Sandy Hook has marked the entrance of New York Harbor since 1764. Money for the project was raised by lottery, and Isaac Conro oversaw the construction of the octagonal, rubble-stone tower. Early in the Revolutionary War the British occupied the tower. Daring rebel artillery soldiers sought to destroy this strategic asset to no avail; the cannon balls the men fired just bounced off the sturdy sentinel. Instead of being endangered by erosion, Sandy Hook Light is experiencing littoral drift. The structure, originally 500 feet from the ocean, now resides almost 1.5 miles from the shoreline.

Year first constructed	1764
Height	25.9m
Location	New Jersey

▶▶ Point Cabrillo Lighthouse:

Sailors called the agile vessels that could navigate the narrow passages and ports along the California coast "doghole schooners," because they squeezed like nimble dogs through the tight waterways. Traffic from these and other vessels increased as San Francisco sought lumber from the Mendocino sawmills to rebuild after the Great Earthquake of 1906. That same year, Congress approved $50,000 for a light at Point Cabrillo. The lighthouse, completed in 1909, resembles a church; its octagonal tower rises from a one-and-a-half-story fog signal station. Many of the original support buildings have been restored, including the blacksmith shop, oil house, and the keeper's dwelling, which now serves as a museum.

Year first constructed	1909
Height	14.3m
Location	California

▶ Gibraltar Point Lighthouse:

Gibraltar Point Light hovers over the Toronto harbor of Lake Ontario. A beautiful 52-foot tall stone tower was erected in 1808 and then raised to 82 feet in 1832. The original exterior structure is intact, and much of the interior architecture— including the Douglas fir stairs that spiral to the lantern—has been in place since 1870. Stories of the first keeper, a friendly, beer-brewing fellow, and his heinous murder on a blustery night keep visitors coming. Some have claimed to have heard the sound of something large and heavy being dragged up the tower stairs.

Year first constructed	1808
Height	25m
Location	Toronto

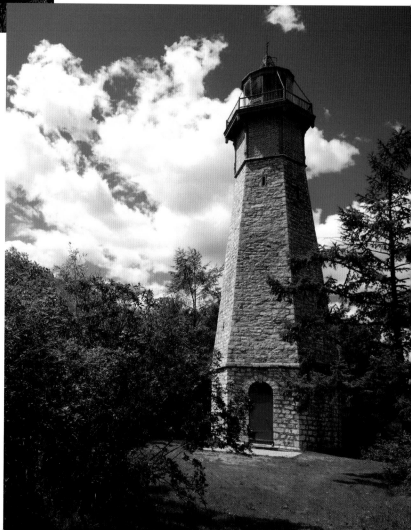

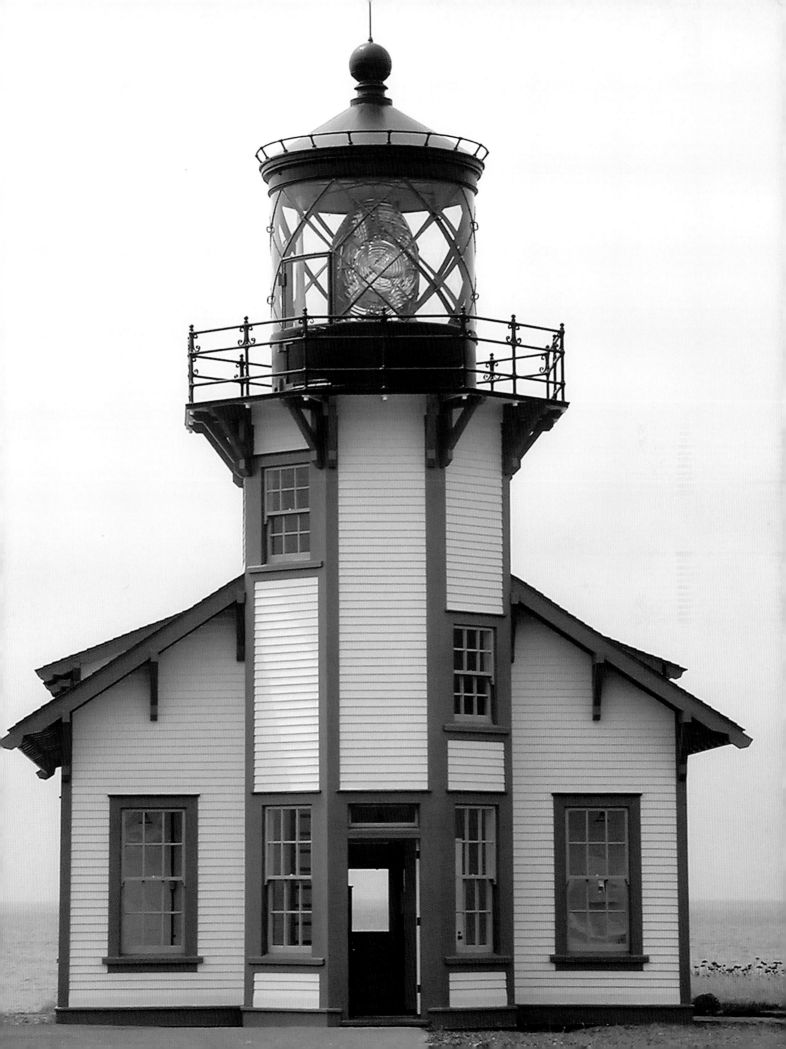

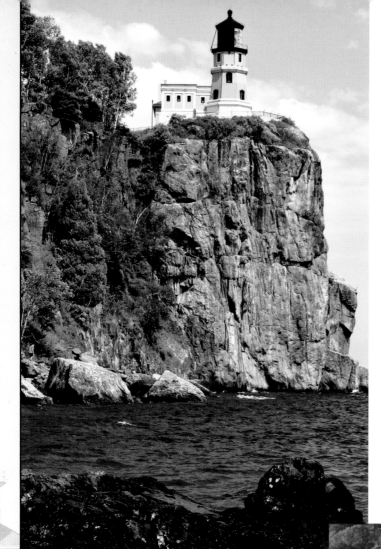

Split Rock Lighthouse:

A single blizzard in 1905 damaged 29 of U.S. Steel's carrier fleet. Two vessels wrecked on the rocky north shore of Lake Superior, and not long after the disaster, a delegation headed by the president of the company began lobbying for a lighthouse there. In 1907 Congress responded by appropriating $75,000 for a lighthouse and fog signal. Locally known as Stony Point, the imposing cliff 3 miles from the Split Rock River was chosen as the site for the new lighthouse that was completed in 1910. After years of service, the light was placed in the care of the Minnesota Historical Society. The group took over the stewardship of the lighthouse and the 25-acre historic site in 1976.

Year first constructed	1910
Height	16.4m
Location	Minnesota

Cape Henry Lighthouse:

In its first session in 1789, the U.S. Congress commissioned the sandstone tower that marks the south side of the entrance to the Chesapeake Bay. The light station, completed in 1792, was deemed unsound 80 years later, due to large cracks on six of the eight walls. A new cast-iron tower, built in 1881, stands 350 feet from its predecessor. Contrary to the predictions of the inspector and the Lighthouse Board, the sturdy stone edifice did not crumble, nor was it swept into the sea. It stands upright and enduring, and the contrast between the younger and older towers attests to the strength of the past and the innovations of the future.

Year first constructed	1792
Height	50m
Location	Virginia

Bald Head Island Lighthouse:

A haven for rogues, such as Stede Bonnet, the gentleman pirate, and his sometime partner, Blackbeard, the Frying Pan Shoals doomed many ships to a watery grave. Ship captains traveling the waterways called for an official light that could not be hijacked by conniving looters that tried to trap unwary vessels in the waters off Cape Fear. Bald Head Island, named for its smooth south-side dunes that resemble a bare head, was chosen for North Carolina's first lighthouse. The second light constructed at this site still stands and is known as "Old Baldy" to locals. The station has gone in and out of service; the Lighthouse Board tried placing other beacons to better light the treacherous shoals. The mottled tower is maintained by a local nonprofit group and exhibits historical artifacts that illuminate 400 years of the area's maritime history.

Year first constructed	1794
Height	30.48m
Location	North Carolina

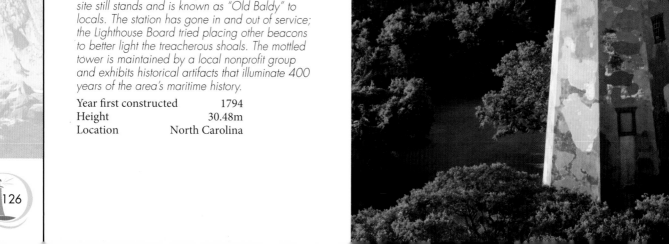

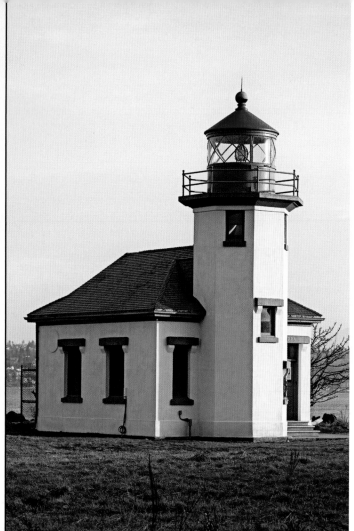

◄ Point Robinson Lighthouse:

Built in 1915, the Point Robinson Light sits on the halfway mark between Seattle and Tacoma on Maury Island. The light was fitted with a fifth-order Fresnel lens, which still resides in the lantern room today. The fog signal building, erected in 1885, is still there, too, but the signal has since been deactivated. The keeper's houses on the island were built prior to the light, the first in 1885, when the island acted as a fog station, and the second in 1907. With a 38-foot tower, the light can be seen 12 miles out at sea.

Year first constructed	1915
Height	12.1m
Location	Washington

►►Point Atkinson Lighthouse:

Although other nearby old-growth forests were razed in logging expeditions, navigational necessity preserved the stand of Douglas fir trees behind the lighthouse at Point Atkinson. The dark background of trees contrasted perfectly with the white tower and made it visible to vessels far out at sea. As a result, the picturesque lighthouse is surrounded by ancient sylvan crones, some five centuries old, that stand in awesome monument to times gone by. The current lighthouse was built in 1912, but a light has shone at the point since 1874.

Year first constructed	1874
Height	18.2m
Location	British Columbia

► Harbour Town Lighthouse:

A privately financed tourist attraction, Harbour Town Lighthouse is the brainchild of Charles Fraser, who developed Hilton Head Island as a resort community. The lighthouse, built in 1970, is the backdrop to Harbour Town Golf Links and has become the symbol of the exclusive Sea Pines development, as well as the entire Hilton Head area. When visitors climb to the top of the 90-foot tower they are afforded a breathtaking view of the harbor, as well as access to the Top of the Lighthouse, a shop that sells souvenirs, jewelry, and Hilton Head collectibles.

Year first constructed	1970
Height	27.4m
Location	South Carolina

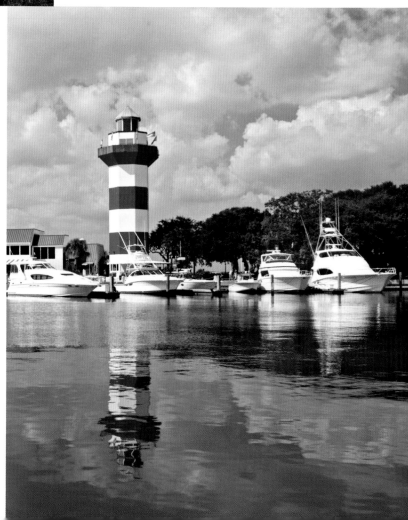

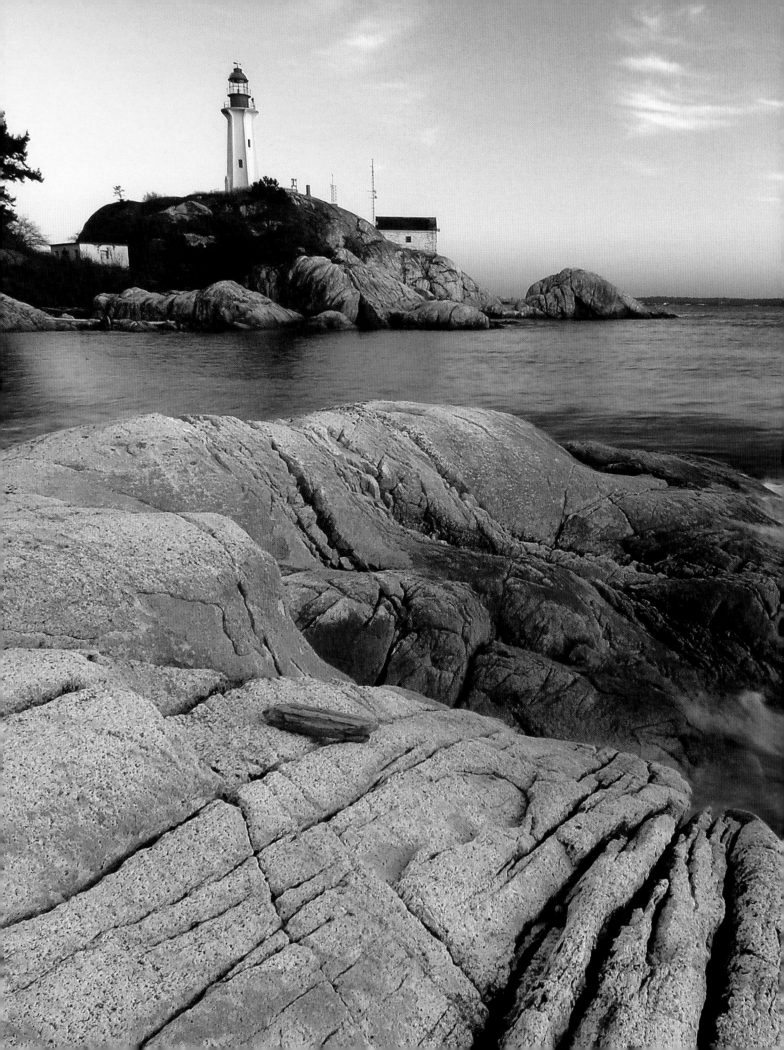

▾ Mukilteo Lighthouse:

One of the few wooden-frame beacons to reach its 100th birthday, the Mukilteo Light Station was built using the design of C. W. Leick and resembles the lighthouses at Ediz Hook and Cape Arago. Named for a Snohomish Indian word for "good camping place," Mulkiteo was the meeting ground for Governor Isaac Stevens and the heads of 22 Puget Sound tribes who came together to create the Treaty of Point Elliot. The lighthouse took up residence about 11 years later and currently sports a fog signal with a remote sensor and a fixed fourth-order Fresnel lens. The local historical society has taken over the care of the light and makes it available for tours and weddings.

Year first constructed 1906
Height 9.1m
Location Washington

▸▸ Block Island Southeast Lighthouse:

Said to be haunted by the disgruntled wife of one of the light's keepers, Block Island Southeast was built in 1875. It housed a first-order Fresnel lens. The light characteristic was changed in 1929 to a flashing green light every four seconds. The Block Island Southeast light survived a hurricane in 1938, and the following year a ship was grounded on the shores in front of the light. In 1990, the light was deactivated, but four years later, after several renovations and being relocated 300 feet inland, it was relit and remains an active aid to navigation.

Year first constructed 1875
Height 15.85m
Location Rhode Island

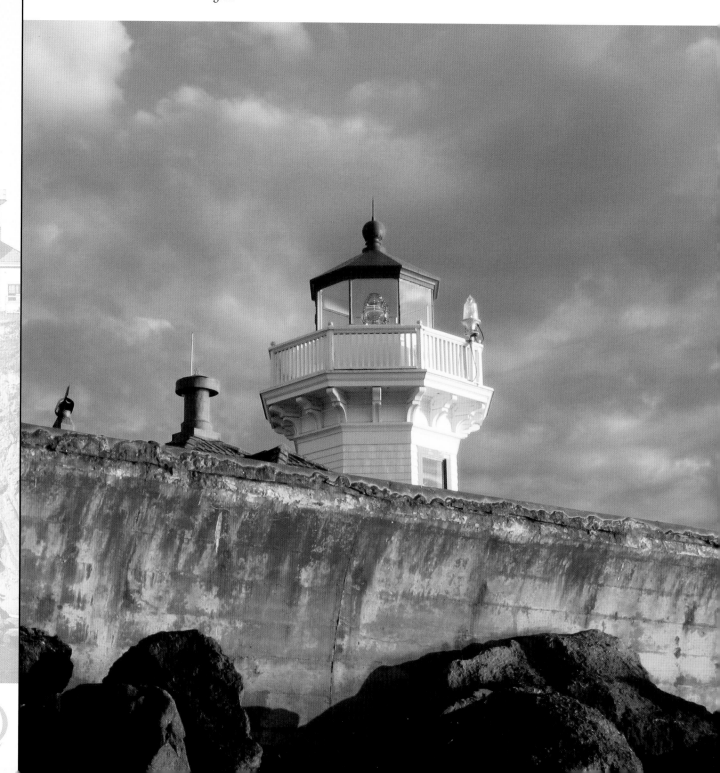

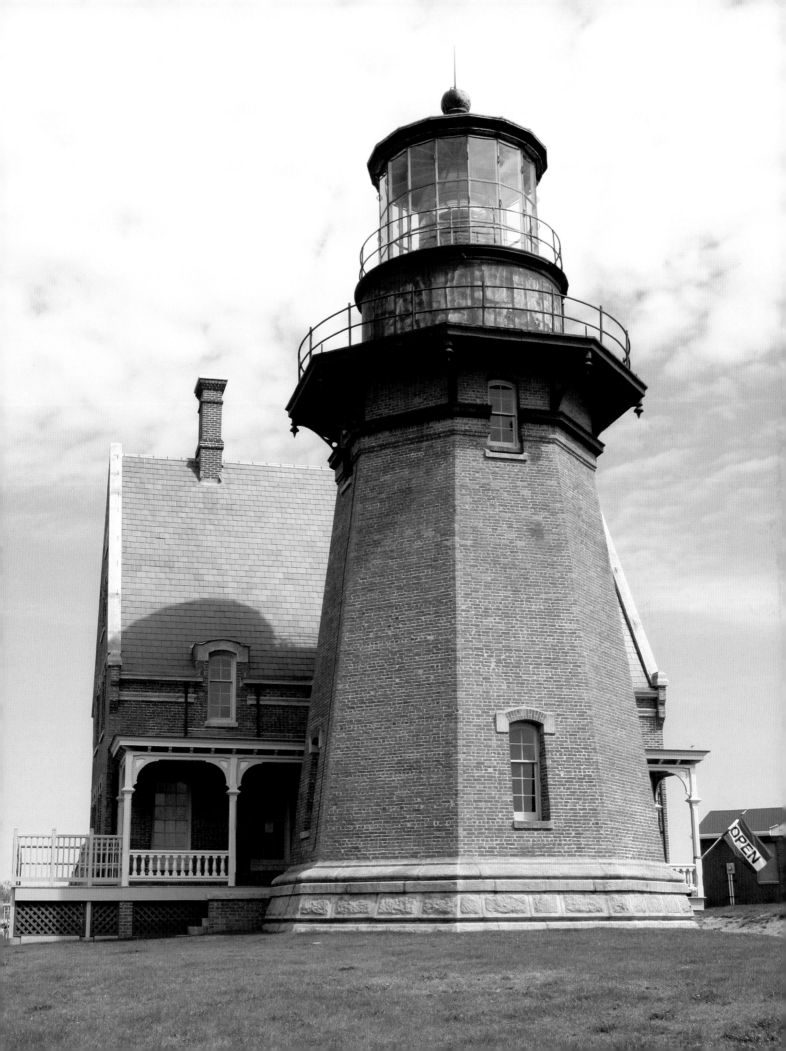

▼ Rawley Point Lighthouse:

Before a brick tower was erected on Rawley Point, 26 ships met sorry fates on its rocks. The worst tragedy occurred in 1887, when the steamship Vernon sank, taking 36 crew members and passengers with her. The light tower, along with an accompanying keeper's house, served mariners until 1894, when a steel tower was built to replace the old brick one. The new tower, which hails from the Chicago World's Fair of 1893, still stands. Its skeletal structure resists the high winds that whip the coast of Lake Michigan. Rawley Point Light is the second tallest in Wisconsin and one of the brightest; its beams are visible as far as 19 miles away.

Year first constructed	1853
Height	33.8m
Location	Wisconsin

▶▶ Whitefish Point Lighthouse:

The oldest active light on Lake Superior, Whitefish Point Light has a steel framework that battles the strong winds of the area with a streamlined grace. The tower, although utilitarian and modern in appearance, was actually built in 1861. The marker at the site states that "the point marks the course change for ore boats and other ships navigating this treacherous coastline to and from St. Mary's Canal." The current structure at Whitefish Point was preceded by a 65-foot stone tower completed in 1849. This light was quickly replaced in response to the boom in maritime traffic caused by the new lock at Sault Ste. Marie.

Year first constructed	1848
Height	23.1m
Location	Michigan

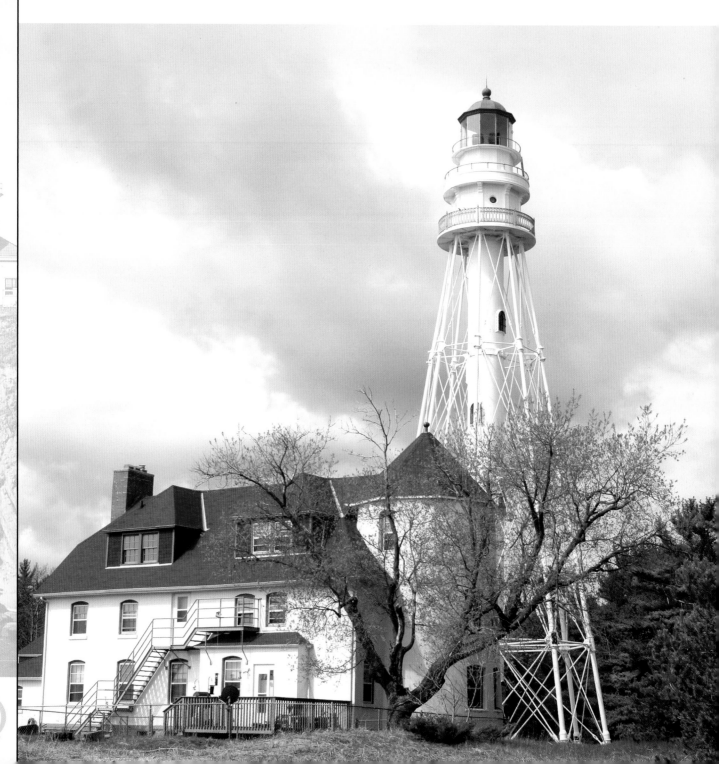

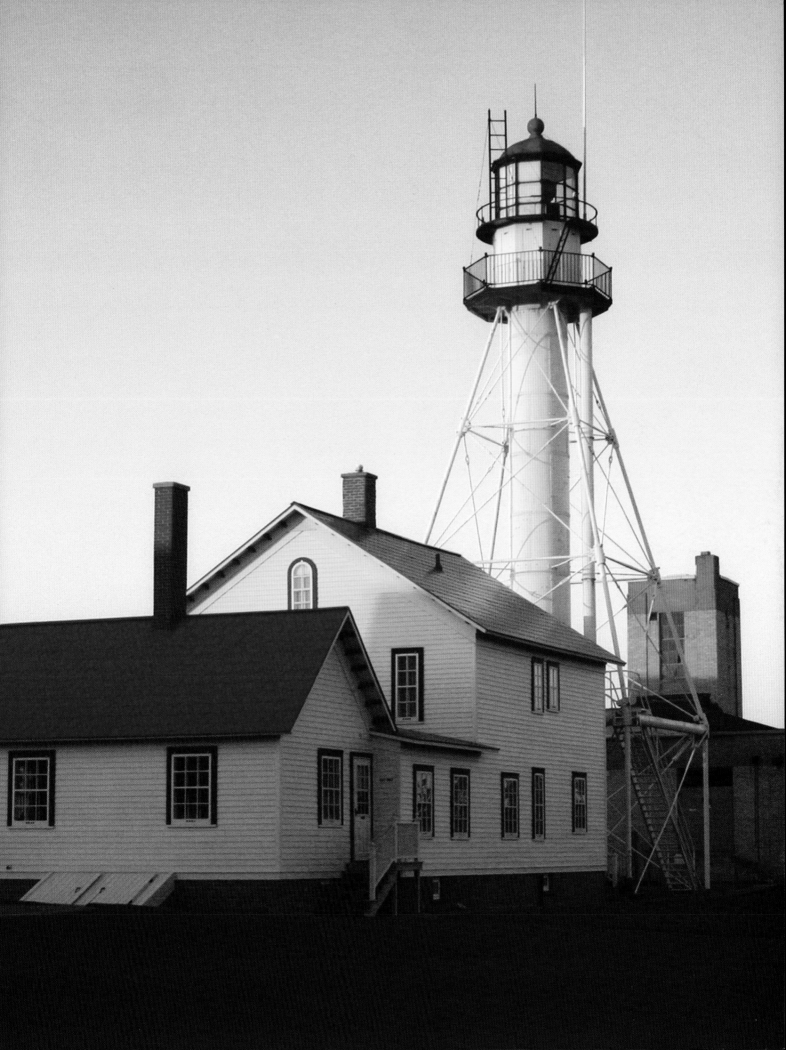

▾ Fisgard Lighthouse:

Fisgard Lighthouse, erected by the British in 1859–1860, is the oldest light on the west coast of Canada. The beacon served as sentinel of the British's Pacific squadron and now marks the home base of the Royal Canadian Navy. Fisgard and her sister station at Race Rocks guide vessels through the entrance of the Esquimalt Harbour, a port that boomed with trade in the wake of the Fraser gold rush. The light is an active aid to navigation, and the keeper's quarters house exhibits on lighthouses and local maritime history.

Year first constructed	1860
Height	14.6m
Location	British Columbia

▸▸ Point Arena Lighthouse:

A star of a lighthouse, Point Arena was featured in the 1982 film Treasure, as well as Mel Gibson's Forever Young in 1992. The tall tower, built by smokestack engineers, stretches up an impressive 115 feet and affords visitors a bird's-eye view from the top. Point Arena Lighthouse is located directly above the San Andreas Fault. Movements at this uneasy juncture of tectonic plates destroyed the original lighthouse, as well as devastated nearby San Francisco in the 1906 earthquake. The current tower, completed in 1908, was the first steel-reinforced concrete lighthouse in the United States.

Year first constructed	1870
Height	35m
Location	California

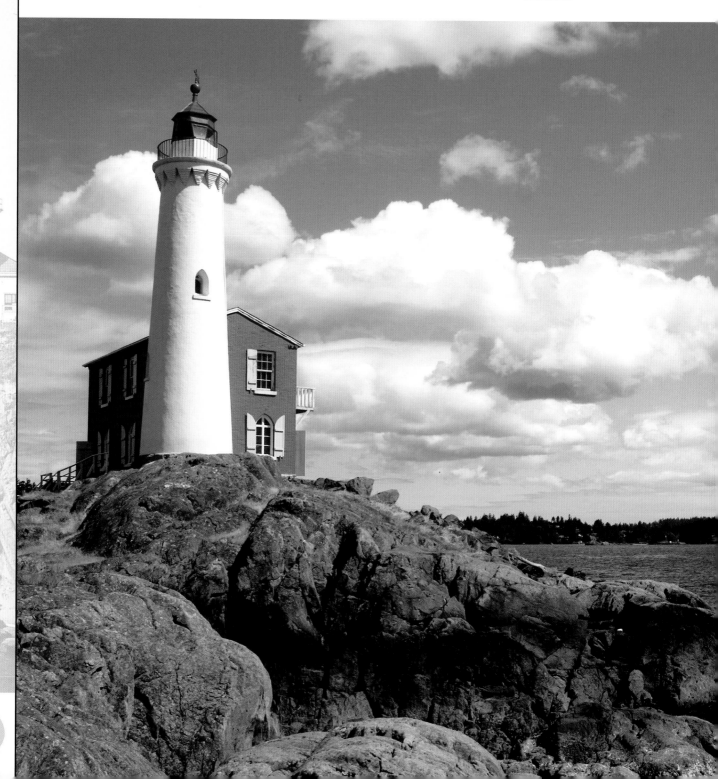

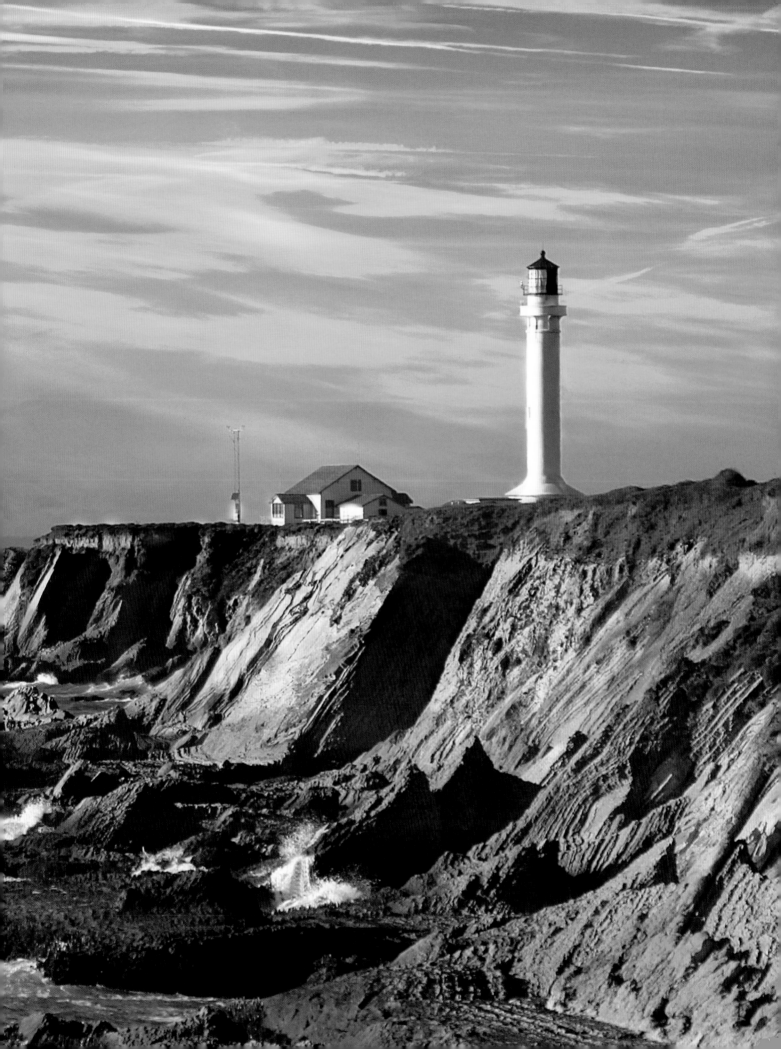

▾ Ponce de Leon Lighthouse:

Soaring to 175 feet, the Ponce de Leon Inlet Lighthouse ranks as the second tallest lighthouse in the United States. The Mosquito and Indian rivers empty into the waterway, making it a key locale for trade. In 1830, local plantations called for a lighthouse to aid in the transport of oranges, rice, and cotton to distant shores. Winslow Lewis was commissioned to build the lighthouse, but like many of his other construction projects, the hastily built, poorly planned beacon soon succumbed to the ravages of weather. More than a million bricks were used to create the foundation, the inner walls, and the outer walls of the replacement tower, which did not see completion until 1887. Beautifully restored and well maintained, the current station houses exhibitions of historical significance and offers visitors a rare opportunity to view a revolving Fresnel lens at work.

Year first constructed 1887
Height 53.3m
Location Florida

▸▸ Yaquina Head Lighthouse:

One of the most visited lighthouses on the West Coast, Yaquina Head Light is located 3 miles north of the entrance to Newport's Yaquina Bay. The outcropping of rock that provides the foundation to this notable tower is composed of magnetized iron that wreaks havoc on compasses that guide vessels through these waters. The lighthouse, built in 1873, steadies the course of the shipping traffic with beams that reach 19 miles out to sea. Yaquina Head Light has the distinction of being the tallest lighthouse tower in the state of Oregon.

Year first constructed 1871
Height 28.3m
Location Oregon

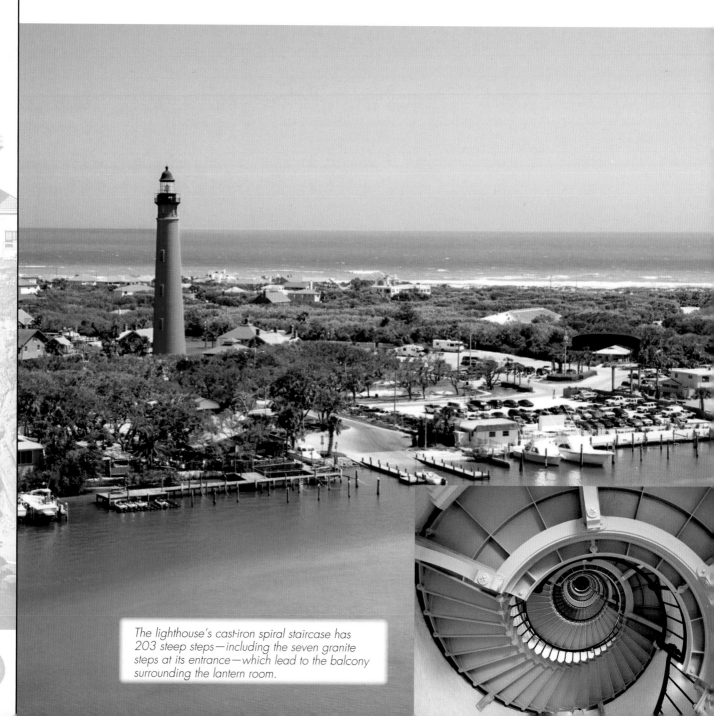

The lighthouse's cast-iron spiral staircase has 203 steep steps—including the seven granite steps at its entrance—which lead to the balcony surrounding the lantern room.

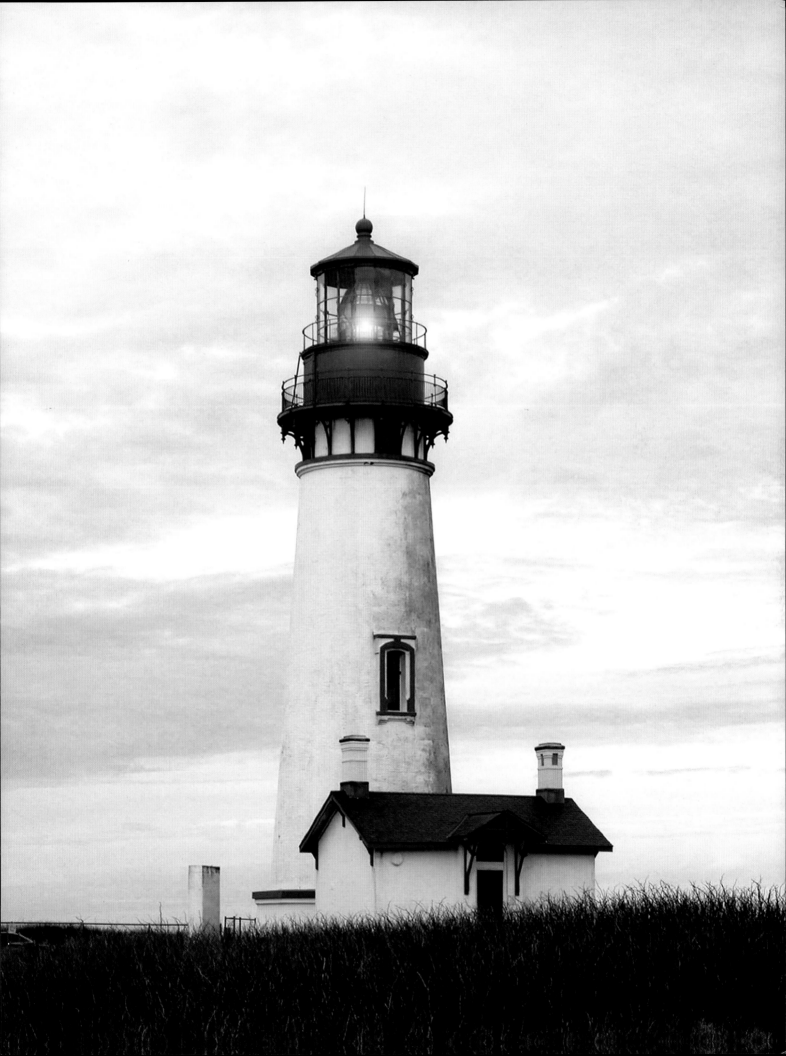

▸▸Heceta Head Lighthouse:

Heceta Head Lighthouse still uses its original first-order Fresnel lens and casts the strongest beam of any lighthouse on the Oregon coast, sending rays that reach 21 miles out to sea. Both the lighthouse and the duplex that originally housed the first and second assistant lighthouse keepers are considered architecturally significant and are on the National Register of Historic Places. The construction cost the federal government $180,000, a colossal sum in the 1890s. The endeavor involved shipping materials to a drop-off point on the nearby Suislaw River and then carting supplies by mule to the steep bluff. A friendly ghost named Rue is said to wander the grounds, and visitors can hope to make her acquaintance while sojourning at the keeper's residence that has since been converted to a bed and breakfast.

Year first constructed	1894
Height	17m
Location	Oregon

Heceta's light is a first-order Fresnel lens crafted in England in 1894, and it originally rotated with the help of a weighted pendulum. Although the original lens is still in operation, today an automatic motor powers the light's movement.

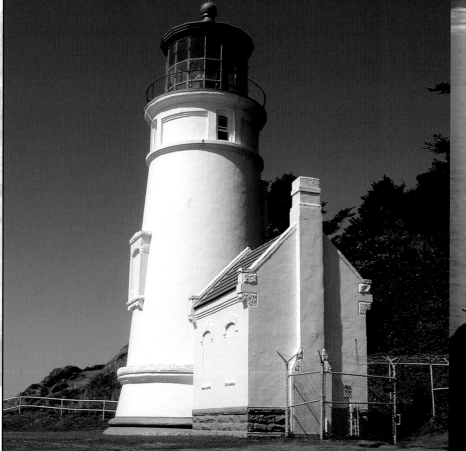

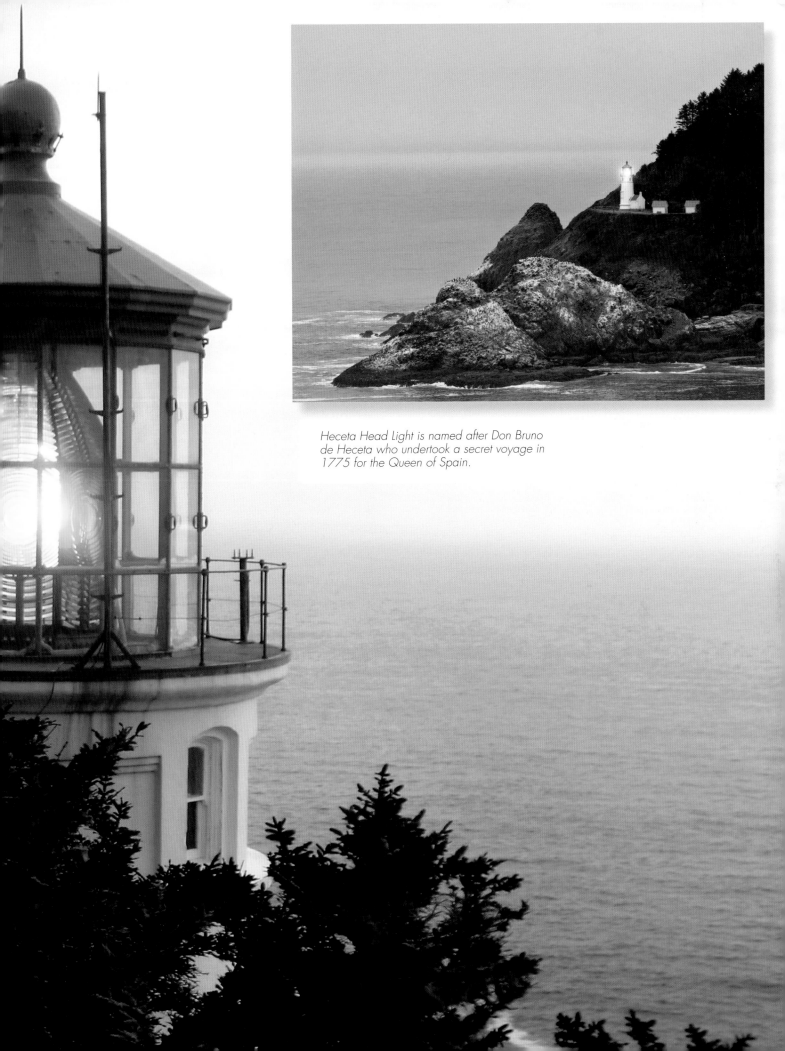

Heceta Head Light is named after Don Bruno
de Heceta who undertook a secret voyage in
1775 for the Queen of Spain.

Portland Head Lighthouse:

A favorite haunt of poet Henry Wadsworth Longfellow, the sentinel at Portland Head provided inspiration for his poem "The Lighthouse." The structure, originally built in 1791, has undergone myriad transformations: 20 feet were added to the tower's height and a second-order Fresnel lens was installed in 1864, following the wreck of the Bohemian. With the advent of a new lighthouse at Halfway Rock, the Portland station was deemed less important. The tower was shortened again, and the second-order lens downgraded to a weaker, fourth-order Fresnel. After complaints, the tower was restored to its former height in 1885. Despite its ups and downs, the light at Portland Head continues to endure stormy seas and steadfastly lights the way to the busy seaport.

Year first constructed	1791
Height	24.3m
Location	Maine

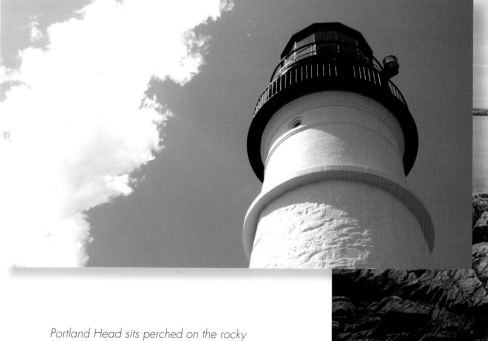

Portland Head sits perched on the rocky headline of the Maine coastland guarding Casco Bay. The red-roofed keeper's house accompanies this monumental pinnacle.

Dedicated to the eminent Revolutionary War general Marquis de Lafayette, v was the first major project tackled by the U.S. federal government in the late eighteenth century. President George Washington took interest and advised Congress to make the lighthouse a priority.

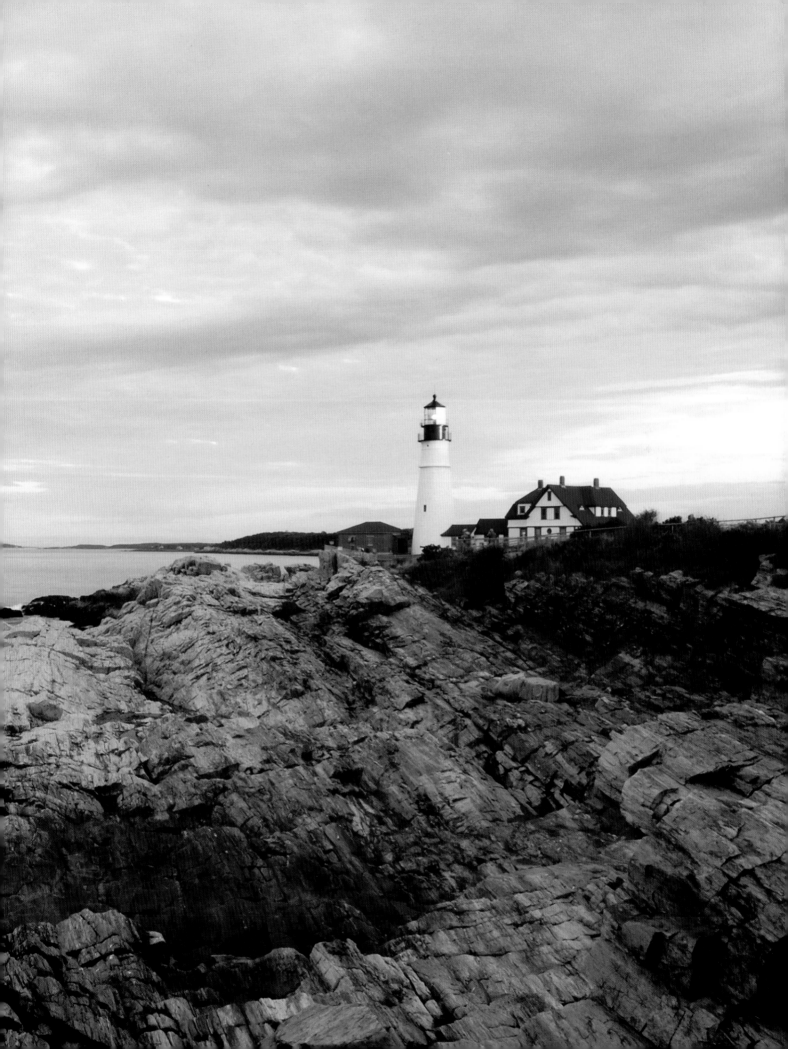

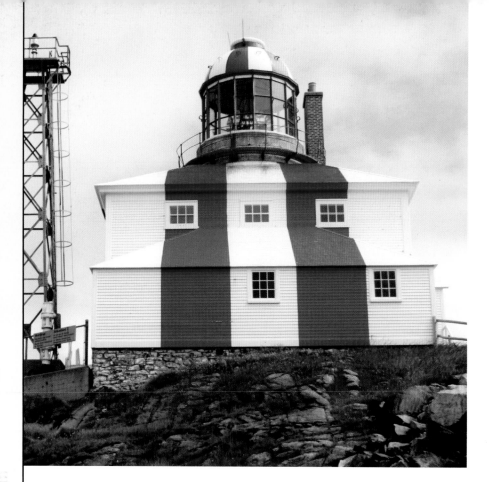

▶▶ Castle Hill Lighthouse:

The land at Castle Hill was sold to the federal government by oceanographer, naturalist, and zoologist Alexander Agassiz for the token amount of one dollar. However low his asking price, he cost the project dearly in time when he refused to allow the contractor to cross his property to access the location for the light. The Lighthouse Board and Agassiz finally came to an agreement, and the station was completed in 1890. The fog bell installed at the light was the source of more contention. Agassiz complained that the noise from the 1,300-pound bell was intolerable. A sound screen between the light and Agassiz's property became the eventual solution. The granite sentinel stands 34 feet tall, and its endurance is a testament to the skill of Henry Hobson Richardson, who is believed to have designed the structure.

Year first constructed	1890
Height	10.3m
Location	Rhode Island

▲ Cape Bonavista Lighthouse:

Legend has it that when John Cabot first saw land after his voyage across the Atlantic in 1497, he looked at the cape on the eastern coast of New Foundland and cried "Buona vista!" although there is some wrangling over whether the cape was indeed his first foray onto dry land, there can be no question about the beauty of the view at Cape Bonavista. The tower was built in 1873 and rises out of a keeper's dwelling that has been traditionally painted with red and white vertical stripes. The light and lens have been transferred to a skeleton tower nearby, which currently serves as the navigational aid for the area, and the old station houses a museum with historic artifacts from the lighthouse's early days.

Year first constructed	1873
Height	10.9m
Location	Newfoundland

▶ Bodie Island Lighthouse:

The first station at Bodie Island suffered from the incompetence and penny-pinching that was the signature of the Fifth Auditor of the Treasury. The unsupported foundation of the structure quickly became unstable, and the tower leaned increasingly off plumb. Within 11 years it was demolished. Its successor also met with an early demise when Confederate troops blew it up in an effort to sabotage the British occupation of North Carolina. In 1872, Dexter Stetson, having recently completed the Cape Hatteras Light, brought his expertise to bear on the construction of the final tower at Bodie Island. He employed his innovative method of driving timber pilings below ground to create a secure foundation in shifting sands. The work has held up admirably, and this last version of the Bodie Island Light shines on in the care of the National Park Service, as a private aid to navigation.

Year first constructed	1848
Height	51.8m
Location	North Carolina

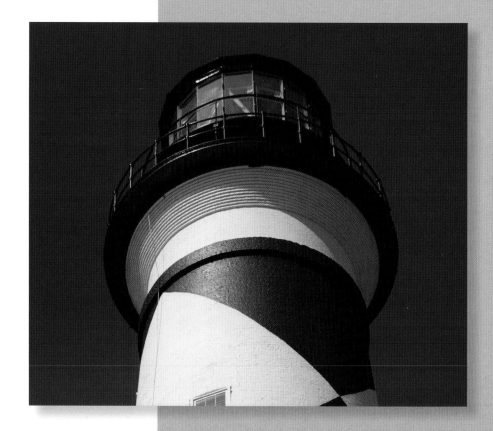

Cape Lookout Lighthouse:

Sailors in the first half of the nineteenth century complained that they were more likely to run aground looking for the weak light at Cape Lookout than be aided by its rays. The second tower, erected at the cape in 1859, greatly improved matters. Built of red brick and still an active aid to navigation today, the tower rises 169 feet, and its light is visible 19 miles out to sea, enabling it to effectively warn boats of the hazards of the Outer Banks. The lens was damaged and the light darkened during the battles of the Revolution. After the war ended, many repairs were made and cast-iron steps replaced the rotten wooden stairs. In 1873 the new keeper's quarters were completed, and the tower was painted with its signature black and white diamonds. Some say that this pattern was originally intended for Hatteras, to indicate proximity to the Diamond Shoals, but because of a mix-up it was painted on the light at Cape Lookout instead..

Year first constructed	1812
Height	51.5m
Location	North Carolina

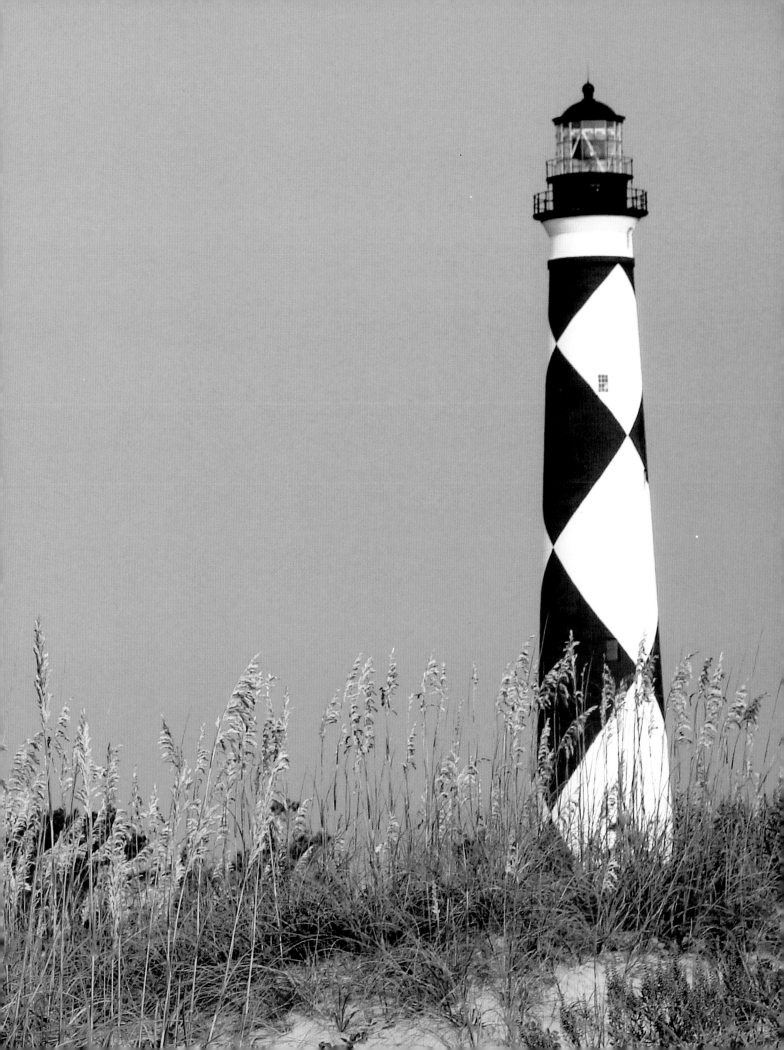

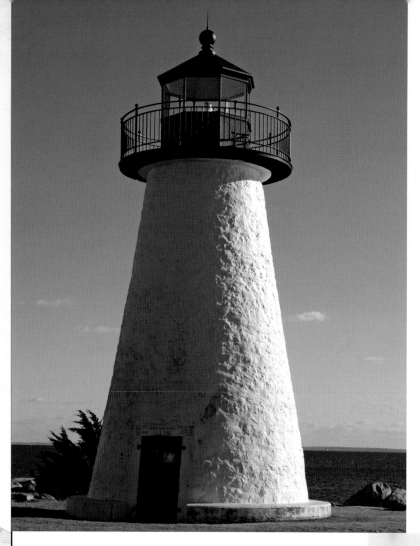

Cape Neddick Light, known as the Nubble, is located on Nubble Island off the coast of Maine. So many vessels foundered on this outcropping of rock when sailing to York Harbor that in 1879, the federal government erected a cast iron, brick-lined station to warn ships of the hazard. The tower could be accessed through a covered walkway from the keeper's quarters in inclement weather. Former keepers traveled over sandbars to the mainland at low tide, but this is currently considered too dangerous a practice for visitors. On a clear day, the vantage point from the top of the Nubble affords a view of Boon Lighthouse, which is more than 6 miles away.

Year first constructed 1879
Height 12.5m
Location Maine

▲ Ned's Point Lighthouse:

Legend has it that Ned's Point Lighthouse got off to a rocky start. Commissioned with the support of then congressman John Quincy Adams the lighthouse experienced a number of delays. The contractor, besides being a shipbuilder and running a salt works, managed a local tavern where he would reportedly lure inspectors to buy time when construction fell behind schedule. Early inspections of the lighthouse testify to a multitude of leaks that even extinguished the light in the lantern from time to time. Improvements such as a new lantern and replacement of old mortar have shored up any failings in the structure. The original tower, completed in 1838, still stands today.

Year first constructed 1837
Height 11.9m
Location Massachusetts

▶ Pigeon Point Lighthouse:

Pigeon Point was named for the clipper ship Carrier Pigeon, which met its demise on the rocky outcropping in 1853. Three subsequent shipwrecks in the 1860s persuaded Congress to approve a lighthouse at the spot. The tower, built in 1872, shares the honor of being the tallest lighthouse on the West Coast with the California's Point Arena Lighthouse. The intertidal zone just off the shore supports a great variety of life, including pods of gray whales that migrate through the area in late winter to early spring.

Year first constructed 1871
Height 35m
Location California

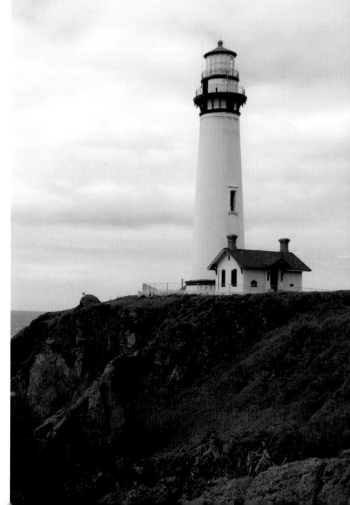

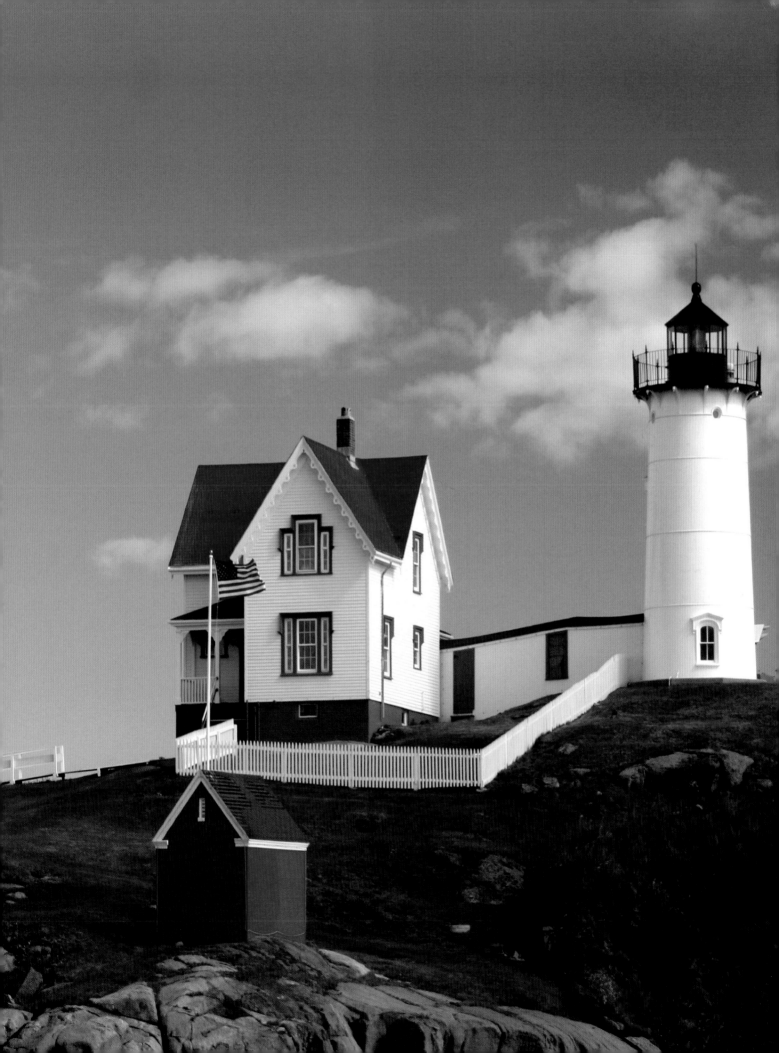

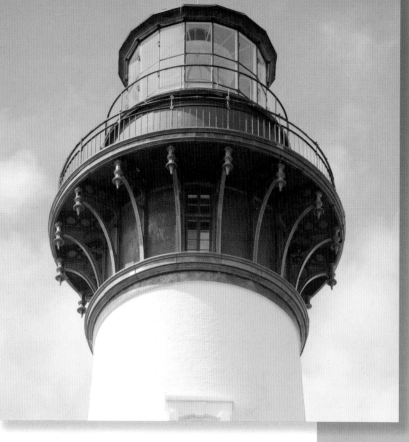

At the time it was built, Cape Hatteras was the tallest lighthouse in the world. Its light, replaced in 1972 with a DCB-24 lens, is visible every seven seconds.

Cape Hatteras Lighthouse:

Extending 14 miles off the coast of Cape Hatteras lie the Diamond Shoals—shifting sandbars that have caused the demise of more than 600 ships. It is here that the sunny Gulf stream and the frigid Labrador Current converge to create big swells and dangerous winds. The original light at Cape Hatteras, completed in 1803, was so weak that other ships mistook it for a steamer. Dubbed a "wretched light" by a Navy inspector in 1851, it was replaced by the 193-foot-tall tower capable of beaming 24 miles out to sea. The current structure is the tallest lighthouse in the United States and has warned ships of the treacherous "Graveyard of the Atlantic" since 1871. When the rising Atlantic and years of erosion jeopardized the foundation of the lighthouse, local organizations raised funds and moved the massive brick edifice farther inland, where it is at least temporarily safe from encroaching waters.

Year first constructed	1803
Height	60.9m
Location	North Carolina

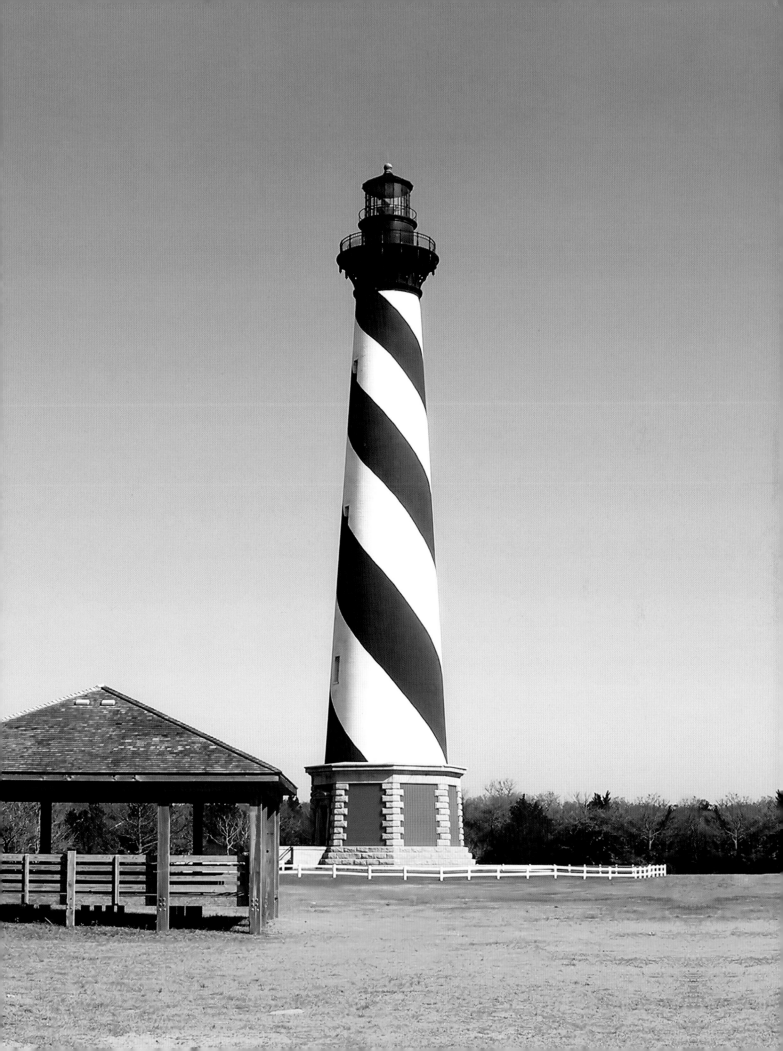

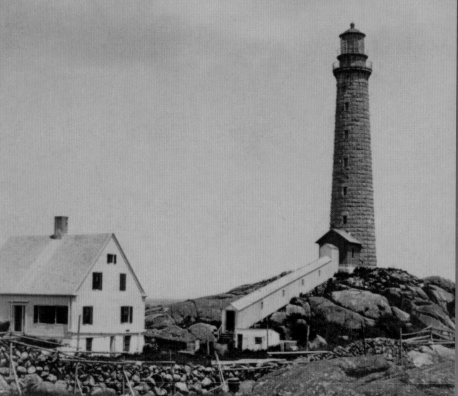

Known as "Thatcher's Woe" in remembrance of the catastrophic shipwreck, Cape Ann is among the oldest lighthouses on the New England coast. It was the last lighthouse to be founded during the Colonial era.

Cape Ann Lighthouse:

The only currently operating twin lights in the nation, the Cape Ann station has woven its place into U.S. history—from its dark days during the Revolutionary War when Tory keeper Captain Kirkwood was forcibly expelled—to the horn blast that warned President Woodrow Wilson's steamer of impending disaster in 1919. The twin lights are located on an island three quarters of a mile off the coast of Rockport, Massachusetts. The island was named for Anthony Thatcher, whose vessel, the Watch and Wait, was wrecked on the shores of the island during a violent hurricane in 1635. Twenty-one of the passengers, including Thatcher's four children, perished in the wreck. The only ones to survive the storm were Thatcher and his wife, Elizabeth.

Year first constructed	1771
Height	37.8m
Location	Massachusetts

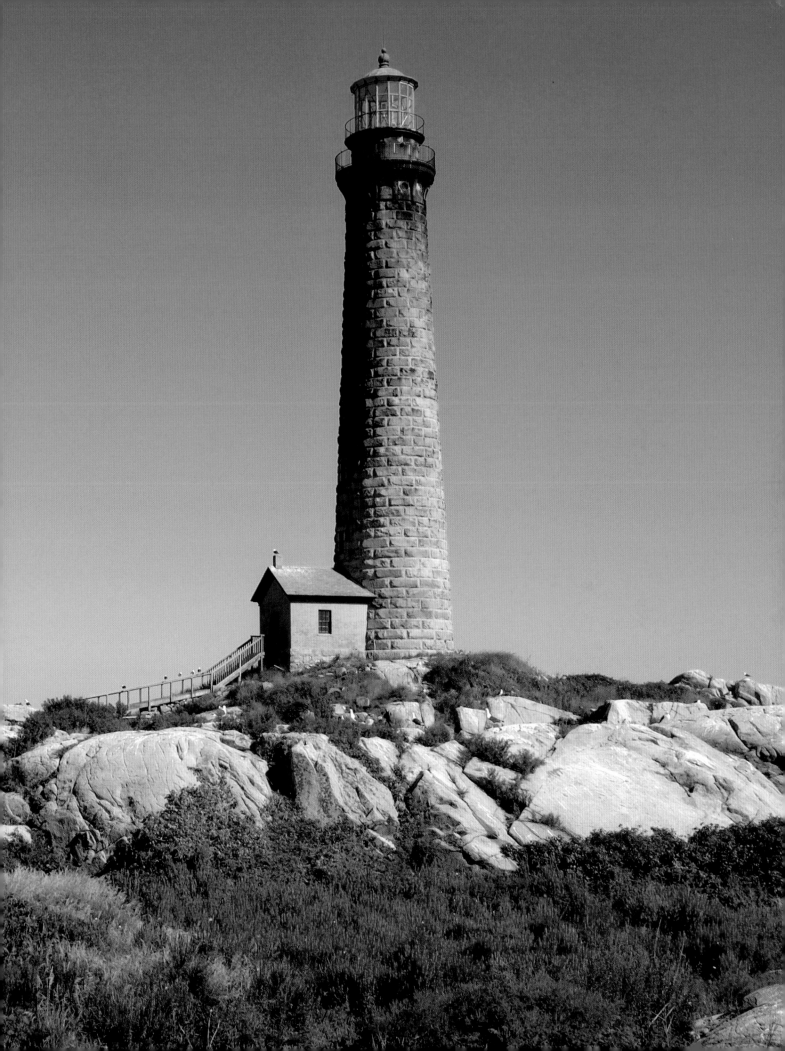

▼ Wind Point Lighthouse:

At the northern end of Racine Harbor sits Wisconsin's Wind Point Light, designed by General Orlando Metcalf Poe in 1880. Before the lighthouse was officially established, a lone tree was the only navigational marker on this portion of the southwest shore of Lake Michigan. The 108-foot tower has four arched windows under the gallery and a 10-sided cast-iron lantern. Besides operating as a beacon for ship captains, Wind Point Lighthouse and its keeper's quarters have served the community as a village hall and police headquarters since 1964.

Year first constructed	1877
Height	32.9m
Location	Wisconsin

One of the tallest and oldest lighthouses active on the Great Lakes, the bright white tower has 144 steps and soars above all trees and buildings that surround it.

After three years of construction, Wind Point Light was completed in 1880. It has guided vessels across the treacherous Racine Shoals with a beaming red light visible for a distance of 19 miles.

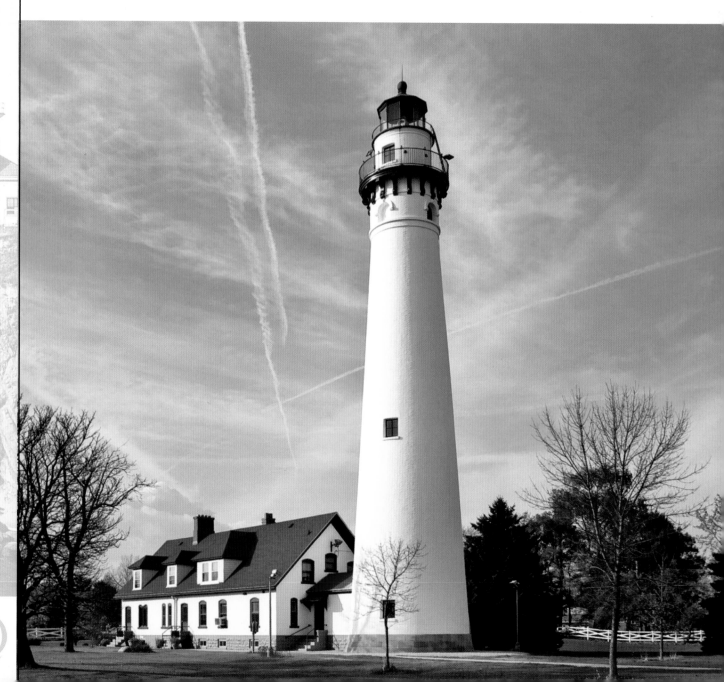

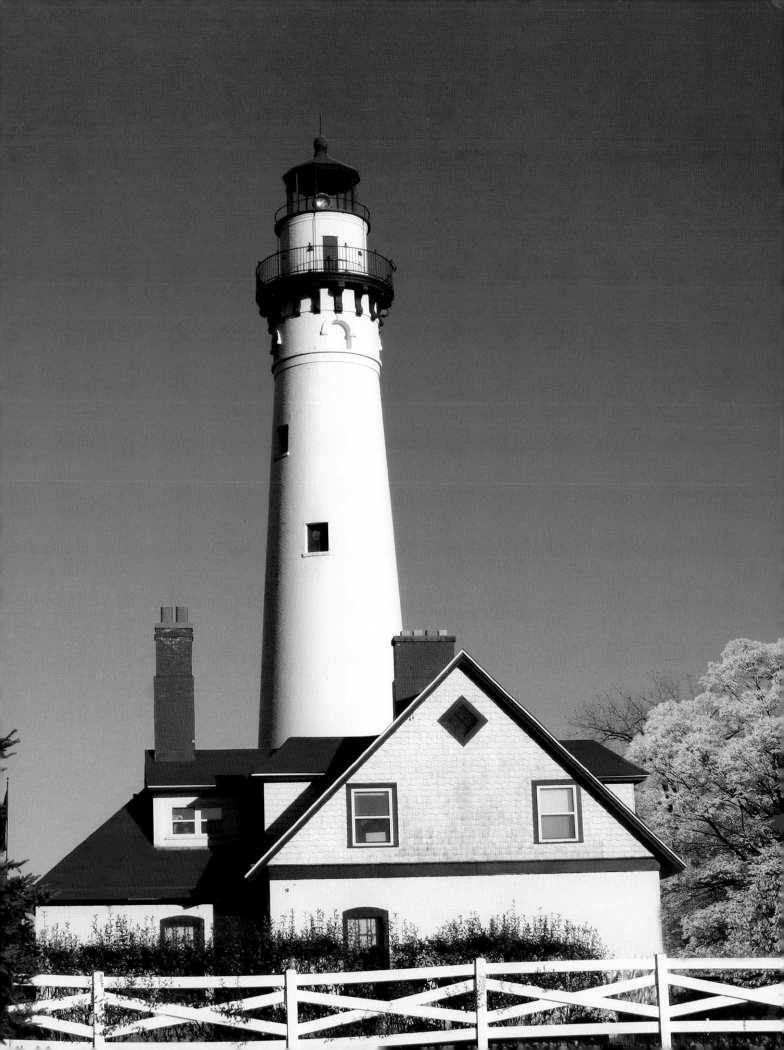

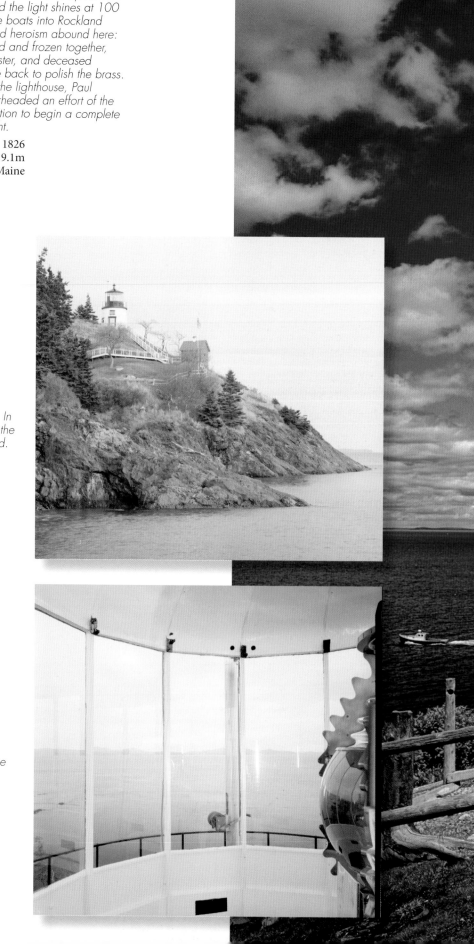

Owl's Head Lighthouse:

Anchored to a promontory whose craggy face was thought to resemble an owl, Owl's Head Light stands just 30 feet tall. The cliff's elevation makes up for the tower's diminutive height, and the light shines at 100 feet above sea level to guide boats into Rockland Harbor. Tales of romance and heroism abound here: lovers who were shipwrecked and frozen together, valiant dogs preventing disaster, and deceased lighthouse keepers that come back to polish the brass. In 2007 former residents of the lighthouse, Paul and Mary Ellen Dilger, spearheaded an effort of the American Lighthouse Foundation to begin a complete restoration of this notable light.

Year first constructed	1826
Height	9.1m
Location	Maine

In 1825 U.S. President John Quincy Adams sanctioned the building of Owl's Head Light. In 1989 the station became one of the last in the country to be automated.

The beacon's cylindrical tower with a black lantern has a fourth-order Fresnel lens that replaced the original lamps and reflectors in 1856.

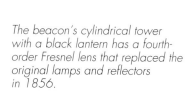

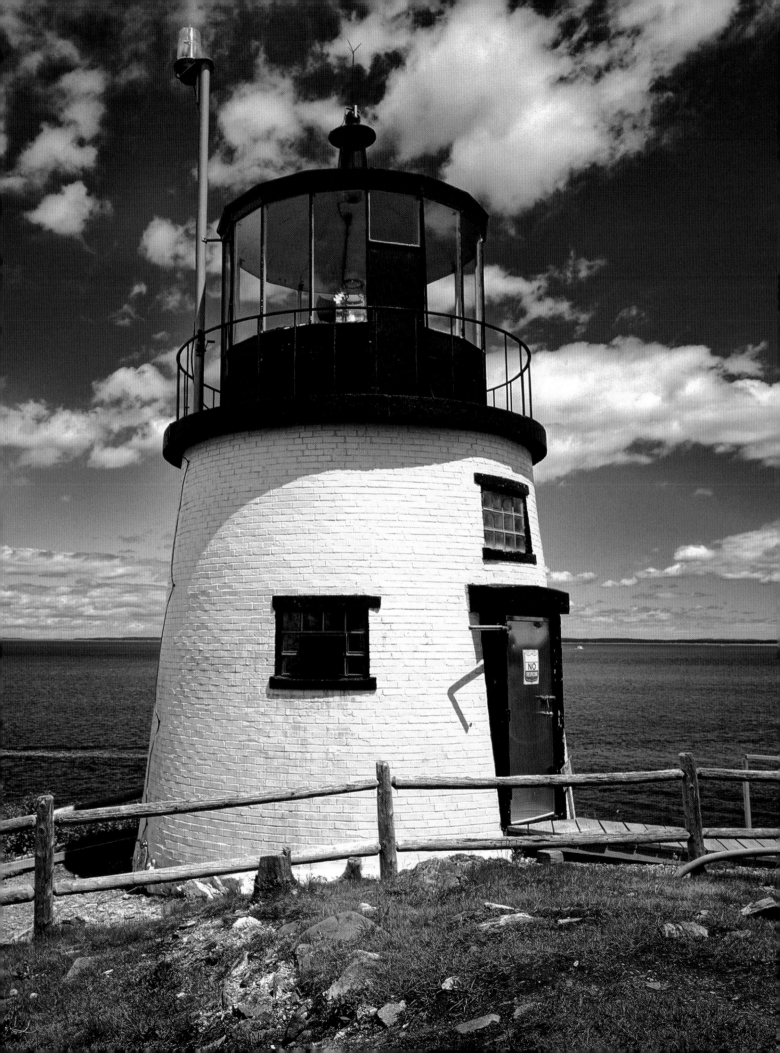

Three Sisters:

Dangerous sandbars off the coast of Nauset prompted the construction of three identical brick towers, 150 feet apart in 1837. The idea was that the light station be distinguishable from nearby lighthouses, the twin lights at Chatham and the single at North Truro. The Three Sisters, as the new towers, built by low-bidder Winslow Lewis, were called, came under criticism for being poorly constructed. The project overseer claimed that the masons repeatedly used sand instead of mortar and laid the bricks randomly. In 1892 three movable wooden towers replaced the brick edifices that gave way to erosion, but these new lights were eventually sold off and used as private summer cottages. In 1975 the National Park Service acquired and reunited the trio, and they stand near the present single light that went into service in 1911 at Nauset Station.

Year first constructed	1837
Height	9m
Location	Massachusetts

Due to the increasing threat of erosion, in 1996 the still-active Nauset Light had to be moved 336 feet farther from its old beach site.

The trio of conical brick towers' nickname, "The Three Sisters of Nauset," is said to have originated because the lighthouses looked like women wearing black hats and white dresses.

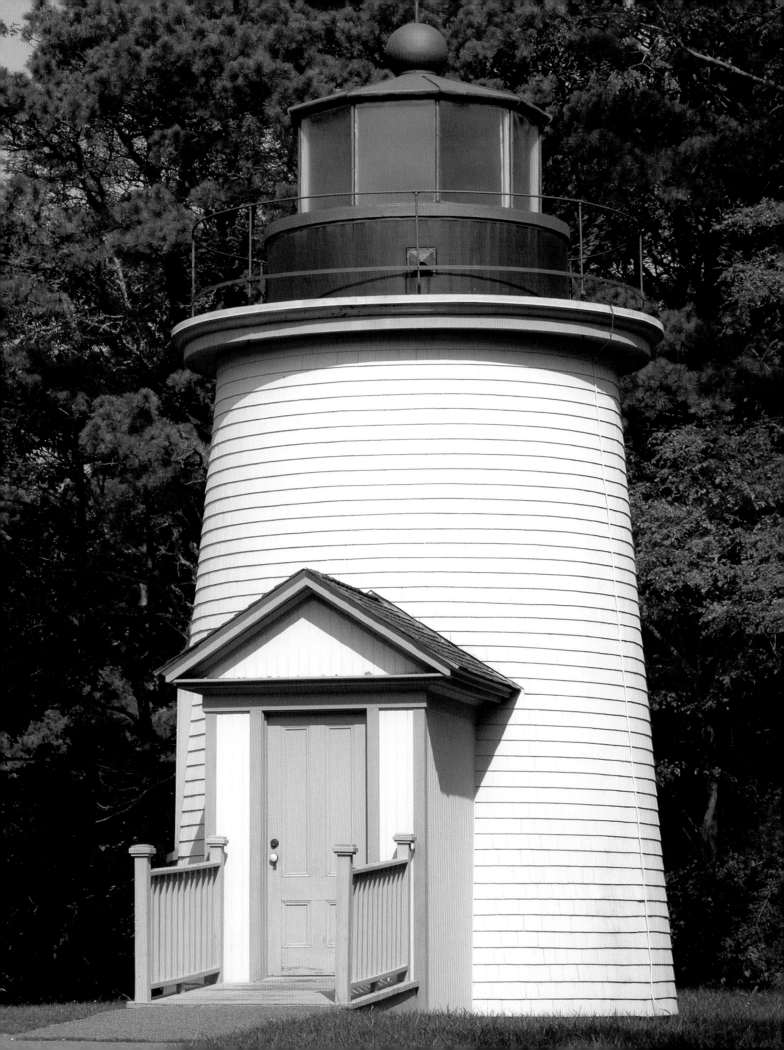

Gay Head:

In 1852, after being ranked the ninth most important seacoast light in the nation, the Gay Head station won the miracle that awed Hunter—a first-order Fresnel lens, composed of 1,008 prisms. This innovative optic would greatly increase the efficacy of lighthouses around the world. Anchored to the colorful striped clay cliffs that allow it to shine 170 feet above sea level, the light is the oldest on Martha's Vineyard and can reach an amazing 25 miles out to sea.

Year first constructed	1799
Height	15.5m
Location	Massachusetts

In 1884 the lighthouse witnessed one of the worst maritime accidents in New England history when the passenger ferry City of Columbus ran aground on Devil's Bridge, killing almost 100 passengers.

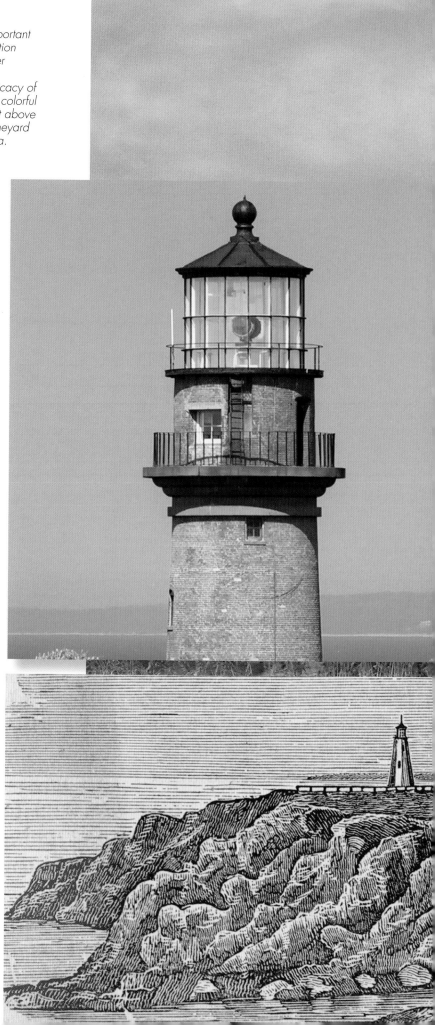

The first light erected at Gay Head was a 47-foot octagonal wooden lighthouse. Its keeper, Ebenezer Skiff, was the first white man to live in Gay Head, which was populated by Wampanoag Indians.

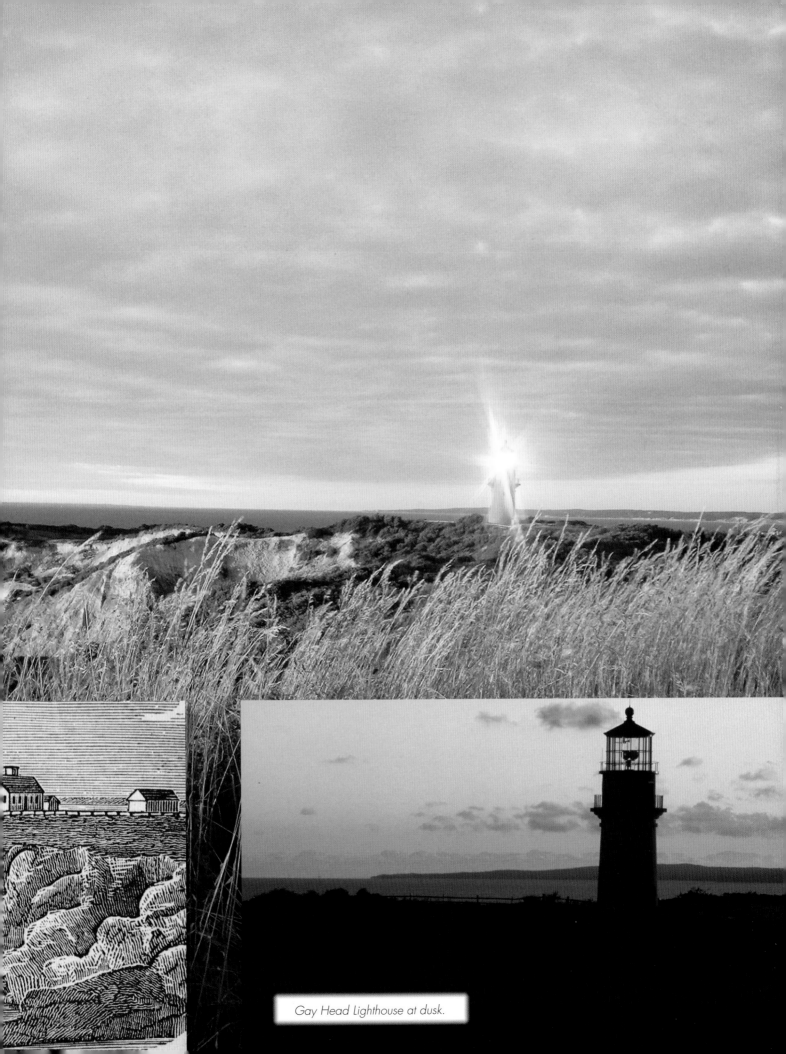

Gay Head Lighthouse at dusk.

West Quoddy Head Lighthouse:

Located on the easternmost point of the contiguous United States, West Quoddy Head Lighthouse has guided fishing and trade vessels through the swift currents of the windy and constricted passage of Quoddy Narrows since 1808. Over time the lighthouse was equipped with a fog cannon, a 4,000-pound bell, and a Daboll trumpet fog whistle to assist ships muddled by the frequent mists in the nearby Bay of Fundy. In 1858 the current tower was built and painted with the signature eight red and seven white "candy stripes."

Year first constructed	1808
Height	15m
Location	Maine

At the same time the West Quoddy Head was erected, a one-and-a-half-story Victorian keeper's house was built. The original rubble-stone lighthouse was demolished and rebuilt in 1858.

A 50-step spiral stairway extends up the 49-foot red-brick tower. The stairs become exceptionally steep as they reach the top and are met with a 10-rung ladder.

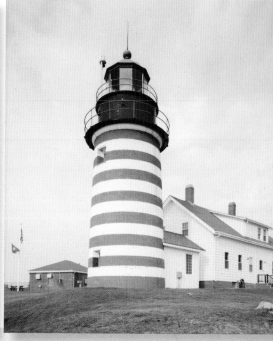

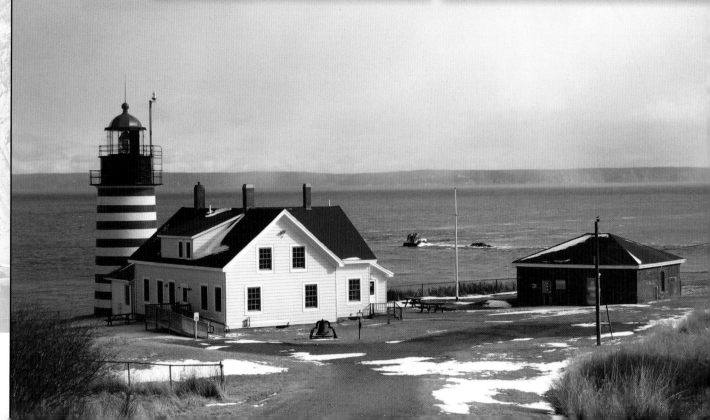

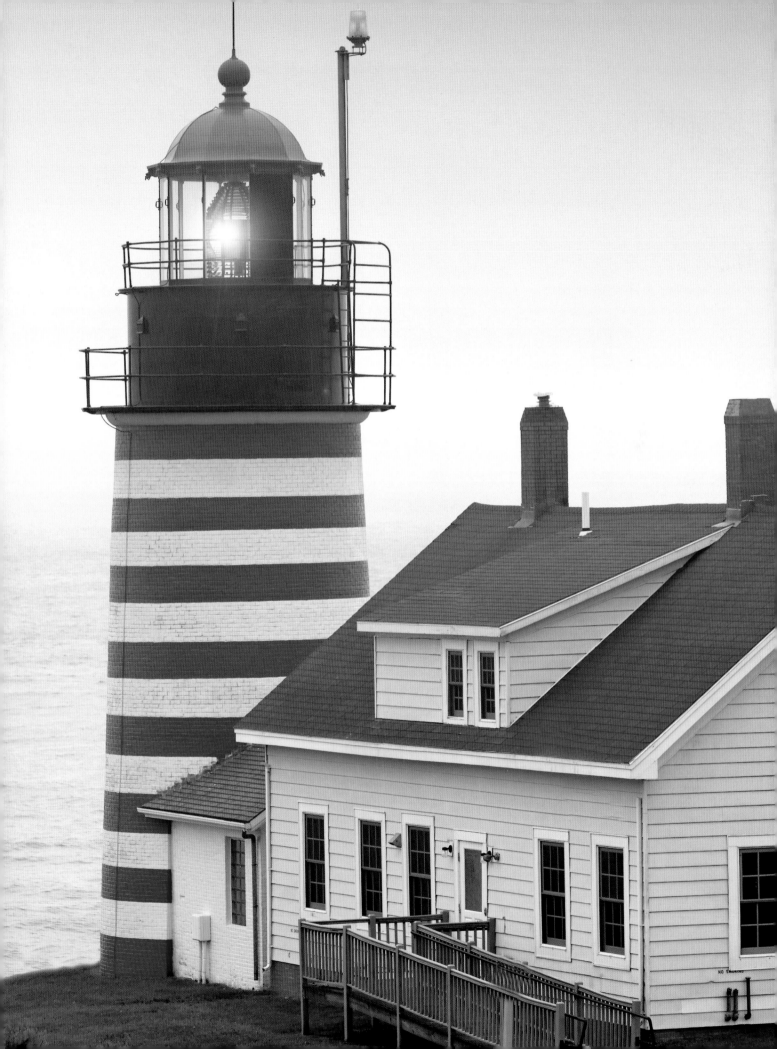

Admiralty Head Lighthouse:

Admiralty Head Lighthouse was one of the Pacific coast's first important navigational aids. Construction on the original red, wooden lighthouse was finished shortly before the beginning of the Civil War, and its light guided many vessels through Admiralty Inlet to the shores of Whidbey Island. The lighthouse's position was considered so strategically significant to the protection of Puget Sound that it was torn down and relocated during the Spanish Civil War to accommodate Fort Casey and the massive guns of the "triangle of fire," a trio of forts set up in the sound to deter enemy invasions. The present Spanish colonial–style structure stands 127 feet above the water, and it was the last brick lighthouse designed by acclaimed architect Carl Leick.

Year first constructed	1861
Height	9.1m
Location	Washington

One of the earliest navigational markers on the West Coast, Admiralty Head sits atop Red Bluff, and its fixed white light's beam directs Puget Sound marine traffic up to 16 miles away.

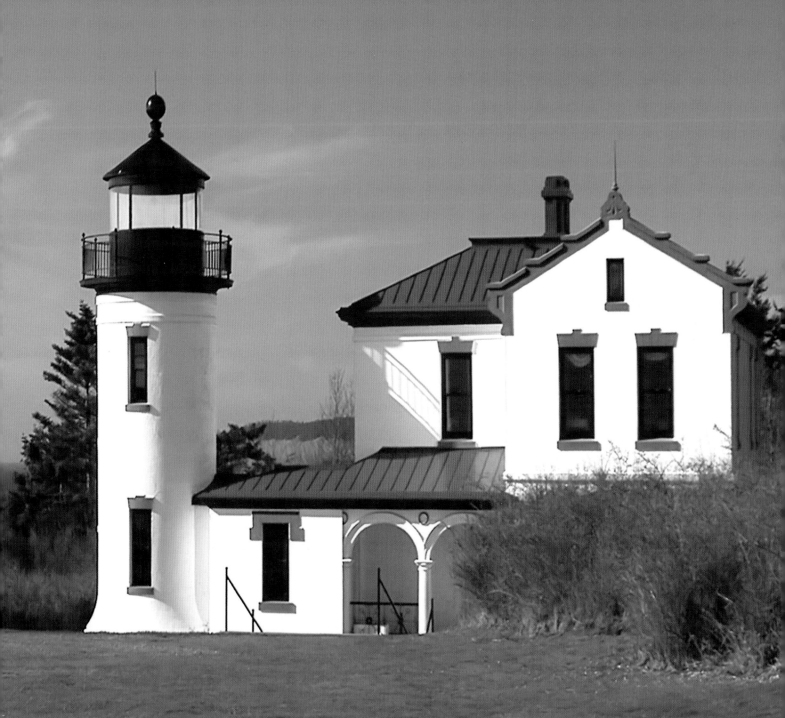

Cape Disappointment:

Known as the Graveyard of the Pacific, the treacherous area at the mouth of the Columbia River has drowned almost 2,000 vessels in the last 300 years. This region harbors a deadly river bar and powerful currents. The light at Cape Disappointment greatly lessened the dangers, even though its construction was fraught with difficulty. The first ship bearing materials for the lighthouse foundered on the shores of the cape. Although a second ship brought more supplies, once the tower was constructed, workers discovered that it was too small to accommodate the 4-ton first-order Fresnel lens assigned to the station. The lighthouse was taken apart brick by brick, rebuilt, and finally lit in 1856. It is the oldest operating light on the Pacific coast.

Year first constructed	1856
Height	16.1m
Location	Washington

The station sits close to Fort Canby, a military reservation established in 1852 to protect the entrance of the Columbia River. The reverberations from the post's substantial artillery range have been known to shatter the lighthouse's windows.

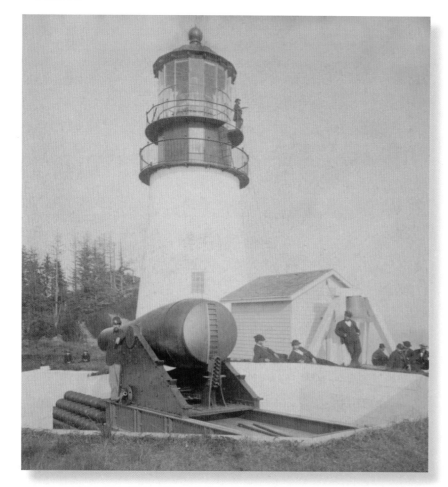

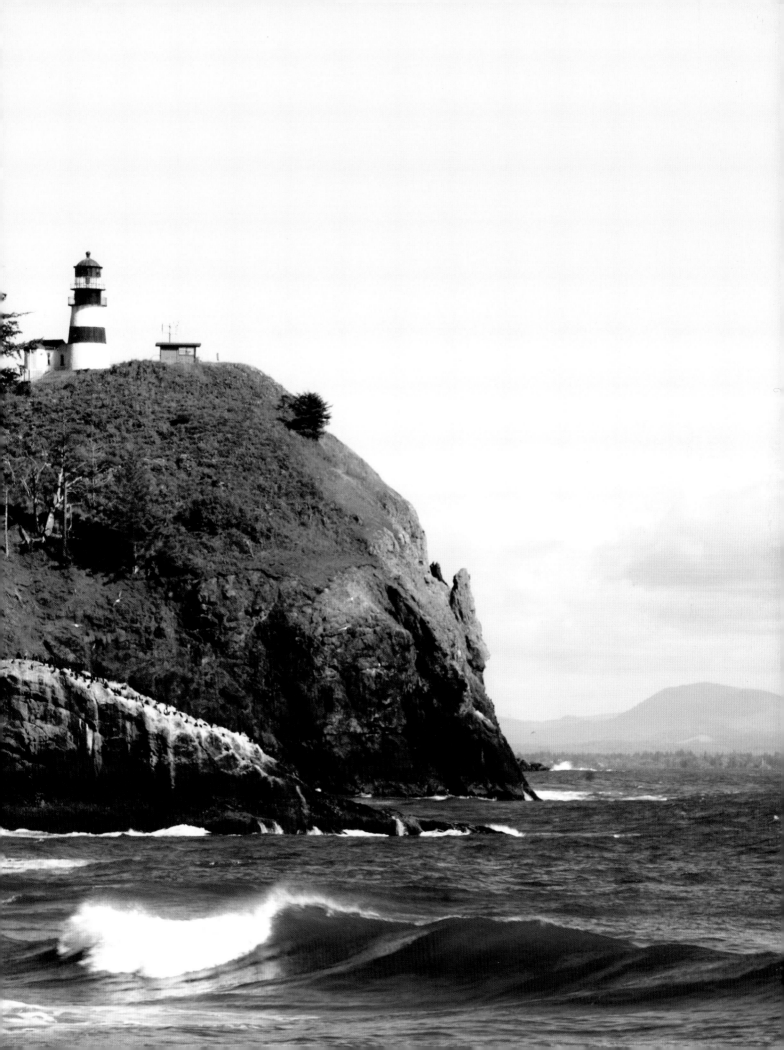

St. Augustine Lighthouse:

St. Augustine Lighthouse is located in the oldest continuing European settlement of North America. As early as 1565, Pedro Menedez, the city's founder, operated a watchtower as a navigational aid at the north end of Anastasia Island, one of the city's barrier islands. In various incarnations the structure was composed first of wood, then coquina (a stone formed of compressed shells), and then brick. The area transferred hands from Spain to Britain, then back to Spain, and finally to the United States in 1821. Paul Pelz, one of the architects of the Library of Congress, designed the lighthouse that remains, which was completed in 1874.

Year first constructed	1823
Height	50.29m
Location	Florida

The original lighthouse of the late sixteenth century was meant to aid mariners, but Sir Frances Drake—on discovering the port of St. Augustine—pillaged and destroyed the town and tower.

The beacon served as a Coast Guard lookout post for enemy ships and submarines during World War II. St. Augustine Light remained staffed until 1955, when it became automated.

The 165-foot lighthouse has a colossal fourth-order Fresnel lens that still remains in operation. Its black and white barber-pole stripes make it a landmark pinnacle of the Florida coast.

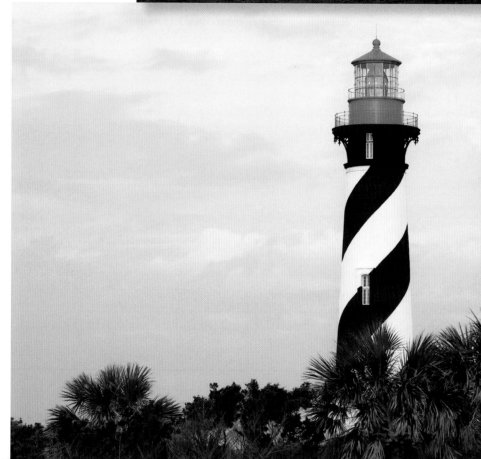

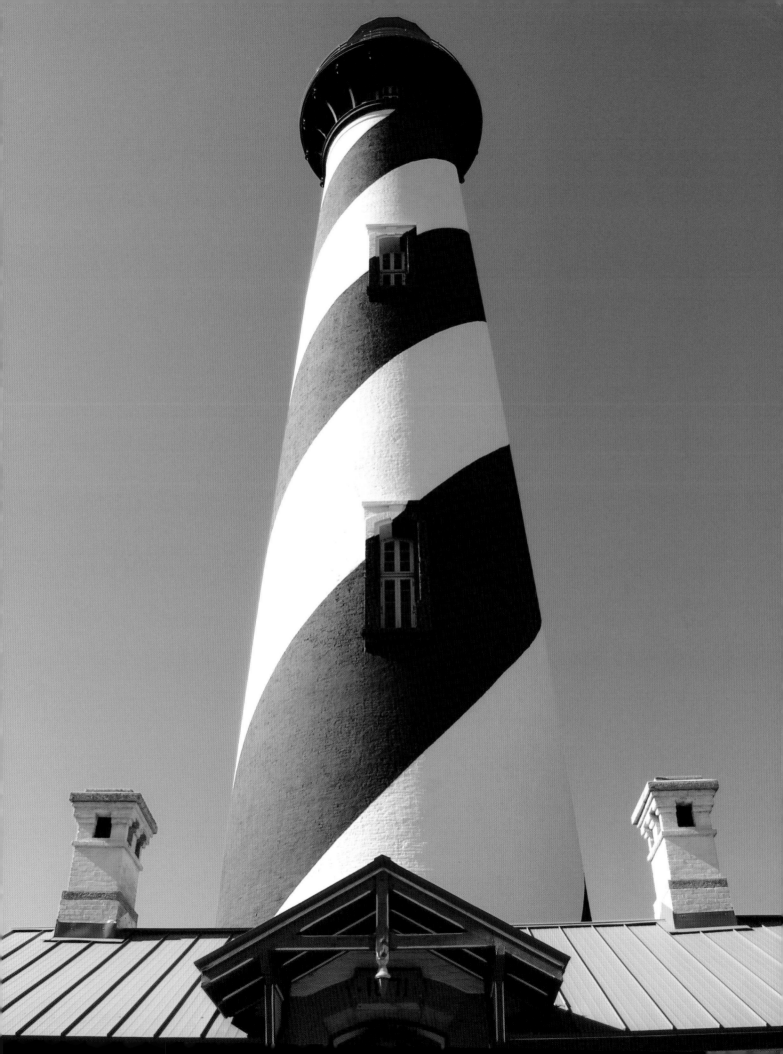

Grand Haven Lighthouse:

Painted fire engine red, the Grand Haven South Pierhead and the Grand Haven South Pier Inner lighthouses sit at opposite ends of a pier that juts out from the shore near the mouth of the Grand Haven River. A small light tower protrudes from the roof of the pierhead light, which is also a fog signal building; this square construction is anchored to a concrete base with a V shape resembling the prow of a ship, which mitigates the effect of waves on the structure. On the other end of a catwalk rises a 51 foot, steel-sided, cylindrical tower with another light at the top. This unusual pair of twin lights guides boats though one of Lake Michigan's most important harbors.

Year first constructed	1839
Height	15.5m
Location	Michigan

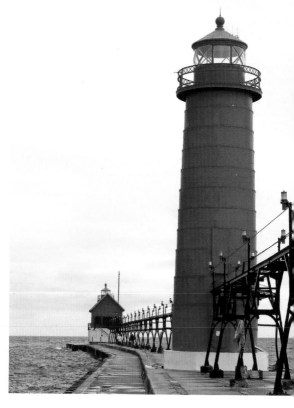

As boats enter the Grand Haven River, the Grand Haven Pier Lights guide them into the narrow channel that leads to one of Michigan's best deep-water harbors. The towers, known as the Grand Haven Inner Light and Pier Light, provide what is known by some as the most recognizable of Michigan lights.

The inner light on the Grand River, first lit in 1905, is still operational today, under the management of the U.S. Coast Guard. The lantern room, surrounded by a parapet, has been automated since 1969.

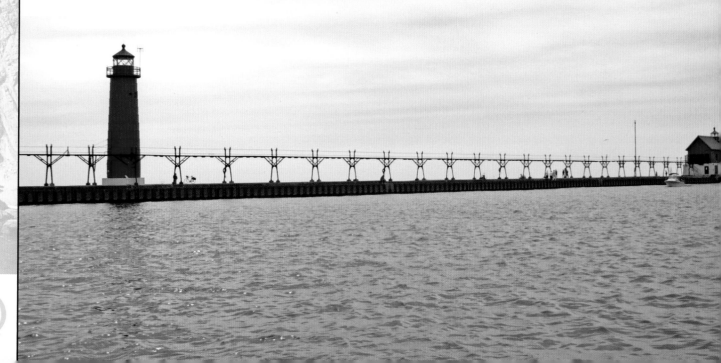

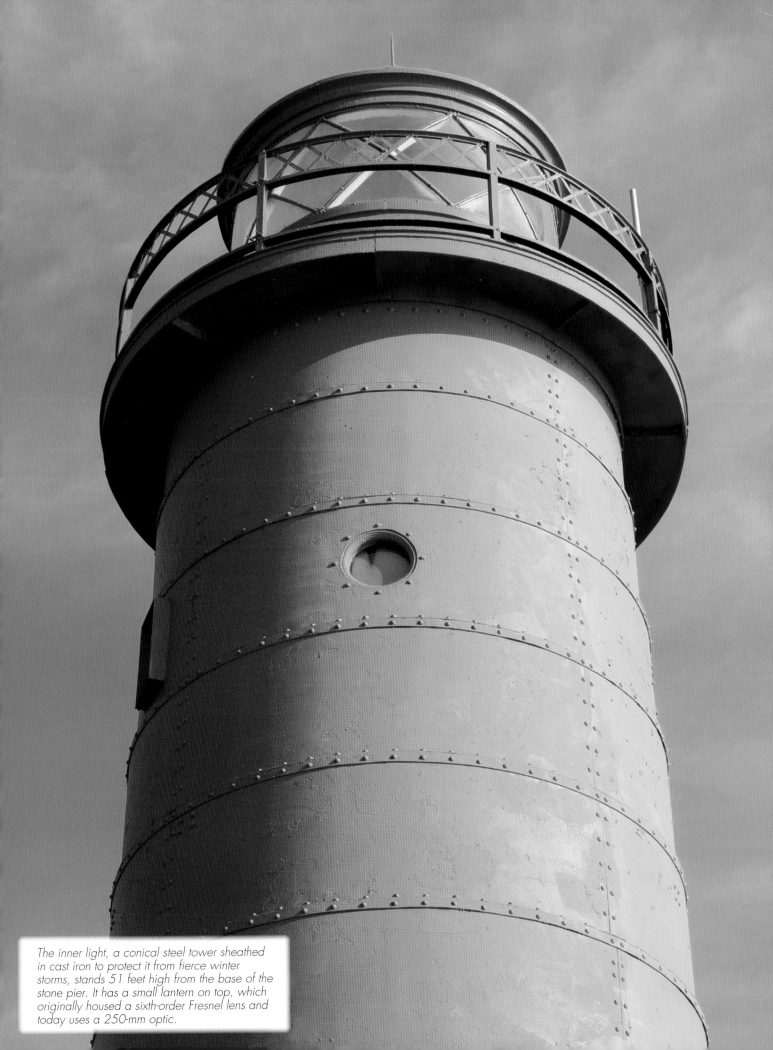

The inner light, a conical steel tower sheathed in cast iron to protect it from fierce winter storms, stands 51 feet high from the base of the stone pier. It has a small lantern on top, which originally housed a sixth-order Fresnel lens and today uses a 250-mm optic.

Tarrytown Lighthouse:

In 1847, Congress authorized funds for a lighthouse to warn of dangerous shoals off the eastern shore of the Hudson River, just north of Manhattan. Wrangling over the location delayed construction of the light station, and the completed tower wasn't lit until 1883. The Tappan Zee Bridge spanned the Hudson in 1955 and six years later the Tarrytown lighthouse was deactivated. Westchester County took over control of the light in the 1970s and constructed a metal footbridge to connect the lighthouse to the shore. Currently open to the public, the Tarrytown Light celebrated its 125th anniversary in 2008.

Year first constructed	1883
Height	18.3m
Location	New York

Though the light was once a quarter-mile offshore, retreating waters have brought it a mere 50 feet from the mainland.

Tarrytown was considered a desirable lighthouse assignment due to its proximity to town.

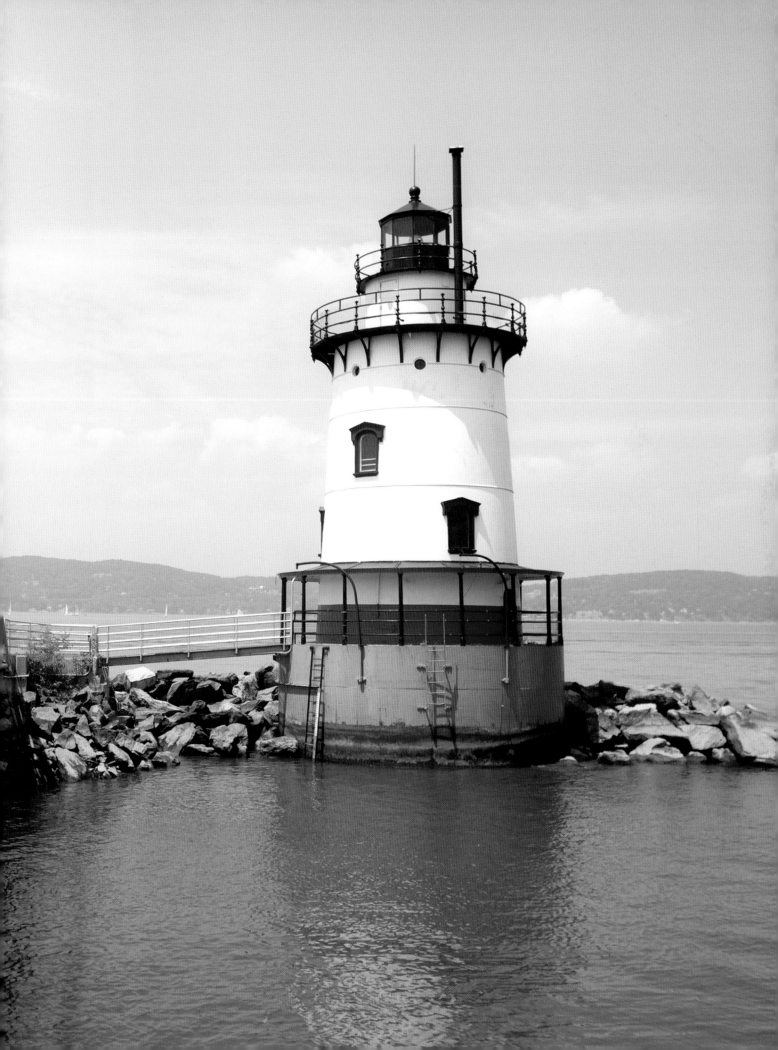

Tarrytown Lighthouse cont'd:

The keeper's house is actually inside the lighthouse, the first floor acting as a kitchen and living area, while the bedrooms are on the next two floors. There was a bedroom on the fourth level as well as a storeroom. The top level stored equipment for the light.

The Tarrytown Light is the only Caisson-style lighthouse on the Hudson River. Caisson lighthouses have cylindrical bases that are sunk into the sea floor then filled with concrete to build the foundation.

It is called the Tarrytown Light, but the tower is actually located in Kingsland Point Park in the village of Sleepy Hollow.

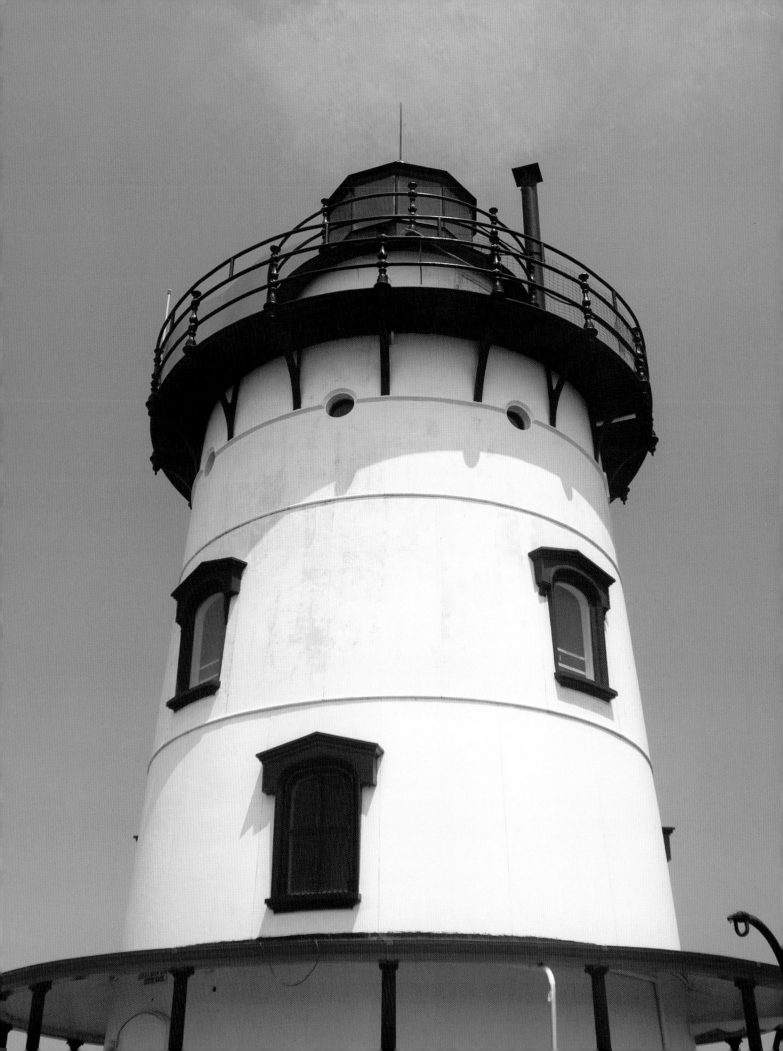

Jeffrey's Hook Lighthouse:

The inspiration for a children's book, Jeffrey's Hook Light, or the Little Red Lighthouse, rests at the edge of the Hudson River. It was built in 1880 at Sandy Hook Point, New Jersey, and was relocated to its current spot in 1921. Ten years later, the George Washington Bridge would tower over the 40-foot Jeffrey's Hook Light and make its beacon obsolete. Although plans were afoot for the Coast Guard to auction off the structure, fans of the lighthouse rallied to save it, and in 1951 the Little Red Lighthouse was given to New York City. The light was renovated in 1986, and again in 2000.

Year first constructed	1889
Height	12.2m
Location	New York

"Once upon a time a little lighthouse was built on a sharp point of the shore by the Hudson River. It was round and fat and red." This is the opening to the book The Little Red Lighthouse and the Great Gray Bridge, which helped save the Jeffrey's Point Light from destruction.

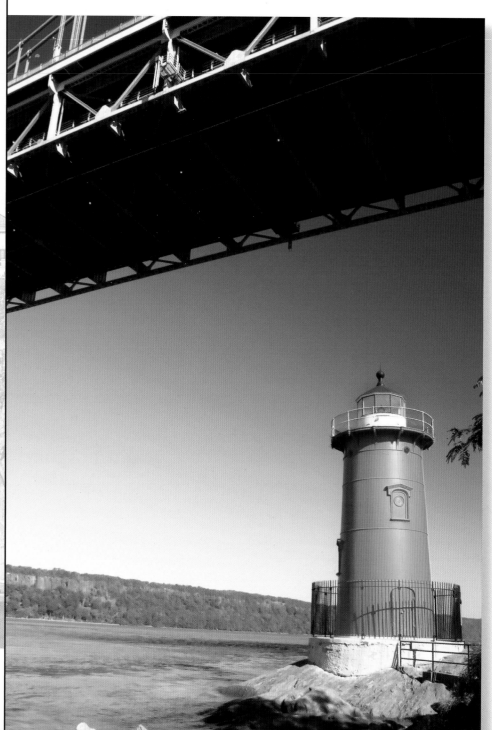

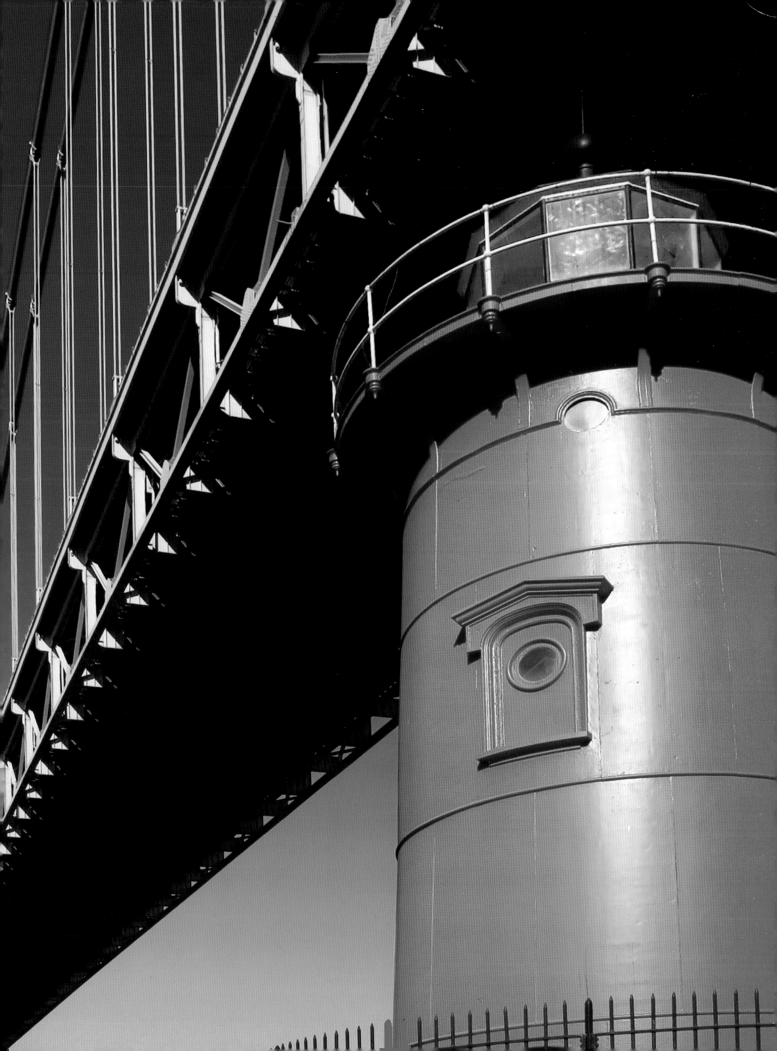

Marblehead Lighthouse:

Completed in 1821, the Marblehead Lighthouse is the oldest operational lighthouse on the Great Lakes. This gracious structure guides boats to the entrance of Sandusky Bay. The tower was originally 50 feet tall, but in 1897 a watch room and a new lighting system were installed to increase the height of the beacon to 65 feet. A third-order Fresnel lens completed the improvements at that time. Marblehead Light was home to the first female keeper on the Great Lakes, Rachel Wolcott, who took over as keeper after her husband's death. The Wolcott residence is the oldest dwelling in Ottawa County and currently houses a museum where visitors can see the tower's Fresnel lens.

Year first constructed	1821
Height	19.8m
Location	Ohio

As the oldest operational lighthouse on the Great Lakes, Marblehead Light has been featured on a U.S. postage stamp and on Ohio's license plate.

The limestone used to construct the outer walls and the keeper's house was also used to build the Empire State Building.

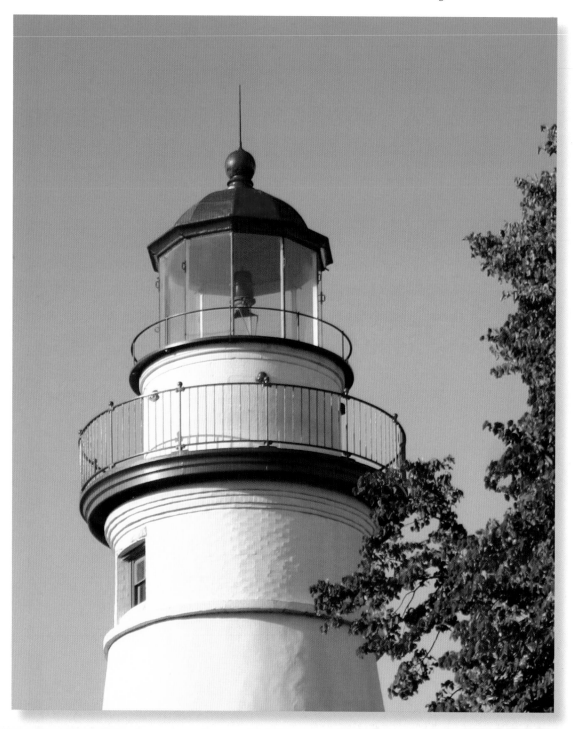

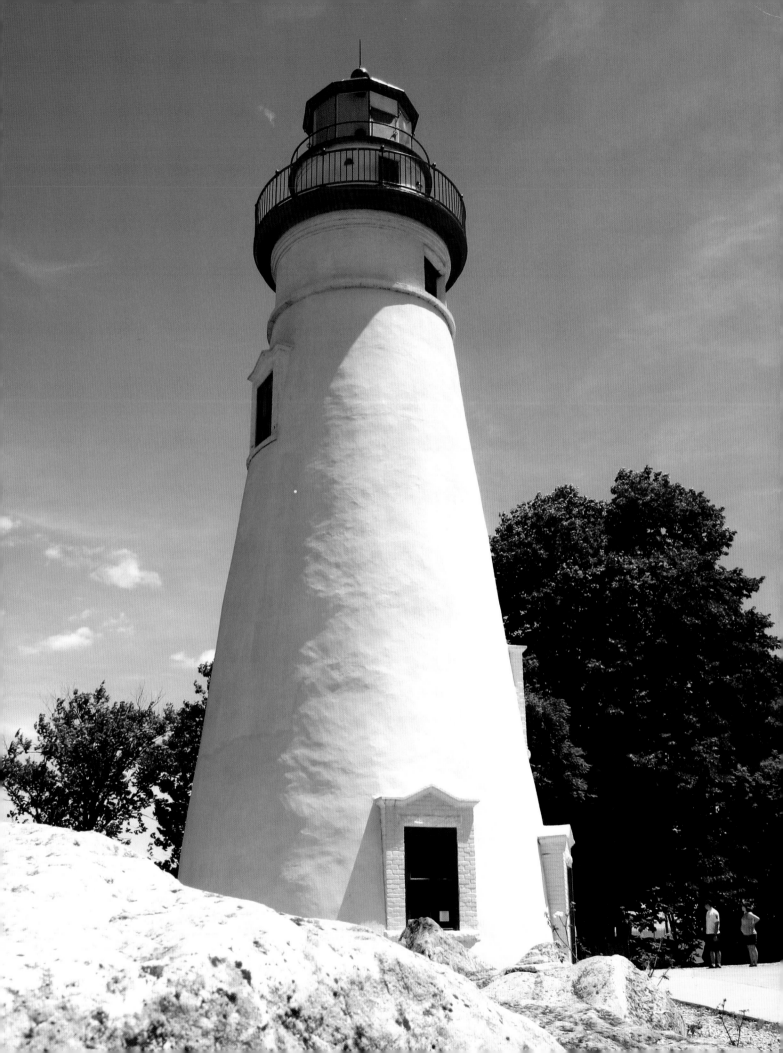

Chicago Harbor Lighthouse:

The Chicago Harbor Lighthouse is the only surviving lighthouse in Chicago. Originally built at the entrance to the harbor in 1893 in honor of the World's Fair, the light was moved out to the breakwater in 1919. A fog signal building and a boathouse are attached to the light on either side. With red roofs on the buildings and a light characteristic that flashes red every five seconds, the Chicago Harbor Light acts not only as an aid to navigation but also as welcome sign to the city.

Year first constructed	1832
Height	14.6m
Location	Illinois

The Chicago Harbor Light houses a third-order Fresnel lens that was showcased at the World's Fair of 1893. The light wasn't automated until 1979.

The keeper's quarters were built into the eighteen-foot-diameter tower. This eliminated the expense of and need for a separate building.

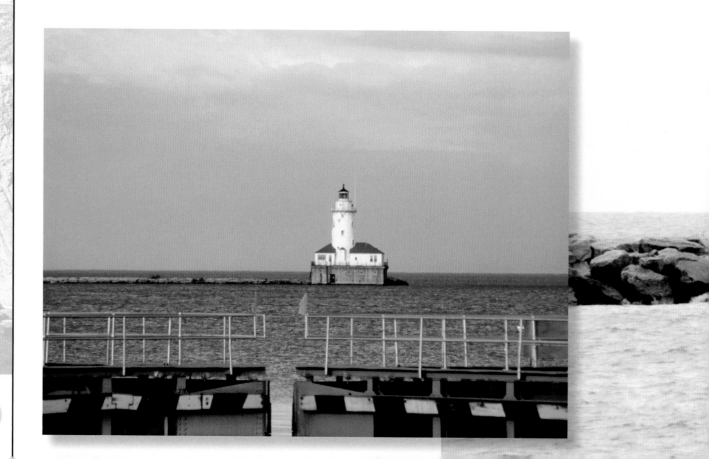

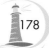

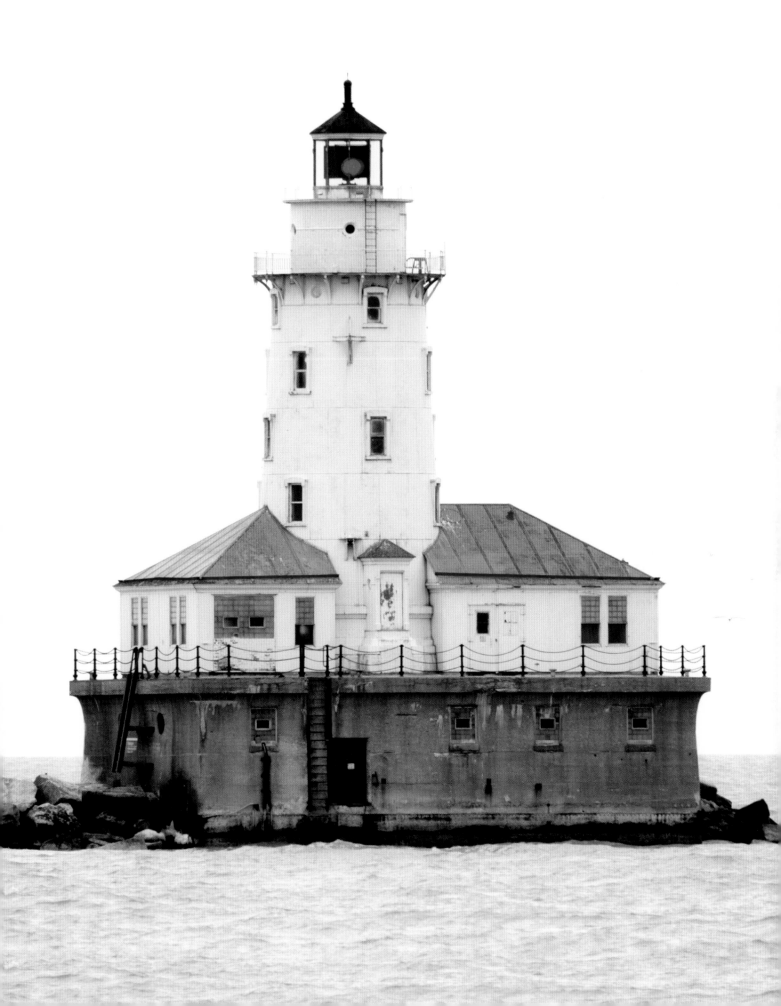

Kilauea Lighthouse:

Located on the north shore of Kauai, Kilauea Lighthouse served as an aid to navigation for ships traveling back and forth from Asia to Hawaii, until the station was damaged in 1976. During its construction the lighthouse at Kilauea met many challenges; all the materials had to be shipped by sea to the island, and when the planned site for the structure was found to be unstable, workers had to dig down 11 feet to reach solid rock. As the result of this excavation, the design of the tower was altered to include a basement, an unusual feature in a lighthouse. A second-order Fresnel lens was installed to focus the Kilauea light, and this original lens remains at the station today.

Year first constructed	1913
Height	15.85m
Location	Hawaii

The ground where Kilauea Light was built was unstable, and workers had to dig 11 feet to find rock solid enough to support the structure. Because of this, Kilauea has a basement.

In 1927, an army air crew attempted the first flight from Oakland, California, to Oahu, Hawaii. The crew lost radio signal and were lost until one of the pilots caught sight of the light from Kilauea.

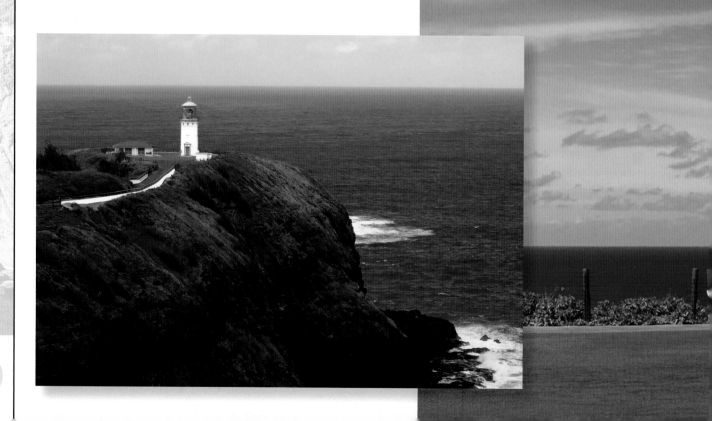

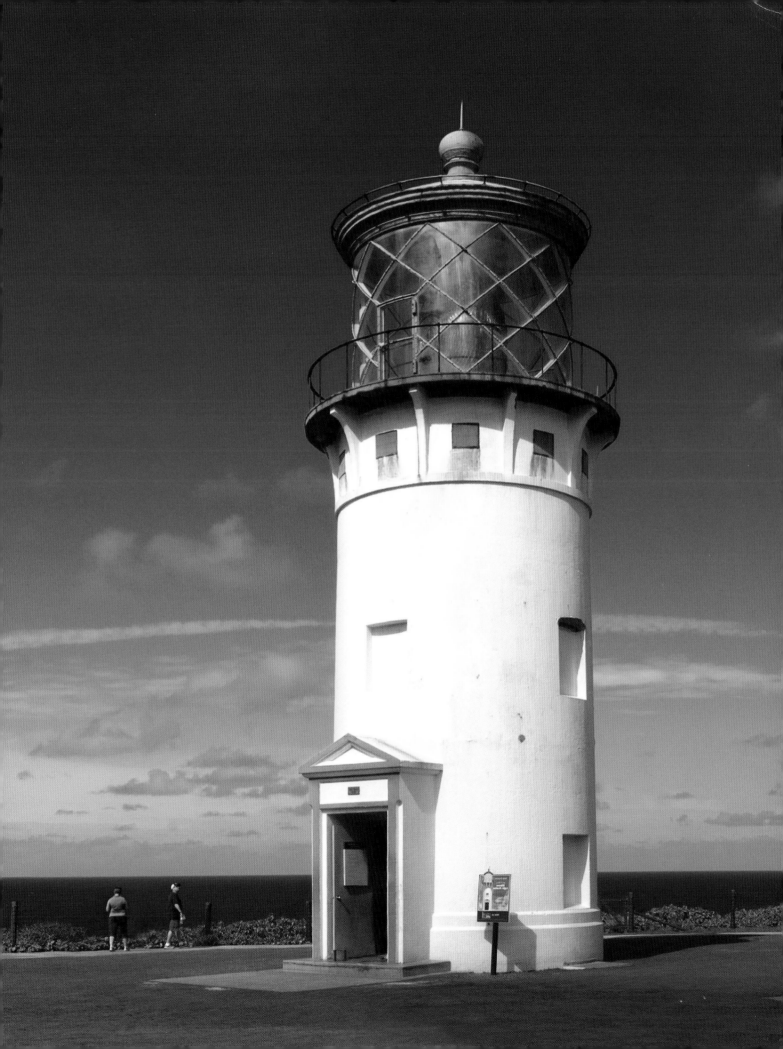

Biloxi Lighthouse:

The Biloxi Light was the first cast iron lighthouse built in the southern United States and the second oldest in the country. Built in 1848 and equipped with a fifth-order Fresnel lens, the light has survived many hurricanes, including the recent onslaught of Katrina—though Hurricane Camille destroyed the keeper's house in 1969. Female keepers have maintained the light at Biloxi longer than at any other lighthouse in the United States. Mary Reynolds was the first female keeper, and she served throughout the Civil War even when the light was darkened. Today the city of Biloxi is being rebuilt after the devastation of Hurricane Katrina, and the lighthouse that weathered the storm is seen as a beacon of hope.

Year first constructed	1848
Height	18.6m
Location	Mississippi

Shortly after the Civil War, the Biloxi Light was painted black to protect it from rust. Many believe that this was done as a sign of mourning for the death of Abraham Lincoln. In 1869, the tower was repainted white.

The Biloxi Light is the last remaining original lighthouse built on the Mississippi coastline.

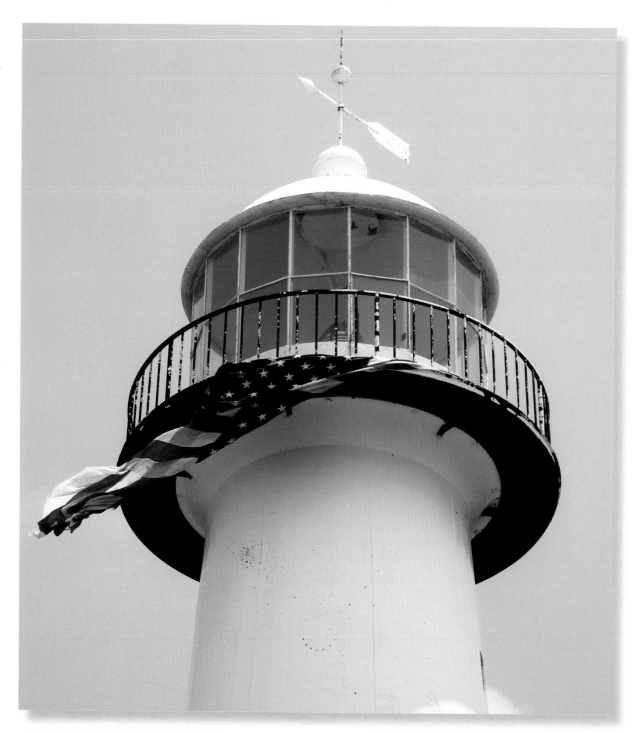

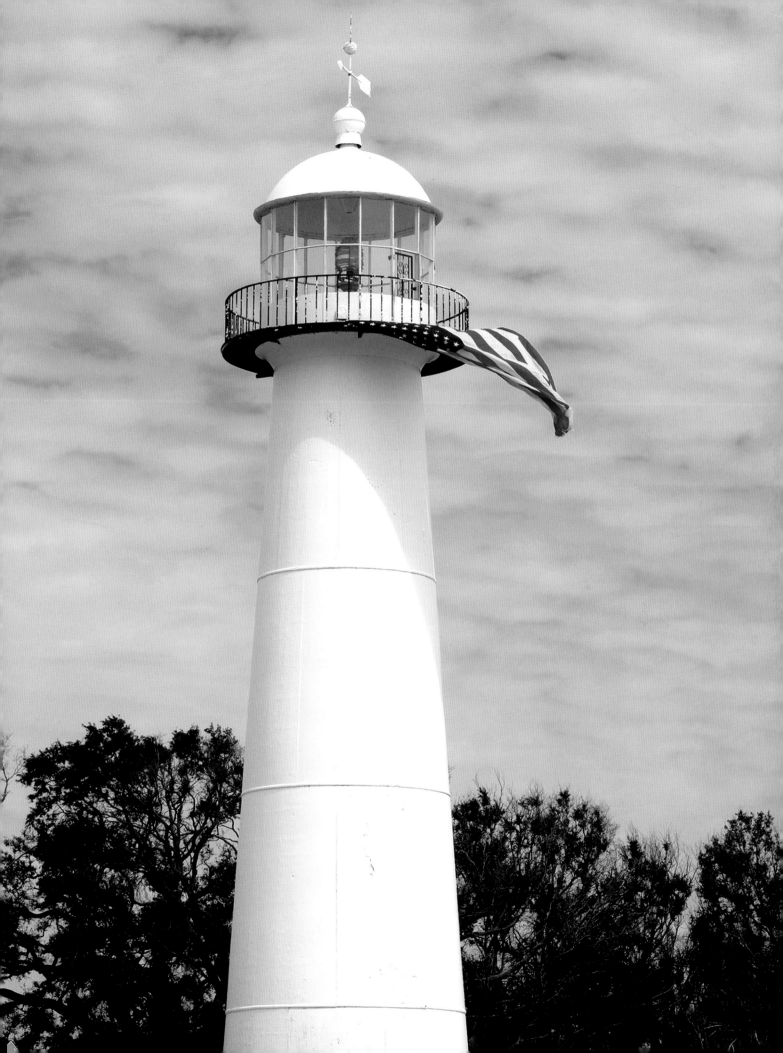

Portland Breakwater Lighthouse:

Until 1855 the rubblestone wall of Portland Breakwater remained unlit. Although it calmed the rough Atlantic waves as they entered the harbor, the barely discernable breakwater proved a hazard to ships. First an octagonal wooden beacon shone at the end of the breakwater. Then, when the wall was lengthened, a temporary lighthouse stood guard. Finally, in 1875, a new tower modeled on a historic building near Athens replaced the decaying interim structure. With six cast iron Corinthian columns at its perimeter and Greek ornamentation on its gallery deck, the lighthouse lit the harbor in style until 1942. The light was reactivated in 2002 as a private aid to navigation.

Year first constructed	1855
Height	7.9m
Location	Maine

The Portland Breakwater Light has six Corinthian columns around its perimeter and the roof edge is decorated with palmettes. The design was modeled on the Choragic Monument of Lysicrates in Athens.

The original fog bell was transported from the Staniford Ledge buoy every winter to the breakwater to warn ships of ice. It was transferred to the breakwater permanently in 1898.

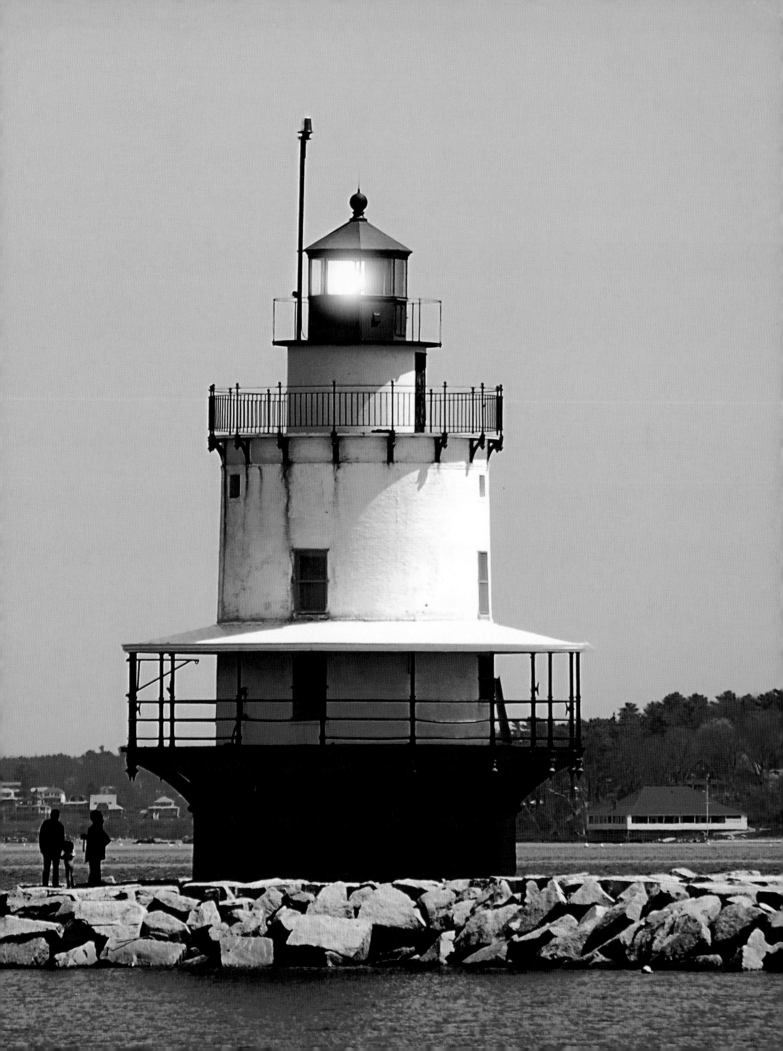

Anacapa Island Lighthouse:

In 1853, the highly publicized shipwreck of the Winfield Scott sent gold rushers' newfound riches to the bottom of the sea. In the wake of this tragedy, President Franklin Pierce ordered that Anacapa Island, a chain of three adjacent islets, be reserved to build a lighthouse. After surveying the steep, perpendicular cliffs of volcanic rock, the U.S. Coast Guard pronounced the site "inconceivable for a lighthouse" since it was "inaccessible by any natural means." Numerous expensive groundings of marine vessels convinced the Lighthouse Bureau otherwise, and in 1932 construction was finally completed on the last major lighthouse to be built on the West Coast.

Year first constructed	1932
Height	12.2m
Location	California

Fixed at the top of a 39-foot concrete cylindrical tower, a solar-powered acrylic lens replaced the third-order Fresnel lens in the 1980s.

After the steamer Liebre ran ashore on the east coast of the Anacapa Island due to foggy conditions, there was a petition to build the last major light station on the West Coast.

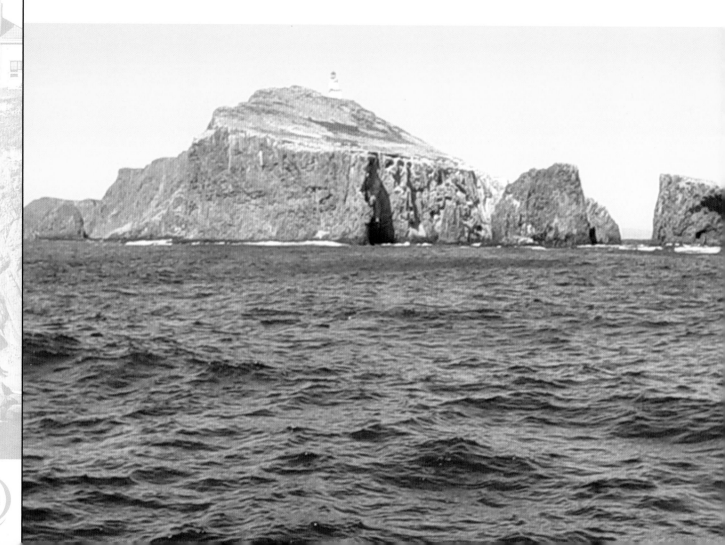

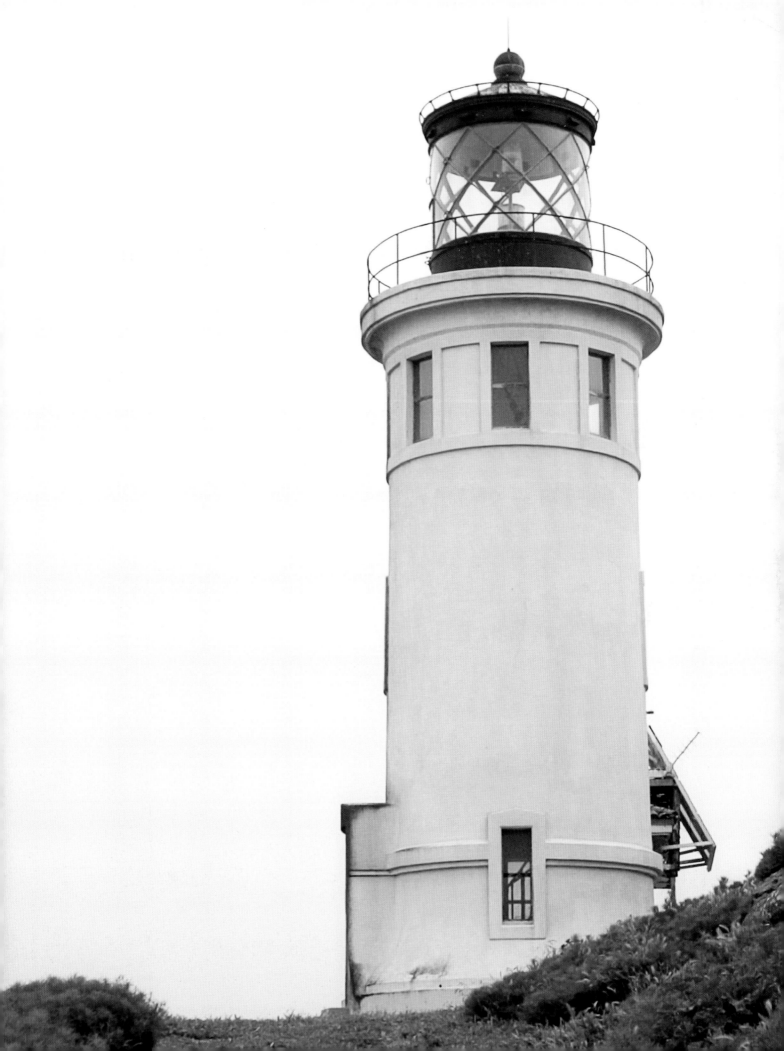

Boston Harbor Lighthouse:

The first lighthouse in America, Boston Harbor light played a key role as the revolutionaries wrested control of the colonies from the British. The initial tower, erected in 1715, was paid for by the colony of Massachusetts Bay and maintained by taxes on vessels entering and leaving the harbor. After the Sons of Liberty tossed 342 chests of tea overboard to protest the British tea tax, the British navy blockaded the harbor and seized the lighthouse. General Washington retaliated by sending Minutemen, who set fire to the lighthouse tower twice. Just as Washington's troops regained control of the area, the fleeing British exploded the remains of the battered beacon. In 1783, builders completed a new tower, and its light still pierces the night sky of the Massachusetts Bay.

Year first constructed 1783
Height 27.1m
Location Massachusetts

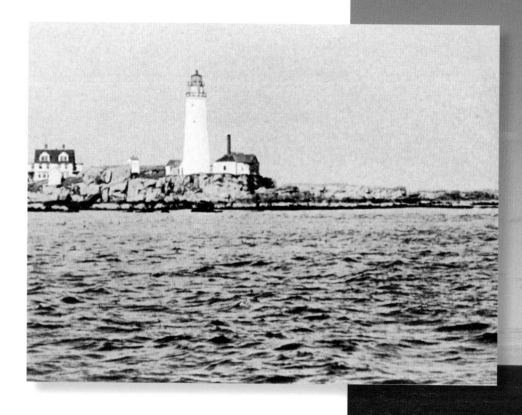

The first keeper of the lighthouse was George Worthylake, who drowned along with his wife and daughter when they were returning to the island's shores in 1718.

Resting on the rocky south point of Little Brewster Island, Boston Harbor Light is 89 feet tall and is the only lighthouse to be actively staffed by the Coast Guard.

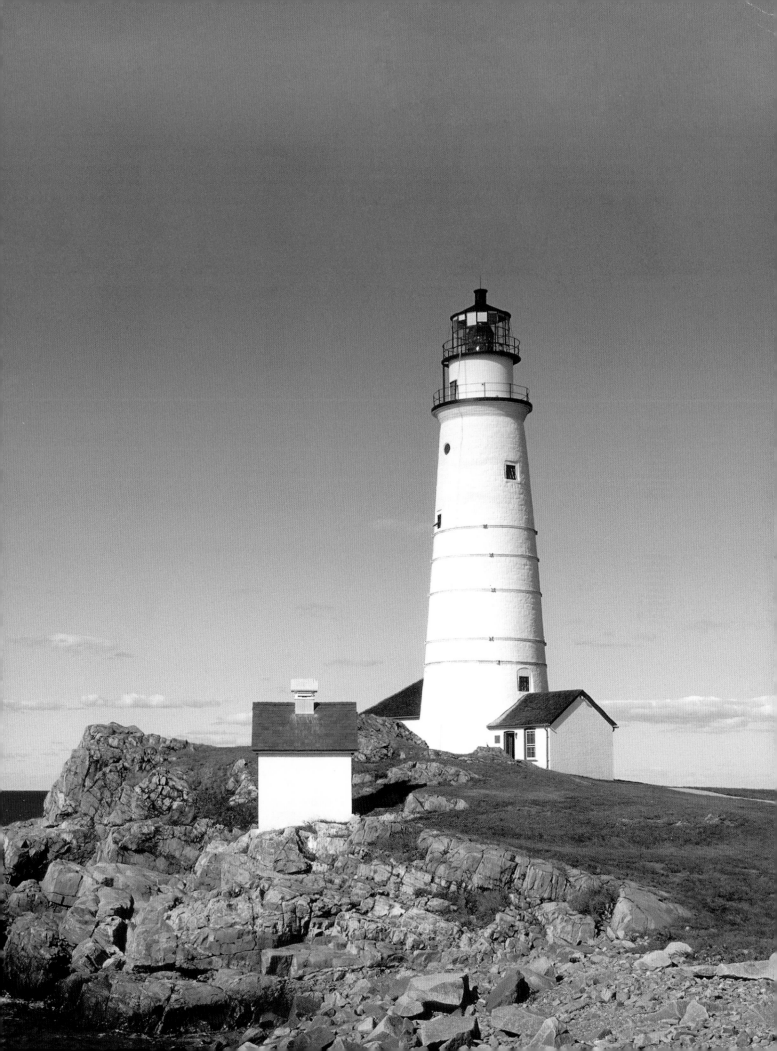

Cape Canaveral Lighthouse:

Although passage to the ironbound, brick lighthouse proved difficult, neighbors traveled over land and sea to get to the Lighthouse Balls at Cape Canaveral in the period following the Civil War. The newly moved and improved lighthouse completed in 1868 was equipped with a first-order Fresnel lens, as well as the only piano in the area. Lightkeeper Mills O. Burnham lived there with his wife and children and tended the light for 33 years. Since then, the beacon has seen the advent of the Space Age. It is rumored that Wernher von Braun watched the early launchings of his rockets from a walkway at the tower's top as they took off at Cape Canaveral. Quite close to the NASA launch site, the lighthouse is currently owned and maintained by the United States Air Force.

Year first constructed	1868
Height	44.2m
Location	Florida

The striped beacon had to be disassembled and moved farther inland due to sand erosion and the encroaching shoreline. Mules dragged the disassembled pieces along tram rails, and after two years, Cape Canaveral Light was relit in 1894.

The first Cape Canaveral lighthouse was only 65 feet tall, and its light was so weak that ships kept running aground on the ocean's rocky shoals. The new cast-iron lighthouse was constructed after the Civil War and peers out over the Atlantic at more than twice the height of the original.

Cape Canaveral's earthshaking rocket launches significantly damaged the tower's first-order Fresnel lens. Beginning i 1993, Cape Canaveral Light underwent a considerable restoration process, and in 1995 a DCB-224 Optic lens finally replaced the original. That same year the Coast Guard continued its repairs by exchanging the old lantern room for a newly modernized one.

In the late 1950s, the lighthouse was often used as a forward observation poin for the launch of missiles and rockets from Cape Canaveral's many seaside launch pads. Experiments of engineers and scientists from the Cape Canaveral Air Force station rocketed past the 145-foot-tall beacon of light.

The original roof and lantern room are now on display as a gazebo at the Air Force Space and Missile Museum. The 1868 Fresnel lens is preserved at the Ayres Davies Lens Exhibit Building at the Ponce de Leon Lighthouse Museum.

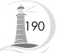